DRAWINGS FROM GEORGIA COLLECTIONS
19th & 20th CENTURIES

Cover illustration:
44. Pablo Picasso, *Two Men Contemplating a Bust of a Woman's Head*, 1931, pencil on paper. Private Collection, Atlanta.

DRAWINGS FROM GEORGIA COLLECTIONS
19th & 20th CENTURIES

PETER MORRIN AND ERIC ZAFRAN

THE HIGH MUSEUM OF ART
ATLANTA

EXHIBITION SCHEDULE

The High Museum of Art
Atlanta, Georgia
May 14 - June 28, 1981

A selection of the drawings
will be exhibited at
The Georgia Museum of Art
University of Georgia
Athens, Georgia
July 12 - August 23, 1981

This exhibition is made possible by grants
from the National Endowment for the Arts and
the Georgia Council for the Arts and Humanities.

Copyright 1981 The High Museum of Art. All rights reserved.
Published by The High Museum of Art, Atlanta, Georgia.
Designed by Jim Zambounis.
Edited by Kelly Morris.
Printed by Preston Rose Company, Atlanta.

Library of Congress Catalogue No. 81-80881
ISBN 0-939802-00-7

4

In a sense, a Museum's treasures extend beyond its walls. Quite often, works held by private individuals play an important part in a community's cultural growth, though the art may not be on public view. It is always rewarding, therefore, to display some of these objects in the Museum, as a measure of the community's humanistic worth.

In light of this, an exhibition of this kind is meaningful beyond the theme of the project itself. In this case, the presentation of drawings by masters of the nineteenth and twentieth centuries should be most rewarding, because the artists of this particular period represent that bold freedom of spirit which can be expressed so effectively through the medium of drawing.

High Museum curators Peter Morrin and Eric Zafran are to be commended for their extensive and successful search for material in Georgia collections. They have uncovered many delightful surprises which are shown to the public for the first time here. Their perceptive scholarship has made this exhibition worthwhile as well as enjoyable. A project of this kind requires a great deal of methodical work on the part of many individuals and I would like to thank both curators as well as the other staff members mentioned in the Acknowledgements for their useful contributions.

Most especially, our thanks go to the collectors and institutions who had the insight and the will to acquire these and other works of art which are such an important element in the sum total of our intellectual treasury. We are deeply grateful to the lenders for making these drawings available to this exhibition.

Gudmund Vigtel
Director

FOREWORD AND ACKNOWLEDGEMENTS

When we arrived in Atlanta slightly more than a year ago, we were certain there were many treasures to be discovered in collections throughout the state. This exhibition is the first fruit of our endeavors and, as can be seen, is indeed a rich harvest. We defined drawings—according to Agnes Mongan's dictum—as any non-printed work on paper. The amount of outstanding material we discovered was extensive, so extensive, in fact, that we have limited this exhibition to the 19th and 20th centuries, and concentrated on European and more recent American artists. It is hoped that at some time in the future we will be able to organize a similar exhibition concentrating exclusively on American drawings.

We wish to thank all the lenders, without whose encouragement, generosity, and good will, the exhibition would not have been possible. Their positive response to our requests for loans has made this a most rewarding undertaking. In addition to the private lenders, both named and anonymous, we also wish to thank our colleagues at other art institutions in the state: Alexander Gaudieri and Feay Shellman at the Telfair Academy in Savannah; Bill Scheele and Fred Fussell at the Columbus Museum of Arts and Sciences; and Linda Steigleder at The Georgia Museum of Art in Athens. A special word of thanks is due to Richard Schneiderman, Acting Director of The Georgia Museum of Art, for his kindness in agreeing to the loan of a number of fine works from that collection and also for making it possible for a selection of the drawings from the exhibition to be shown there.

The exhibition and the catalogue were both made possible by grants from the Georgia Council for the Arts and Humanities and the National Endowment for the Arts. We thank them and fervently hope they will continue to flourish and support such "grass roots" projects. In addition, we received a generous contribution toward the publication of this catalogue from Mrs. Rosalee Marks Goldstein, for which we are most grateful.

In preparing the catalogue we have drawn on the expert knowledge of a number of scholars and would like to acknowledge the following for their helpful information: Marc Gerstein, Dewey Mosby, Sally Yard, John Howett, and Clark Poling. Also, the staffs at the following libraries and research centers have facilitated our work and we are most grateful: The Frick Art Reference Library, The Institute of Fine Arts, Knoedler and Company, The Metropolitan Museum of Art, The Fogg Art Museum, The Museum of Modern Art, and Yale University Library.

In the gathering of research material we have been ably assisted by Rachel Bessent, Phyllis Schwartz, Marianne Lambert, Julie Pietri, and Kimberly Carr. The bulk of the photography was by Jerome Drown. The job of preparing the catalogue manuscript was carried out admirably by Rhetta Kilpatrick and Martha Sweeny. We would also like to acknowledge the assistance of Shelby White Cave, Joel Sturdivant, and Frances Robertson Francis of the Registrar's Office. Kelly Morris was the most accommodating of editors and Jim Zambounis a model designer. We also wish to acknowledge the enthusiastic support of the Museum's Director, Gudmund Vigtel.

There has been no hard and fast rule in the division of labor on the catalogue entries, and we have both benefitted from the interchange of ideas and information that occurs in the presence of great works of art.

Peter Morrin
Curator of 20th Century Art

Eric Zafran
Curator of European Art

CATALOGUE OF THE EXHIBITION

In all measurements, height precedes width.

"Lugt" refers to Frits Lugt,
Les Marques de collections de dessins & d'estampes
(The Hague, 1956), with supplement.

Jacques-Louis David (French, 1748-1825)

1. *Portrait of Thirus de Pautrizel,* ca. 1795

Ink and wash with white highlighting on paper, circular, 7½ inches (19 cm.) in diameter.

Signed in pen at lower right: *L. David.* Inscribed on the mat: *Thirus de Pautrizel, Capitaine de Cavallerie en 1785. Représentant de la NATION FRANÇAIS en 1794 et 1795.*

Exhibitions: Caracas, *Exposicion de dibujos del renacimiento al siglo XX,* May 24-June 9, 1957, no. 8; Palais des Beaux-Arts, Charleroi, *Fragonard–David,* October 24-December 1, 1957, no. 32; UCLA Art Gallery, *French Masters, Rococo to Romanticism,* March 5-April 18, 1961.

Provenance: Gairac Collection, Paris; Wildenstein and Co., New York, to 1961; Private Collection, New York.

Lent by a Private Collection, Atlanta.

David, more than any other artist, captured the spirit of France during the periods of Revolution and Empire and recorded the look of the individuals involved. From the 1780s onward, his portraits seem to display the intensity of the times and he purposely made use of stark decor to focus on character. Even when imprisoned briefly following the fall of Robespierre, he continued his work, portraying his fellow Conventionnels, as in the study of Jeanbon Saint-André (Art Institute of Chicago). In this and other portrait drawings in chalk or pen, such as the probably slightly earlier portrait of Thirus exhibited here, David perfected a format of small round portraits with subjects shown in sharp profile. This was perhaps inspired by antique coins and medals. It may be related to his plans for the multifigured composition of 1791, *Le Serment de Jeu de Paume.* A similar use of profile, but to the right, is employed for a *Portrait of a Man* (Louvre, Cabinet des dessins, RF4233). There is also a chalk *Self-Portrait* of this type (Private Collection, Brussels, reproduced in René Verbraeken, *Jacques-Louis David,* Paris, 1973, no. 0.69). Women and children were also shown this way, as for example the *Portrait of Mlle. Susanne Charlotte Sedaine* (Louvre) or the *Two Children of David* (Collection Mme. Bianchi).

Jean-Baptiste-Louis-Thirus Pautrizel was born at L'ile de Ré (Charente-Inférieure) on August 25, 1754. He became a land owner in la Basse-Terre on the French Caribbean Island of Guadeloupe. In the Revolutionary period, he rose to the rank of captain and was appointed, in October 1792, a member of the Convention as a deputy from Guadeloupe. He was eventually denounced before the Convention for a seditious attitude and he was imprisoned for a time. The date of his death is unknown. (See Adolphe Robert and Edgar Bourloton, *Dictionnaire des Parlementaires Français,* v. XI, Paris, 1891, p. 562.) As a deputy he would undoubtedly have met David, who was himself elected in 1792. The emphasis on the aquiline nose and high forehead recalls David's *Portrait of Michel Lepeletier de Saint-Fargeau* (Bibliothèque Nationale). David's subtle modeling in wash adds warmth and atmosphere, enlivening what otherwise would be a coldly formal portrayal.

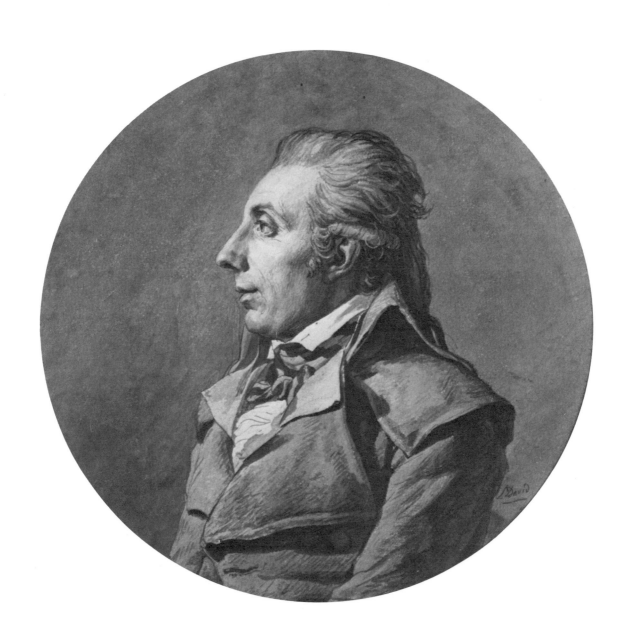

2. *Studies of Joan of Arc and the Head of a Woman,* ca. 1844

Pen and ink (*recto*) with graphite (*verso*) on tracing paper, now mounted on blue wove paper, 11⅞ x 15⅜ inches (30.2 x 39.1 cm.)

Inscribed by Raymond Balze along the base of the altar: *ces croquis preparatoire a un tableau/autre que le portrait costumé/du Museé du Louvre.* And inscribed at the lower left: *Dessins pour Le plutarque français;* and at the lower center: *note de R. Balze.*

Bibliography: Henri Delaborde, *Ingres,* Paris, 1870, p. 302, no. 338 (?); George Wildenstein, *Ingres,* New York, 1954, p. 221, under no. 273; Robert Rosenblum, *Jean-Auguste-Dominique Ingres,* 1967, p. 161.

Exhibitions: Fogg Art Museum, Cambridge, *Ingres Centennial Exhibition, 1867-1967,* Feb. 12-April 9, 1967, no. 92; Metropolitan Museum of Art, New York, *Classicism and Romanticism, French Drawings and Prints 1800-1860,* September 15-November 1, 1970, no. 55.

Provenance: Raymond Balze; Sale R. W. P. de Vries, Amsterdam, 1929, p. 125; Sale Stuttgartner Kunstkabinett, Stuttgart, May 20, 1953, no. 709; Private Collection, New York.

Lent by a Private Collection, Atlanta.

In 1841 Ingres returned to Paris from Rome, where he had been Director of the French Academy, and began to assume his position as the most distinguished representative of the academic school. He was named a Commander of the Legion of Honor in 1845, the first of his many official honors.

Beginning in the 1820s, he had painted a series of works depicting episodes from French history—such as *The Entry of the Dauphin into Paris* of 1821 (Wadsworth Atheneum, Hartford). Therefore, he was an appropriate choice as an illustrator of a new edition of the compendium of biographies of great Frenchmen known as *Le Plutarch français,* prepared by Edouard Mennechet and I. Hadot and published from 1844 to 1847. The first edition of 1835 had had a depiction of Joan of Arc after a drawing by Boilly, but Ingres was an artist more to the taste of the Louis-Philippe period. Indeed, he was entrusted with representing some of the most distinguished figures of French history, supplying, in addition to Joan of Arc, images of Le Sueur, Poussin, La Fontaine, Racine, and Molière. Ingres chose to present Joan of Arc at the peak of her career, standing heroically by an altar as she attended the coronation of Charles VII at Reims Cathedral in 1429, following the successful seige of Orléans. Her future sainthood is indicated by the halo, but this is not included by Pollet in the engraving he made after the drawing.

Preliminary sketches at the Musée Ingres in Montauban show that the artist first established the pose and then studied the figure nude and finally, after experimenting with an antique tunic, arrived at the costume of medieval armour seen in this drawing. Here he drew in graphite on tracing paper the more finished of the two studies, now visible at the right. Then he folded the page and traced the figure in ink to achieve the outline drawing now seen at the left. As the open sheet is now preserved, the graphite drawing is thus on the back side of the tracing paper. Ingres obviously went through this process of folding and tracing so that he could determine how the engraving, which would be reversed from his drawing, would look.

A decade later, in 1854, Ingres painted a more elaborate version of *Joan of Arc at the Coronation of Charles VII* (Louvre, see the exhibition catalogue *The Second Empire,* Philadelphia Museum of Art, 1978, p. 319, no. VI-70); but, as the two inscriptions by his former student Raymond Balze on this drawing make clear, this sheet is not a preliminary study for that, although he did actually reuse the same basic composition.

If the drawing is turned sideways to the left, one can see clearly the features of a woman's profile. This is a larger version of the head of a kneeling woman holding a banner, which Ingres copied after details of an engraving by Dürer (see Edouard Gatteaux, *Collection de 120 dessins . . . de M. Ingres,* Paris, 1875, pl. 82).

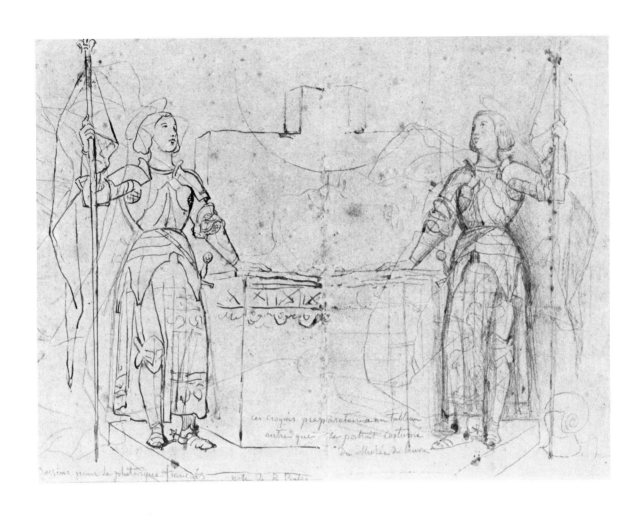

3. *Studies of Nude Male Figures for the "Frise de la Guerre,"* ca. 1833

Pencil on paper, 7⅛ x 9 inches (18.1 x 22.9 cm.)

Stamped with the artist's estate stamp at the lower right (Lugt 838): *ED*

Provenance: Private Collection, Paris; Private Collection, New York.

Lent by a Private Collection, Atlanta.

It was in 1833 that Delacroix received his first commission for a large-scale mural decoration, the Salon du Roi in the Palais Bourbon. As Delacroix later wrote, the room was not appropriate for paintings, since there were so many windows and doors. Nevertheless, he designed a scheme of four friezes to fit on the narrow spaces between the arches and the ceiling cornice. These compositions symbolically represent the various powers of the state: Justice, Agriculture, Industry, and War. The project was completed in 1838.

Delacroix set about his task in a traditional manner. A study for the overall scheme is in the Louvre (RF 23313; see Maurice Sérullaz, "Delacroix Drawings for the Salon du Roi," *Master Drawings*, v. I, no. 4, 1963, pl. 28a). The rough sketches for the arrangement on each wall are now in The Tate Gallery, London (see Maurice Sérullaz, *Memorial de l'exposition Eugène Delacroix*, Paris, 1963, no. 266-268). The artist then made studies from the nude model to get the proper pose for each figure. This sheet contains studies for figures in the War frieze (see Maurice Sérullaz, *Les Peintures Murales de Delacroix*, Paris, 1963, figs. 6 and 13-14). The kneeling nude was transformed into a bearded barbarian who laces his sandals in the first *pendentif* from the left in the section described by Delacroix as *"Les femmes emmenées en esclavage"* (women led away in captivity), and the other two studies were used for the robed figure holding a spear seated at the extreme right of the frieze in the section showing the preparation of armaments. Delacroix's powerful studies indicate not only what became the final form of these figures, but also the pattern of light and dark shading that he attempted to achieve in the paintings.

The study at the right reminds one of the pose of the youth in Rodin's first monumental sculpture, *The Age of Bronze*, cast in 1876. This could be just the repetition of a similar traditional modeling attitude, or the sculptor may indeed have seen this or other studies by Delacroix, as well, of course, as the finished paintings in the Palais Bourbon.

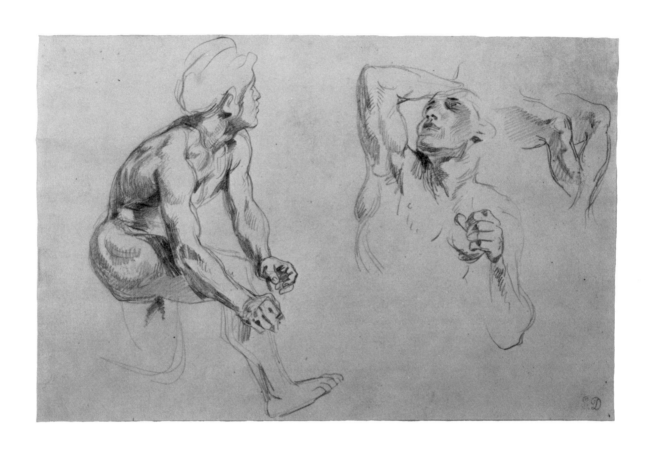

13

Eugène Delacroix (French, 1798-1863)

4. *Studies for the Figure of Ceres*, ca. 1852.

Pen and ink on paper, 5⅛ x 8 inches (13 x 20.4 cm.)

Stamped at lower center edge with the artist's estate stamp (Lugt 838): *ED*

Provenance: Private Collection, New York.

Lent by a Private Collection, Atlanta.

Sometime in late 1851, Delacroix was commissioned to paint the ceiling decoration of the Salon de la Paix in the Paris Hôtel de Ville. His program included a circular center painting representing Peace consoling Mankind and bringing Abundance. Eight rectangular coffers flanking this represented those ancient divinities in harmony with Peace: Ceres, Cleo, Bacchus, Venus, Mercury, Neptune, Minerva, and Mars. According to contemporary descriptions, it was a splendid ensemble, but unfortunately it was destroyed during the Paris Commune of 1871.

Copies after Delacroix's originals by Pierre Andrieu do exist and allow us to identify the studies on this sheet as attempts by the artist to work out the pose for the figure of the earth goddess, Ceres (see Alfred Robaut, *L'Oeuvre complet d'Eugène Delacroix*, Paris, 1885, p. 305, no. 1150). Given the attitude of an ancient river goddess or nymph, she is recumbent upon the ground, holding her scythe. The position of the head placed in the crook of the arm, seen in the two studies at the lower right, was the one ultimately chosen by the artist for his painting. With marvelous fluidity and economy, the artist's pen rendered these various alternatives.

Similar studies of several of the other mythological figures for the coffer paintings are on two sheets in the National Museum, Stockholm (see Maurice Sérullaz, "Unpublished Drawings . . .," *Master Drawings*, v. 5, no. 4, 1967, pls. 44 and 45).

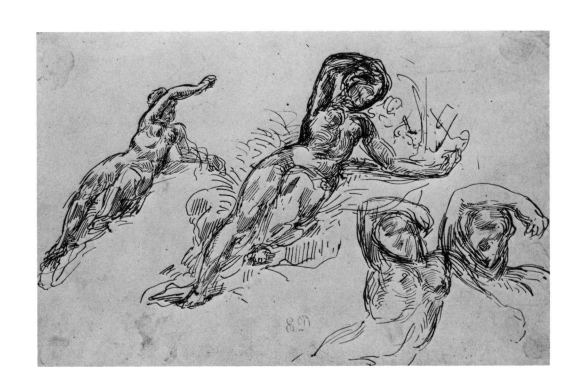

15

Eugène Delacroix (French, 1798-1863)

5. *Two Plant Studies*

Green watercolor and charcoal, 6¼ x 3⅞ inches (15.9 x 9.8 cm.)

Stamped in red at the lower right with the artist's estate stamp (Lugt 838): *ED*

Provenance: Mrs. K. E. Maison, London; Private Collection, New York.

Lent by a Private Collection, Atlanta.

It was during his stay with George Sand at Nohant in 1842 that Delacroix seems to have discovered the beauty of flowers. Mme. Sand wrote of the incident,

> I came upon him in an ecstasy of enchantment before a yellow lily, whose beautiful architecture (his own happy phrase) he had just understood. He was in a fever to paint it, for he saw that, when it was put in water, its flowering became at every moment more complete and the bloom kept changing its shade and attitude . . . He began again each day, for the lily became more and more architectural, exhibiting geometrical forms as it dried up. This led him to draw dried plants, for, as he put it, cut plants are grace in death. (Quoted in Yvonne Deslandres, *Delacroix, A Pictorial Biography*, New York, 1963, p. 87).

Delacroix continued to express his delight in flowers in a series of oil paintings and watercolor studies of great spontaneity and brilliance. In his estate sale of February 29, 1864, lot 625 consisted of seventy-seven diverse studies of flowers. These are now dispersed but this drawing may originally have been one of the group. A similar sheet with studies of *Physalis* (although using just pastel) was exhibited at the Galerie Dru, Paris, April 1925, no. 23. And a watercolor study of *fleurs de laurier-rose* is in the Musée Bonant, Bayonne, while yet another similar study was in the Thatcher collection, Washington, D.C. (photograph in the Frick Art Reference Library).

This small sheet is beautifully conceived, so that the curving rhythm of the drooping stalk is repeated in an almost musical manner.

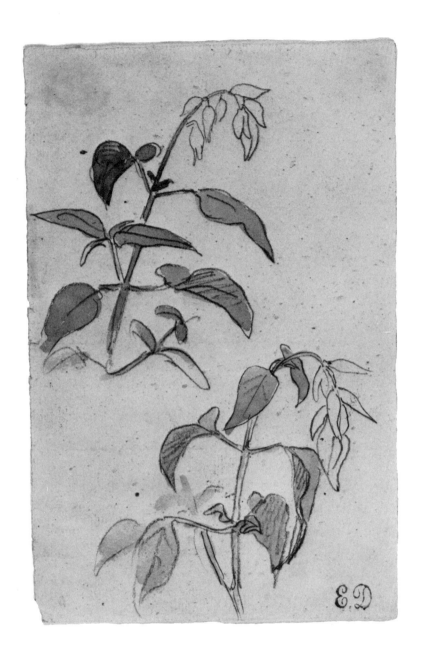

6. *A Tiger*, ca. 1835

Pencil and charcoal on tracing paper, 4¼ x 8¾ inches (11.8 x 22.3 cm.)

Stamped at the lower right edge with the artist's estate stamp (Lugt 220): *BARYE*

Exhibitions: Los Angeles Municipal Art Gallery, *Collection of Mr. and Mrs. John Rewald,* March 31-April 9, 1959, no. 3; The Newark Museum, *Nineteenth Century Master Drawings,* Newark, N. J., March 16-April 30, 1961, no. 8; Helene C. Seiferheld Gallery Inc., New York, *Animal Drawings from the XV to the XX Century,* December 1962, no. 8.

Provenance: Mr. and Mrs. John Rewald; Sale Sotheby, London, July 7, 1960, no. 4; Private Collection, New York.

Lent by a Private Collection, Atlanta.

In the early 1820s Barye, who had studied in the ateliers of Bosio and Baron Gros, worked for the goldsmith Fauconnier modeling animals in the Jardin des Plantes in Paris. Beginning in 1827, he exhibited at the annual Salons the animal sculptures and watercolors that were to become his life's work.

Barye not only sketched live animals in the zoo, but attended animal dissections. He would carefully study each form to create a perfect composite image of the animal, usually in silhouette. Then, on a transparent sheet, he would trace the main contours and any distinctive markings. The traced image could then be transferred to watercolor paper or serve as the basis for sculpture (see Charles O. Zieseniss, *Les Aquarelles de Barye,* Paris, 1954, p. 42). This method of working may explain why the present drawing on tracing paper has more the look of a tiger rug than a full-blooded living beast. The sinuous flattened form of Barye's tiger also recalls Delacroix's 1829 lithograph of *A Royal Tiger.*

The tiger with open snarling mouth and one paw extended onto its victim occurs in a number of Barye sculptures. One of his earliest was the *Tigre devorant un gavial* that caused a sensation at the Salon of 1831 and won the sculptor a second class medal. The critic Théophile Gautier wrote of this, "What energy, what ferocity, what a thrill of satisfied lust for killing shows in the flattened ears, the savage gleaming eyes, the curved nervous back, the clutching paw, the rocking haunches, and the writhing tail of the tiger." (See Stuart Pivar, *The Barye Bronzes: A Catalogue Raisonné,* Woodbridge, 1974, p. 13 and fig. A61). The tiger in this drawing resembles most closely the one in the sculpture entitled *Tigre devorant un paon* (Pivar, fig. A64).

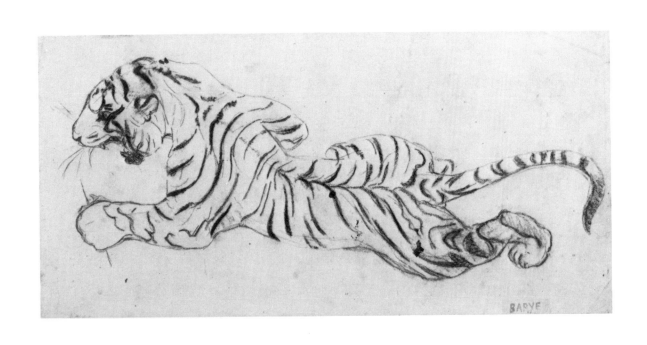

7. *Le Petit Savoyard*, ca. 1831

Watercolor and gum arabic on paper, 5¼ x 6½ inches (13.2 x 16.5 cm.)

Bibliography: Dewey F. Mosby, *Alexandre-Gabriel Decamps*, New York, 1977, v. II, p. 437, no. 102.

Exhibition: Detroit Institute of Arts, 1950, no. 45.

Provenance: Paul Grigaut, Detroit; Lakeside Studio, Lakeside, Michigan, 1970.

Lent by Emory University, Department of the History of Art Collection.

Decamps was one of the most original artists working in France in the mid-nineteenth century. His anecdotal themes, and his Near Eastern subjects painted in a dark manner with heavy impasto, made him extremely popular.

As is evident in this watercolor, Decamps derived much of the inspiration for his style from seventeenth century Dutch and Flemish art. A number of his early works depict street activity, including itinerant entertainers and their pet animals (see Mosby, v. II, pls. 66 and 20). The representation of the young street beggars, ostensibly from Savoy, first appeared in French painting in a work by Watteau around 1708. In the nineteenth century, a number of artists, including Chatillon and Bonvin, took up the theme and treated the children in a sympathetic, romantic manner (see Gabriel P. Weisberg, *The Realist Tradition*, exhibition catalogue, The Cleveland Museum of Art, 1980-81, p. 42, no. 1).

Decamps had originally depicted an impoverished savoyard and his monkey in a lithograph of 1823, *Savoyard et le Singe* (Mosby, v. II, pl. 163b). In this drawing, he reworked the theme, probably in preparation for another lithograph, *Le Petit Savoyard*, which was published in *L'Artiste* in 1831 (see Adolphe Morneau, *Decamps et son oeuvre*, Paris, 1869, p. 26, no. 10; Mosby v. II, pl. 172a). The motif of the dressed monkey on the back of the dog also occurs in another watercolor of about 1830 called *Singe Jockey* (Private Collection, Paris, see Mosby, v. II, pl. 123b). It may have been out of these works that Decamps developed, about 1833, his *singeries*, pictures in which monkeys are used to satirize human activities.

Decamp's softly modeled, atmospheric forms complement the wistful appeal of the young boy who gazes out at the passer-by, his hat held in readiness for any offering. A glow of diffused light surrounds his head, adding to the sense of innocence. Within the small format, the colors of the watercolor have a brilliant gem-like sparkle that is enhanced by the application of gum arabic.

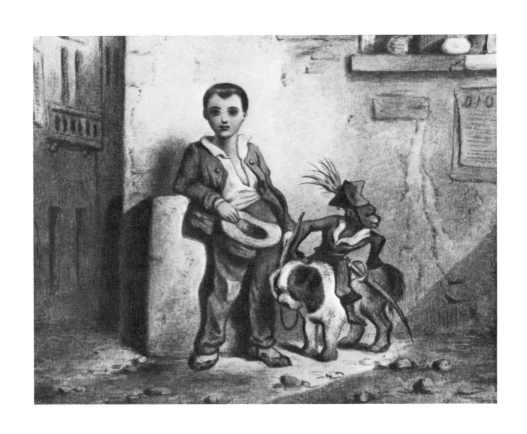

Victor Hugo (French, 1802-1885)

8. *Stormy Landscape*, ca. 1866

Ink wash on paper, 4$^{15}/_{16}$ x 7$^{15}/_{16}$ inches
(12.5 x 20.2 cm.)

Inscribed in purple ink at the lower left: *V.H.*

Provenance: Private Collection, New York.

Lent by a Private Collection, Atlanta.

Victor Hugo, the celebrated writer and poet, was also an artist of extraordinary originality. His chosen medium was ink wash and he was justly praised by Baudelaire for "the magnificent imagination which streams through his drawings just as mystery streams through the heavens." (Salon review of 1859, *Art in Paris 1845-1862 . . . Reviewed by Charles Baudelaire,* translated and edited by Jonathan Mayne, Greenwich, 1965, p. 202.)

This drawing is done in the free, broad style Hugo evolved during his years in exile, when he travelled and lived in such rugged and romantic locals as the Orkneys and along the Rhine River. It is comparable to several other drawings of the mid-1860s, in which the artist drags his brush or pen across the surface of the paper to create an effect of great sweep. (See Gaëtan Picon, *Victor Hugo Dessinateur,* Paris, 1963, figs. 230, 231, 262, 271).

To achieve the rich coloration of his ink Hugo would often mix coffee into it. On small pieces of paper he would create miniature scenes of tremendous power, full of foreboding. He seems to have been so enraptured in this drawing that he incorporated his own finger print into the composition.

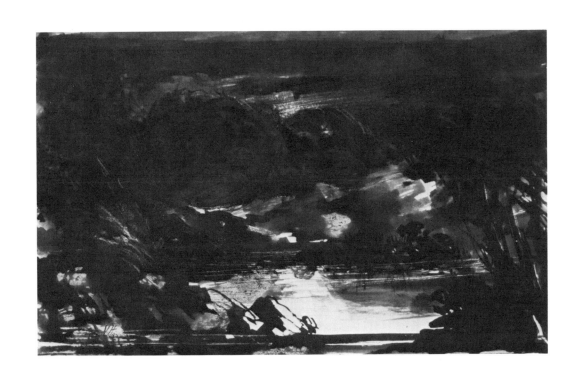

9. *La veille funèbre (The Watch by the Deathbed)*, ca. 1865

Pen and ink on paper, 9¹/₁₆ x 11⁷/₁₆ inches (23 x 29 cm.)

Bibliography: K. E. Maison, *Daumier Drawings*, New York, 1960, pl. 107; K. E. Maison, *Honoré Daumier, Catalogue Raisonné*, London, 1967, v. II, p. 141, no. 408.

Provenance: A. Vollard, Paris; Paul Cassirer; Marianne Feilchenfeldt, Zurich; Private Collection, New York.

Lent by a Private Collection, Atlanta.

This drawing and another very similar one (Maison, 1967, no. 407), both depicting deathbed scenes, are among the most bizarre and horrifying in Daumier's extensive *oeuvre*. In this one, the old man in the chair has a demonic look. The subject, although not specifically identified, seems related to the biting satire of the medical profession which Daumier created after Molière's *Le Malade Imaginaire* in a watercolor in the Cortauld Institute, London, and a pen and wash drawing in the Wetmore collection, New York (Maison, 1967, nos. 485 and 486). Death in the form of a skeleton coming to claim an old man lying in bed is seen in a charcoal drawing in a Parisian private collection (Maison, 1967, no. 402). This open style with highly charged pen line is characteristic of Daumier in the mid-1860s.

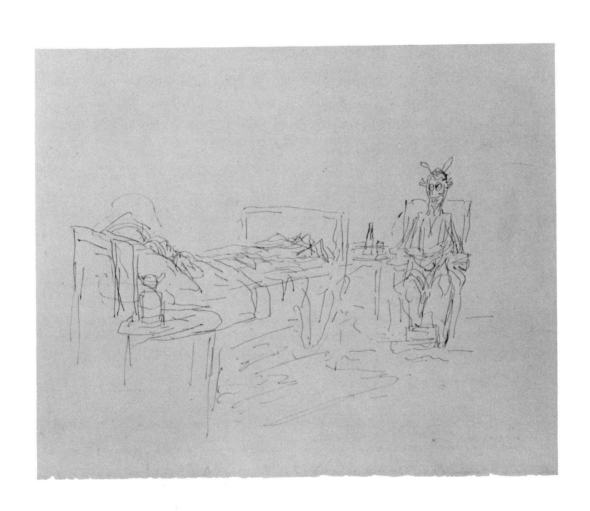

10. Recto: *Return from the Fields*, ca. 1867
Verso: *Peasant Leaning on a Staff and Studies of Cows*

Black chalk on blue-grey paper, 5^{11}/$_{16}$ x 9^5/$_8$ inches (14.4 x 24.4 cm.)

Stamped in blue ink at the lower right corner *recto* with the artist's estate stamp (Lugt 1460): *J.F.M.*

Exhibitions: The Drawing Shop, New York City, *The Non-Dissenters*, March 5-April 19, 1963, no. 37.

Provenance: The Drawing Shop, New York; Private Collection, New York.

Lent by a Private Collection, Atlanta.

Millet was one of the greatest draughtsmen of the nineteenth century. In innumerable chalk drawings, his powerful, broad manner captured the simple nobility of the lives of the peasants among whom he had been born in Normandy and with whom he continued to live after settling in Barbizon. The drawing on the *recto* of this sheet has an unusually wide vista which dwarfs the mounted figure set against the austere sky. Similar compositions of the weary return on horseback are found in a drawing in the Louvre (Roseline Bacou, *Millet, One Hundred Drawings*, New York, 1975, no. 48). The horseman holding his whip also occurs in two compositions entitled *Le Retour de labourer* of 1863 (reproduced in E. Moreau-Nélaton, *Millet raconté par lui-même*, Paris, 1921, v. II, figs. 172 and 176.)

On the *verso*, the figure of a peasant in his hat and cloak, leaning on his staff watching his animals, is one that Millet frequently repeated. See, for example, the drawing reproduced in Moreau-Nélaton, v. III, fig. 346, and two others of the early 1870s in the exhibition catalogue, *Millet*, Paris, 1975-76, nos. 232, 233, as well as a painting in the Brooklyn Museum.

The image of the large cow grazing or drinking at the lower right *verso* also figures in various compositions over a good many years, from a painting of 1858 to one of 1873 (*Millet*, Paris, nos. 67 and 238). The image also appears, in conjunction with the watchful peasant, in a large pastel in the Yale University Art Gallery (*Millet*, Paris, no. 212).

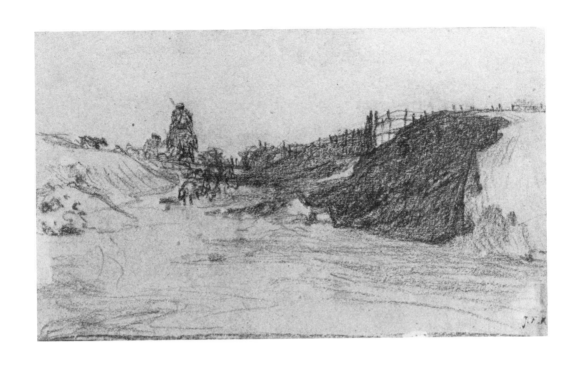

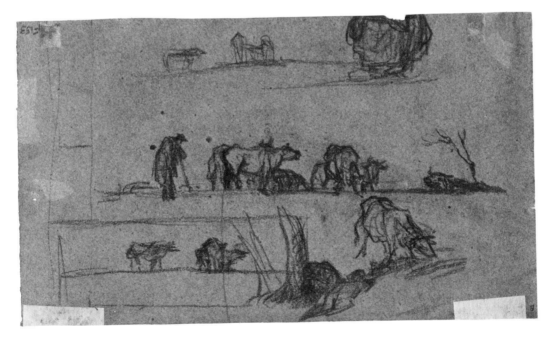

11. *Mme. Manet in a Hat*, 1880

Black wash applied with brush on lightly printed graph paper, 6³/₁₆ x 4⅝ inches (16.8 x 12.7 cm)

Bibliography: T. Duret, *Edouard Manet,* trans. by E. Waldmann, Berlin, 1910, p. 42; Alain de Leiris, *The Drawings of Edouard Manet,* Berkeley, 1969, p. 137, no. 579; D. Rouart and D. Wildstein, *Edouard Manet: catalogue raisonné,* Lausanne-Paris, 1975, v. II, p. 152, no. 409.

Exhibitions: Fogg Art Museum, Cambridge, 1958.

Provenance: Cottereau collection, France; Private Collection, New York.

Lent by a Private Collection, Atlanta.

Throughout his career Manet dashed off closely observed sketches of the figures about him, especially if they were attractive and well-attired ladies. He seems to have had a fondness for interesting hats. Such studies were not necessarily preliminary ideas for paintings, but often they approach that, and this study is quite close to the *Portrait of Mme. Manet at Bellevue* of 1880 (Horowitz collection, New York; see Rouart and Wildenstein, v. I, no. 345). A nearly identical head study in black wash appears in a letter of 1880 sent by Manet to Henri Guerard, to accompany greetings from his wife and mother (see E. Moreau-Nélaton, *Manet raconté par lui-même,* Paris, 1926, v. II, fig. 282). Manet had the ability to suggest color and form with just a few strokes, and he used the brush and his favorite black wash with the greatest facility—almost in the manner of an Oriental calligrapher.

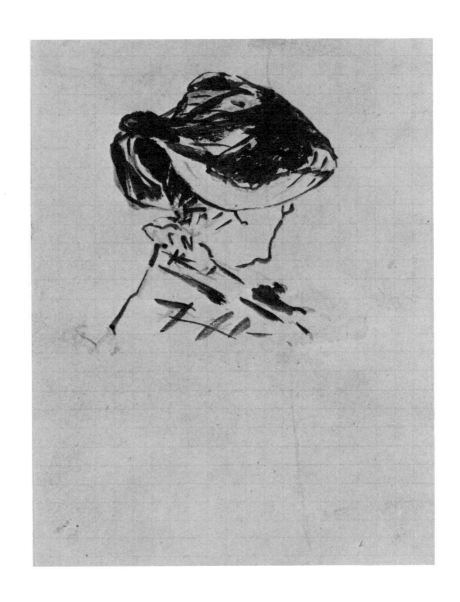

Edouard Manet (French, 1832-1883)

12. *Portrait of Henri Vigneau,* ca. 1874

Pencil on paper mounted on board, 5 x 3¾ inches
(12.5 x 9 cm.)

Inscribed in pencil at the lower left corner: *Manet/à
son ami Vigneau*

Bibliography: E. Bazire, *Manet,* Paris, 1884, p. 31; D.
Rouart and D. Wildenstein, *Edouard Manet: catalogue
raisonné,* Lausanne-Paris, 1975, v. II, p. 170, no. 471.

Provenance: Auguste Pellerin, Paris; Sale Hôtel
Drouot, Paris, May 7, 1926, no. 61; Sale Christies,
New York, May 14, 1980, no. 6.

Lent by Dr. and Mrs. Michael Schlossberg, Atlanta.

Henri Vigneau was one of the many lesser
artists who gathered around Manet and the
other future Impressionists in the late 1860s
at the Café Guerbois. (On the correct spell-
ing of his name see Anne Coffin Hanson,
Manet and the Modern Tradition, New
Haven, 1977, p. 163.) The discussions on art
at the café could become quite heated, and
in February 1870 the writer Duranty and
Manet had a violent quarrel which led to a
duel. Emile Zola and Vigneau acted as
Manet's seconds at this extraordinary event
in the forest of Saint-Germain. Ignorant of
the art of fencing, the two opponents threw
themselves at each other so violently that the
seconds had to pull them apart. But by that
very evening, they had become the best of
friends (see John Rewald, *The History
of Impressionism,* New York, 1973, p. 198).

Possibly in commemoration of that event,
Manet drew this rapid study and dedicated
it to his friend. The features reveal an intel-
ligent and sympathetic individual. Manet
also made a nearly identical pen and ink
study with just a bit more elaborate shading
(Cone Collection, Baltimore Museum of Art;
see Rouart and Wildenstein, *Manet,* v. II,
no. 472).

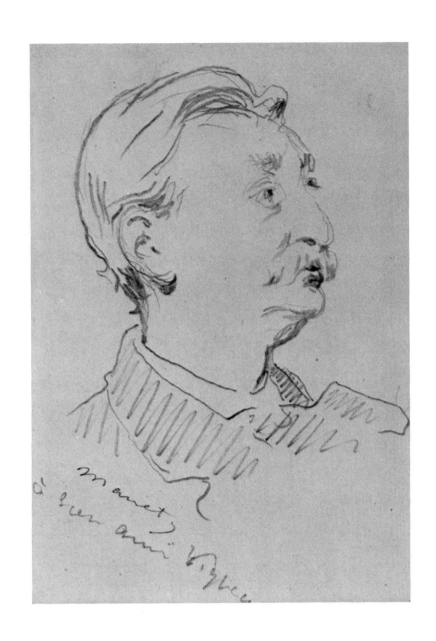

13. *Standing Male Nude*, ca. 1856

Pencil on paper, 16¾ x 10½ inches (42.5 x 26.7 cm.)

Inscribed at the lower right: *Rome*

Stamped at the lower right corner with the artist's estate stamp (Lugt 658): *degas,* probably over the original pencil signature.

Provenance: Mr. and Mrs. Morris Sprayregen, New York.

Lent by Jacqueline and Matt Friedlander, Moultrie.

During his stay in Rome from 1856 to 1858, Degas spent a good deal of time at the French Academy's sessions of life drawing at the Villa Medici. Of these studies of models in traditional studio poses, Jean Sutherland Boggs has acutely observed,

> there seems to be a certain contradiction between subject matter and technique. The bodies are ungainly and the models' personalities assertive in spite of the tradition of the classically beautiful and impersonal, even anonymous, male nude; but the drawing itself is of the most meticulous pencil, applied with the greatest refinement. (Jean Sutherland Boggs, *Drawings by Degas,* exhibition catalogue, City Art Museum of Saint Louis, 1966, p. 32).

In part, this meticulous style has to be seen as a conscious homage paid by the young Degas to Ingres, whom he had met in 1855 and who gave him the advice, "Draw lines, young man, many lines; from memory or from nature, it is in this way that you will become a good artist." (See John Rewald, *The History of Impressionism,* New York, 1973, p. 16.) In this sensitive drawing, which did not appear in the artist's estate sales, we note the particular emphasis he has given to the strained neck muscles and the sense of poignant concentration upon the man's face.

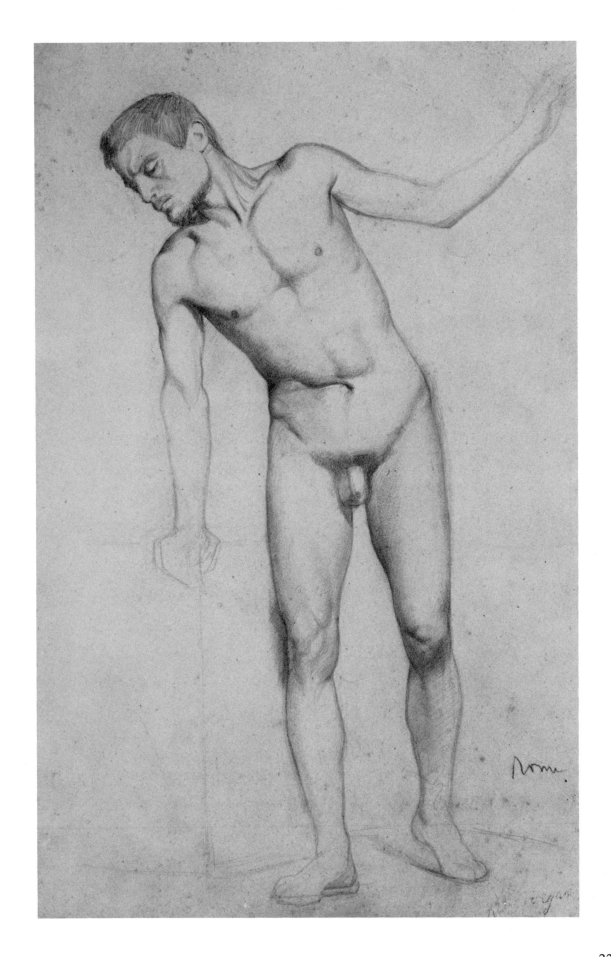

33

14. *Studies of Female Nude*, 1856-58

Pencil on paper, 17¾ x 11⅜ inches (45 x 29 cm.)

Inscribed at the lower right: *Rome;* and in pencil at the lower left corner: *Pb 2354;* stamped at the lower left in red and on the *verso* with the estate stamps (Lugt 657 and 658): *degas.*

Exhibition: University of Iowa, *Drawing and the Human Figure, 1400-1964*, 1964, no. 91.

Provenance: Degas Atelier Sale, fourth sale, Georges Petit Gallery, Paris, July 2-4, 1919, p. 120, no. 126b; Lucien Heuraux, Paris; Private Collection, New York.

Lent by a Private Collection, Atlanta.

Although they could have been made from a live model, this group of studies gives the impression of being copied from other works of art, either sculpture or painting. The full-length standing nude is reminiscent of studies Degas made after paintings in his 1854-55 notebook (now in the Bibliothèque Nationale): the facelessness of the nudes reminds us of his copy of Sodoma's *Leda* in the Louvre and her upturned head and prayerful hands of a figure in Perugino's *Ascension* at Lyon (see Theodore Reff, *The Notebooks of Edgar Degas*, Oxford, 1976, v. II, figs. Nb. 2, pp. 47 and 50).

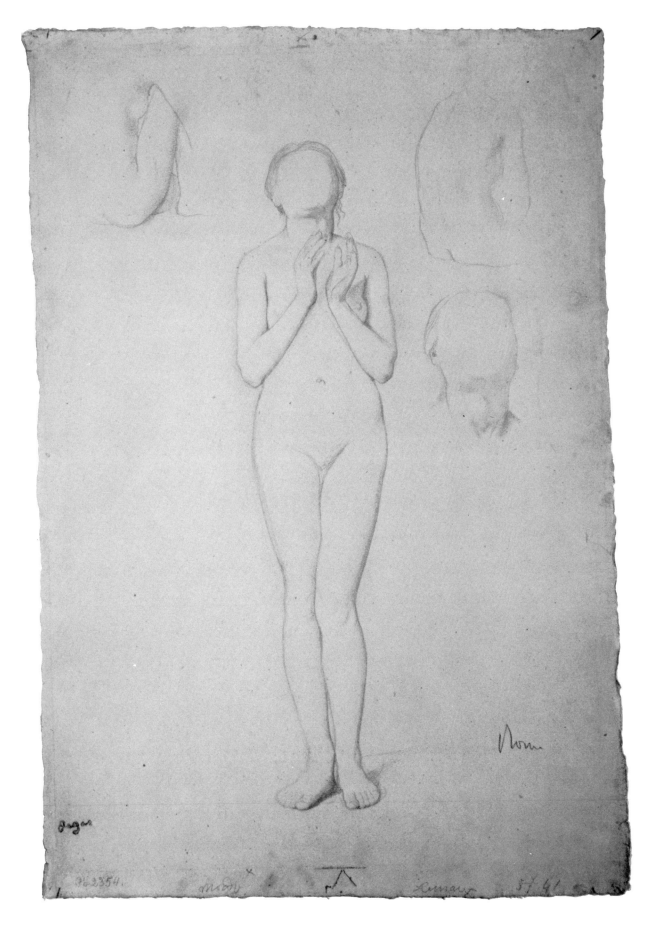

35

Edgar Degas (French, 1834-1917)

15. *View of Mt. Vesuvius,* ca. 1856

Pencil on white laid paper, 10¼ x 14¼ inches
(26 x 36.8 cm.)

Exhibition: Dayton Art Institute, *French Artists in
Italy, 1600-1900,* October 15-November 28, 1951, no.
53.

Provenance: The Drawing Shop, New York; Private
Collection New York.

Lent by a Private Collection, Atlanta.

Apparently, Degas first journeyed to Italy,
where he had relatives in both Florence and
Venice, in 1854. He was already responsive
to the splendors of the Italian landscape,
including Mt. Vesuvius (Paul-André
Lemoisne, *Degas et son oeuvre,* 1954, v. I,
p. 23). In 1856 he returned, arriving in
Naples in July, and over the next few years
he was in Italy several times, culminating
with a trip of 1860. This last is commemo-
rated in one of his notebooks by a delicate
drawing of the Bay of Naples with the
mountains in the distance (Theodore Reff,
The Notebooks of Degas, Oxford, 1976, v. II,
fig. Nb. 19, p. 3).

While landscape studies abound in the
notebooks, such highly finished landscape
drawings as this one are rare. It is of the
utmost refinement, seeming to have been
breathed upon the surface of the paper, and
is consonant with his drawing style in the
mid-1850s. An Italian landscape in a similar
style, dated 1857 by Degas, was in the Curtis
Baer Collection, New Rochelle (photograph
in the Fogg Photo Archives). The memory of
the shape of the volcano may have lingered
in Degas's mind when he composed the
background setting for his 1860 painting *The
Young Spartans* (National Gallery, London).

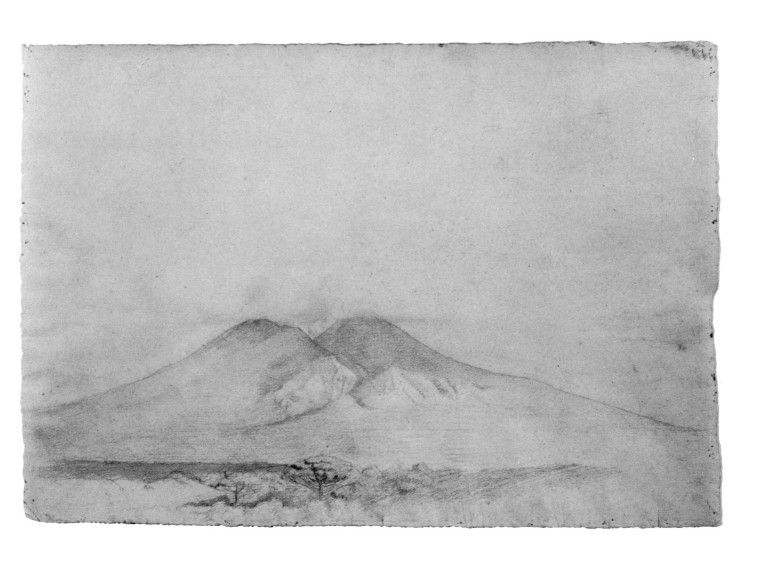

Edgar Degas (French, 1834-1917)

16. *Study of Two Dancers, ca. 1884-85*

Charcoal with highlights in white pastel on paper, 17½ x 22½ inches (44.4 x 57.1 cm.)

Stamped in red at the lower right corner and on the *verso* with the artist's estate stamps (Lugt 657 and 658): *degas*

Bibliography: Lilian Browse, *Degas Dancers*, New York, ca. 1949, p. 375, no. 112a.

Exhibition: Knoedler and Co., New York, March, 1963.

Provenance: Degas Atelier Sale, third sale, Georges Petit Gallery, Paris, April 7-9, 1919, no. 223; Dr. Viau(?); Adam-Dupre, Paris; Matthiesen Gallery Ltd., London; Lilienfeld Galleries, New York; Mrs. Ralph J. Hines, New York City; Mrs. Harry E. T. Thayer and Robert S. Pirie, Cambridge, Massachusetts.

The High Museum of Art. Anonymous Gift, 1979.

In his many studies of ballet dancers, Degas sought not to transmit the glamour and illusion of dance, but rather to portray the hard work that went into creating this illusion. Thus he was particularly interested in depictions of the dancers at rehearsals or in moments between performances. Then he would attempt to catch their most telling poses and unstudied attitudes.

The two poses seen here—the brooding head on hands and the adjustment of a slipper—were so striking that Degas incorporated them into several other works. The most finished form is the pastel *La Classe de Danse* (see Paul Lemoisne, *Degas et son oeuvre*, Paris, 1947-48, no. 1107) where they appear on a bench with another dancer pulling on her tights. They also figure in slightly different form in a drawing of *Three Seated Dancers* and a pastel of *Dancers at Rest* (Lemoisne, nos. 530 and 531).

Degas has rendered the outlines with his boldest, most muscular strokes, smudged the charcoal for coloration in some areas, and then added the white chalk for dramatic highlighting. The effect achieved is one of intense life, and in the dancer at the left a sense of exhaustion to the point of despair.

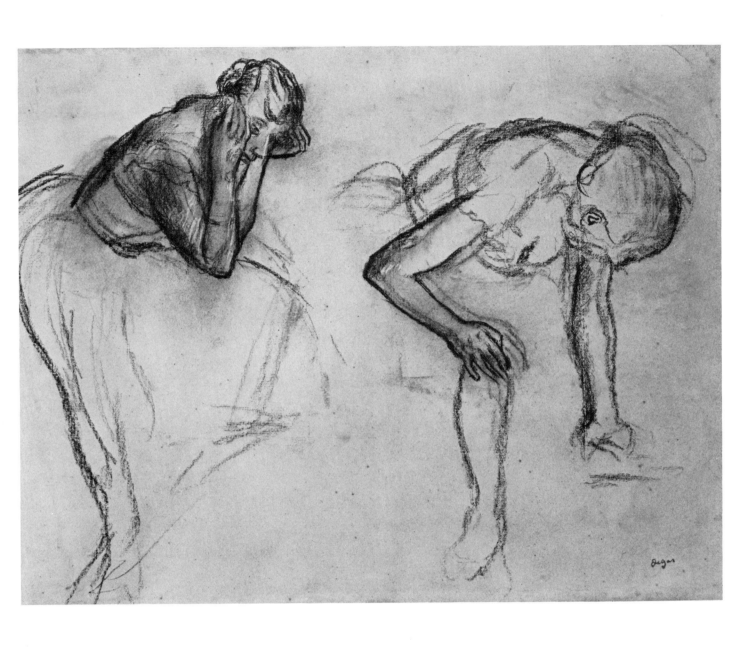

39

17. *After the Bath, Woman Wiping Her Feet,* ca. 1893

Pastel on paper, 17⅞ x 23 inches (46 x 59 cm.)

Stamped in red at the lower left corner with the artist's estate stamp (Lugt 658): *degas*

Bibliography: F. Fosca, *L'Amour de l'Art*, 1927, p. 111; Paul Lemoisne, *Degas et son oeuvre*, Paris, 1948, v. III, p. 658, no. 1137.

Exhibitions: Wildenstein and Co., New York, *Degas*, April 7-May 14, 1949, no. 82; Wildenstein and Co., New York, *The Nude in Painting*, November 1-December 1, 1956, no. 29.

Provenance: Degas Atelier Sale, second sale, Georges Petit Gallery, Paris, December 11-13, 1918, no. 63; Charles Comiot, Paris; Wildenstein and Co., New York; Mr. and Mrs. Morris Sprayregen, New York.

Lent by Jacqueline and Matt Friedlander, Moultrie.

This is one of a number of elaborate pastels Degas made about 1893 of women drying themselves after the bath (see Lemoisne, nos. 1136, 1138-39). He had begun working on this theme at the beginning of the decade, fascinated by the contorted pose the body was forced to assume. But in these later pastels, done when his eyesight was already beginning to fail, he was more interested in texture and color. The crouching body with the face obscured is treated almost as one great ovoid shape balanced on the thick supports of the legs. The surface is covered with hatchings and splotches of colored pastels that serve to enliven the broad masses of body, tub, and floor, creating an overall luminosity.

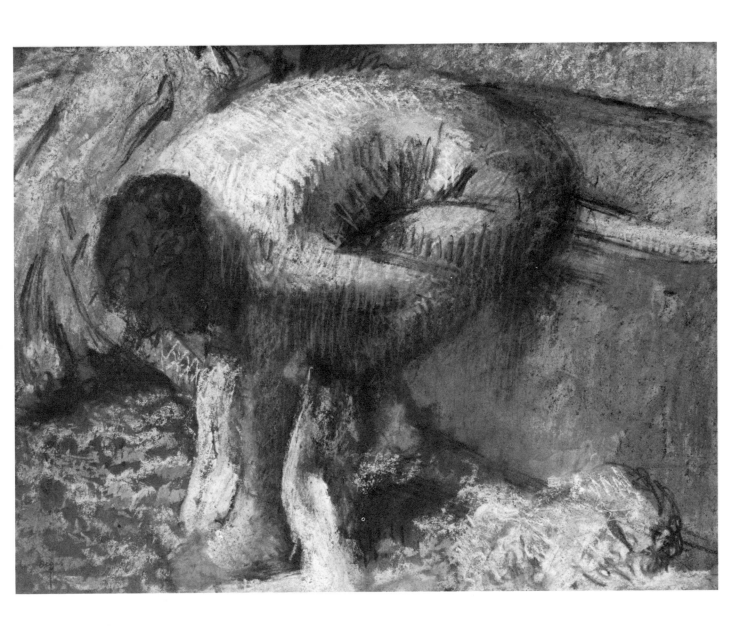

18. *Mother Berthe Holding Her Baby (The Young Mother)*, 1900

Pastel on paper, 22⅝ x 17⅛ inches (57.5 x 43.5 cm.)

Signed at the lower right corner: *Mary Cassatt*

Bibliography: Achille Segard, *Un Peintre des Enfants et des Mères, Mary Cassatt*, Paris, 1913, fol. p. 108; Adelyn D. Breeskin, *Mary Cassatt, A Catalogue Raisonné of the Oils, Pastels, Watercolors, and Drawings*, Washington, 1970, p. 140, no. 319.

Exhibitions: Durand-Ruel Gallery, New York, 1924, no. 12; M. Knoedler & Co., New York, *Pictures of Children*, 1941; Baltimore Museum of Art, *Mary Cassatt*, 1941-42, no. 40.

Provenance: Albert Pra, Paris; Sale Hôtel Drouot, Paris, June 17, 1938, no. 3; M. Knoedler and Co., New York; Mme. Mayer, Paris; Dr. Chester J. Robertson, Pelham, New York.

Lent by a Private Collection, Atlanta.

By the last decade of the nineteenth century, Mary Cassatt had achieved full mastery of the pastel medium. As seen here, she could convey the rich, soft feel of flesh, the diaphanous texture of cloth, and the sheen of freshly washed hair. The intimate relation of mother and child was Cassatt's specialty. The device of having the baby leaning on his mother's shoulder and looking directly out at the viewer also occurs in the pastel *Maternity* of ca. 1890 (Breeskin, no. 180).

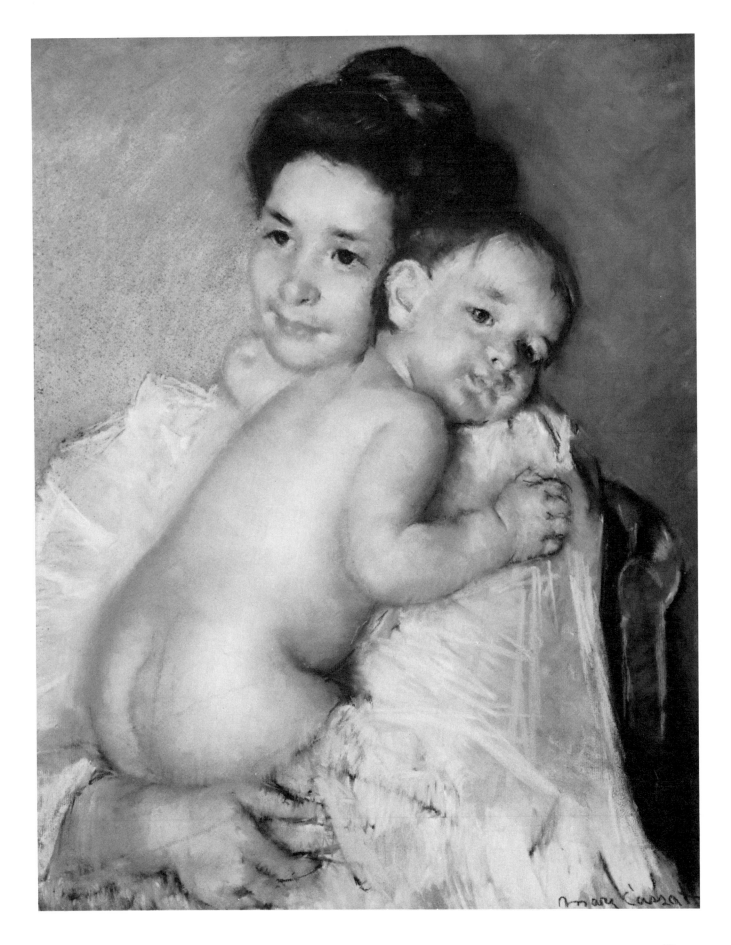

Camille Pissarro (French, 1830-1903)

19. *Child at Table*, ca. 1880

> Pencil on paper, 12⅜ x 7¾ inches (31.4 x 19.7 cm.)
>
> Stamped at the lower right corner with the artist's initials (Lugt 613a): *CP*
>
> Provenance: Folio Fine Art, London; Sale, Sotheby Parke Bernet, New York, November 8, 1979, no. 703.
>
> Lent by Dr. and Mrs. Michael Schlossberg, Atlanta.

This charming drawing is undoubtedly a preliminary sketch for the gouache of 1880 entitled *Enfants à table* (see L.-R. Pissarro and L. Venturi, *Camille Pissarro, son art, son oeuvre*, vol. II, pl. 261, no. 1334). It is one of a number of works by Pissarro reflecting the intimate home life of his ever-growing family. The child seen from the back in this drawing and the gouache is most likely his son, Ludovic-Rodolphe, born in 1878. In the gouache he is accompanied by Félix, who was born in 1874. The same curved-back chair occurs in other family interiors of the period, such as the *Portrait of Félix*, and *The Little Country Maid*, both in the Tate Gallery, London (see John Rewald, *Camille Pissarro*, New York, 1963, pp. 129 and 133).

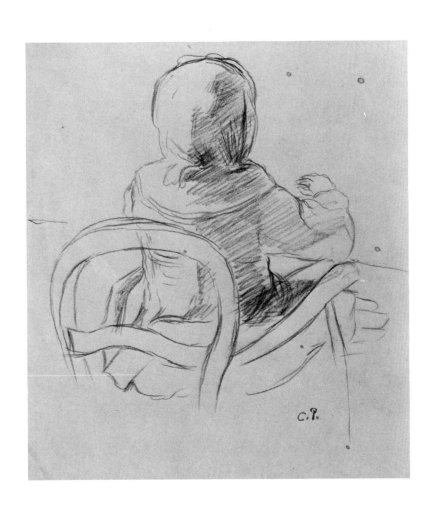

Paul Cézanne (French, 1839-1906)

20. Recto: *Various Studies including a Seated Nude, a Standing Woman, and an Embracing Couple,* ca. 1865
Verso: *Studies of a Seated Woman and Men in Cocked Hats*

Pencil, pen and ink on paper, 4⅞ x 8⁵/₁₆ inches (12.3 x 21.1 cm.)

Bibliography: Theodore Reff, "Cézanne and Hercules," *Art Bulletin,* v. XLVIII, 1966, p. 35, fig. 6; Meyer Schapiro, "The Apples of Cézanne," *Art News Annual,* v. XXXIV, 1968, p. 53; Adrien Chappuis, *The Drawings of Paul Cézanne,* Greenwich, 1973, v. I, p. 64, no. 57, and p. 90, no. 189; v. II, figs. 57 and 189.

Provenance: Cézanne family, Paris; Huguette Beres, Paris; Mrs. Charles B. Nunnally, Atlanta.

The High Museum of Art, Atlanta. Gift of Mrs. Charles B. Nunnally, 1965.

Cézanne made his first visit to Paris in 1861. He had already begun sketching but his visits to the Louvre and the Salon inspired him in 1862 to dedicate his life to art. Failing the entrance examination for the Ecole des Beaux-Arts that year, he frequented the Académie Suisse, where he could draw from the model. There he met Pissarro, whom he later credited as his teacher. Cézanne's early drawings reflect his struggle to learn by copying from the masters. A good deal of his own intractable character is, however, already in evidence.

This double-sided page is from a notebook formerly in Cézanne's studio in Aix-en-Provence and subsequently dispersed. Cézanne's compulsive approach is evident in the way he draws new subjects over old ones. It is possible that he used the notebook first in one direction and then in another, so there may be some time lag between the two sides, but in any case the drawings seem to date from the early 1860s.

The two figures in cocked hats on the *verso* recall policemen who appear in other early drawings (Chappuis, nos. 16 and 937). The pen study of the seated woman resting her head on her hand is thought by Chappuis to be related to a painting and other drawings of a composition known as *The Conversation,* but her melancholic attitude seems rather to be copied after some other work of art, possibly a print or a sculpture. Certainly this is the case with the pen study of the standing woman on the *recto,* which has the appearance of a Mary Magdalene. Likewise, the bold study of a seated man seen from the back does not seem so much like an "academic study," as Chappuis suggests, but a free copy after a sculpture such as Puget's *Hercule Gaulois* that Cézanne used on a number of occasions (Chappuis, nos. 576-577). The man lying on his side, also sculptural, is repeated in a wash drawing by Cézanne (L. Venturi, *Cézanne, Son Art, Son Oeuvre,* Paris, 1936, no. 812).

The embracing couple sketched more lightly at the lower left has been identified by Theodore Reff as Paris and Venus in a preliminary study for Cézanne's 1860 painting *The Judgement of Paris* (Venturi, no. 16), where the young man's intimacy with the goddess to whom he awards the apple is stressed (Reff, p. 38). Meyer Shapiro, however, has expressed doubts about this identification (Shapiro, p. 53), and again one suspects it may have been copied after another source, such as an Adam and Eve, or, since the man is bearded, possibly Lot and his daughters. Such scenes of sexual abandon were on Cézanne's mind during this period and culminated in the oil painting *The Orgy,* 1864-68 (Venturi, no. 92).

21. *Studies of Soldiers*, 1880

Pencil and colored crayons on paper, 5⅞ x 9⅜ inches
(14.9 x 23.8 cm.)

Inscribed (now almost illegibly) in blue on the back
of the original mount: *Dessin de Seurat/15 cm x 24 cm*
and initialed *P.S.* and *ff* and also with the dedication:
*A Madame Laurent Delkire ces guerriers dessinés par
Seurat en 1879-1880 à Brest, où il faisait son volontariat
d'un an. Félix Fénéon.*

Bibliography: C. M. de Hauk, *Seurat et son oeuvre,*
v. II, Paris, 1961, p. 44, no. 364.

Exhibition: Paul Rosenberg, Paris, *Seurat,* February
3-29, 1936, no. 58.

Provenance: Emile Seurat; Félix Fénéon; Madame
Delkire; Sale Gutekunst and Klipstein, Berne, June
5-6, 1959, no. 779; M. Knoedler and Co., New York;
Sale Sotheby Parke Bernet, Nov. 8, 1979, no. 715.

Lent by Dr. and Mrs. Michael Schlossberg, Atlanta.

Seurat, the future leader of the Neo-
Impressionists, received academic training
at the Ecole des Beaux-Arts in Paris. This
ended in November 1879 when he began a
year's military service in an infantry regi-
ment stationed at Brest on the Atlantic coast.
There he turned his artistic talents to re-
cording in a notebook the activities of his
fellow soldiers. The more than fifty sheets of
this notebook, of which this is one, have
now been widely scattered. (Several others
are reproduced in Robert Herbert, *Seurat's
Drawings,* New York, 1962, figs. 31-34.)

Represented on this sheet are such mun-
dane activities as reading mail and mend-
ing, although the simple design of a boat at
the upper left serves to recall the proximity
of the sea. Works such as this, done away
from the classroom environment, allowed
the young artist to begin his process of
closely observing the human form and re-
ducing it to almost geometric shapes. Strong
outlines create these forms and the shading
is achieved by clustering strokes of the col-
ored crayons. These sketchbook pages thus
allowed him to find the basis for the style of
his subsequent work. When he returned to
Paris in 1880, Seurat was to devote himself
to drawing in black and white in the sum-
mary outline manner he had begun to mas-
ter in Brest.

This drawing once belonged to the writer
and critic Félix Fénéon who was an early
supporter of Seurat and actually coined the
term "Neo-Impressionists."

Charles Angrand (French, 1854-1926)

22. *Mother and Child*, ca. 1899

Conté crayon with white chalk, 23½ x 17¾ inches (59.7 x 45 cm.)

Signed at the lower right: *CH ANGRAND*

Exhibition: Chateau- Musée de Dieppe, *Charles Angrand,* June 19-September 20, 1976, no. 20 (?).

Provenance: O'Hana Gallery, London; Sale Sotheby Parke Bernet, New York, June 8, 1977, no. 15.

Lent by Dr. and Mrs. Michael Schlossberg, Atlanta.

Born in Normandy, Angrand had at first treated rural themes in a naturalistic manner. But when he came to Paris in 1882, he discovered the new artistic trends and was a founding member of the Société des Artistes Independants in 1884. He soon became a close friend of fellow members Seurat and Signac and helped them in the formulation of the Neo-Impressionist aesthetic, adopting the pointillist style for many of his own works. The glowing black and white drawings of Seurat particularly impressed him and after the latter's death in 1891, Angrand concentrated almost exclusively on drawing with conté crayon and pastels.

Following the death of his father in 1896, Angrand returned to the small Norman village of Saint-Laurent-en-Caux. Although separated from his artist friends, he continued to correspond with them and to develop his art. In 1899 he was given a one-man showing at the Durand-Ruel Gallery in Paris and exhibited a series of drawings on the theme of mother and child called *Mater-*

nités. They did not receive significant public attention, but Signac was aware of their distinction and noted in his diary entry for March 15, 1899:

> Angrand: his drawings are masterpieces. It would be impossible to imagine a better use of white and black, or more sumptuous arabesques. These are most beautiful drawings, poems of light, of fine composition and execution. And yet everybody passes by without realizing their incomparable quality; although some visitors may notice their clean execution and the beauty of the graded tones, no one feels the deep inner qualities of Angrand this great artist.

The poetic quality described by Signac is evident here. The conté crayon applied to the rough surface of the paper marvelously suggests a shimmering light, and this glow is not without the power to endow the secular theme with a religious connotation. The spiritual and physical warmth of the maternal relationship is evoked.

Others from the *Maternités* series include an 1896 drawing in a private collection in France, reproduced in John Rewald, *Post-Impressionism,* New York, 1978, p. 117; one exhibited at Fisher Fine Art Limited, London, June-July 1973, no. 2; one in a private collection and one in the Petit Palais, Geneva, both in the Angrand exhibition at Dieppe, 1976, nos. 20 and 22. The artist continued the theme in his work and several *Maternités* were shown in the Salon des Independants of 1905.

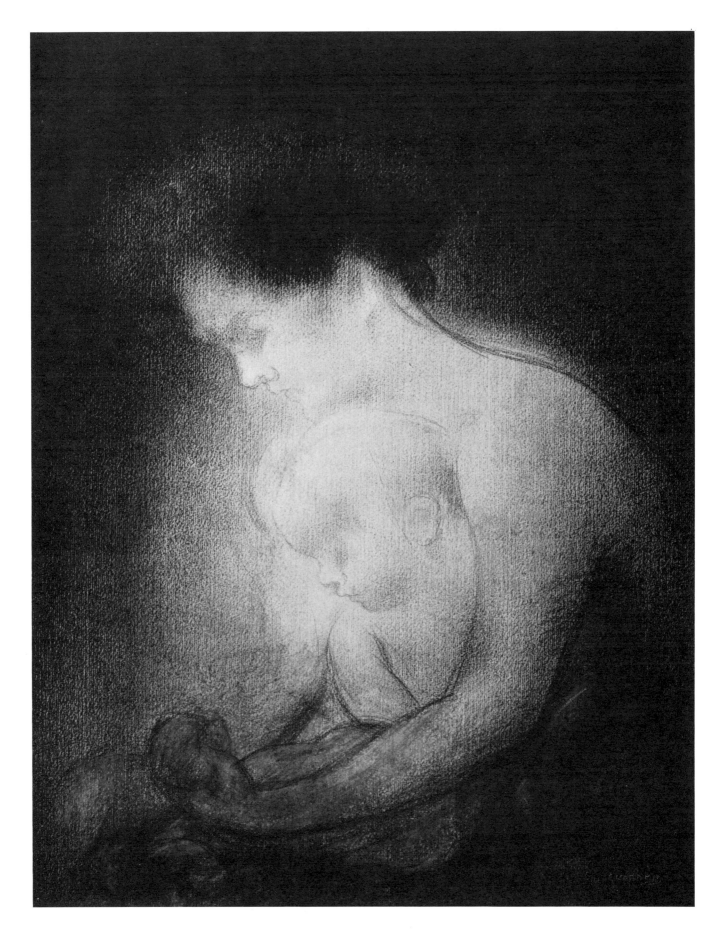

23. Recto: *Study of a Cellist*, ca. 1881
Verso: *Study of a Sleeping Child and a Woman*

Charcoal on grey paper, 11½ x 9 inches (29.2 x 22.9 cm.)

Affixed to the backing, a photo-copy of a certificate stating:
Je certifié que cet album contenant trente-trois feuilles est celui de mon père Paul Gauguin et que tous les croquis ont été fait par lui.
Oslo le 24 1920
Pola Gauguin

Provenance: Pola Gauguin; L. Latouche, Paris; Sale, Sotheby Parke Bernet, New York, June 13, 1978, no. 9.

Lent by Dr. and Mrs. Michael Schlossberg, Atlanta.

These tentative studies record the state of Gauguin's artistry about 1881 when, still working as a stock broker, he began to study art. Under the tutelage of Pissarro, he sought to master the fundamentals of draughtsmanship by sketching the figures about him, primarily his wife and children, who may be represented on the *verso* here. He had painted a *Portrait of Clovis Gauguin Sleeping* in 1879 (Private Collection, Copenhagen; see John Rewald, "Gauguin et le Danemark," in *Gauguin, sa vie et son oeuvre*, Paris, 1958, p. 66, fig. 2). In this early period Gauguin made numerous studies of his children; and other examples are in the Cleveland Museum and the Museum of Art at the Rhode Island School of Design. The cellist is unidentified, although, much later, Gauguin again represented a cellist in his 1894 oil *Portrait of Upaupa Schneklud* (Blastein collection, Baltimore, see Georges Wildenstein, *Gauguin Catalogue*, I, Paris, 1964, p. 211, no. 517). This sheet is probably one of a number that Gauguin's son Pola removed from a sketchbook of his father's which he ultimately gave to the National Museum, Stockholm (inv. no. 1-36/1936).

Vincent van Gogh, (Dutch, 1853-1890)

24. *Wood Gatherer*, 1884

Watercolor, 13 x 9⅞ inches (32.5 x 25 cm.)

On the *verso*, a pencil drawing of two classical sculptures.

Bibliography: J.-B. de la Faille, *L'Oeuvre de Vincent van Gogh*, Paris, 1928, no. 1081; Walter Vanbeselaere, *Vincent van Gogh, Catalogue de Periode hollandaise*, Antwerp, 1938, pp. 110, 261, 410; J.-B. de la Faille, *The Works of Vincent van Gogh*, Amsterdam, 1970, no. 1081; Paolo Lecaldano, *L'Opera pittorica completa di van Gogh*, Milan, 1977, v. I, p. 96, no. 59A; Jan Hulsker, *The Complete van Gogh*, New York, 1980, p. 123, fig. 515.

Exhibitions: Wildenstein and Co., Inc., New York, *Van Gogh Loan Exhibition*, March 24-April 30, 1955, no. 90; Leggatt Brothers, London, *The Collection of the Earl of Inchcape*, Autumn, 1961, no. 17.

Provenance: Oldenzeel Art Gallery, Rotterdam; F.W.R. Wentges, The Hague, 1909; Oldenzeel Sale, Rotterdam, April 30, 1912, no. 41; Jacques Blot, Paris; E.J. van Wisselingh and Co., Amsterdam, 1951; W. Weinberg, Scarsdale, New York, 1955; Sale Sotheby, London, July 10, 1957, no. 52; The Earl of Inchcape, London; David Carritt Limited, London.

Lent by Mr. and Mrs. Simon S. Selig, Jr., Atlanta.

In late 1883, the thirty-year-old Vincent van Gogh returned to the home of his parents at Nuenen in the eastern part of North Brabant. He remained there until the death of his father in 1885. Following the example of Millet, whose works he first emulated in 1880, van Gogh made many studies of the people working on the land, which culminated in the large painting *The Potato Eaters.*

August of 1884 brought him a commission from a Mr. Hermans, a former goldsmith in Eindhoven, who, as van Gogh explained in a letter to his brother Theo,

> wanted to decorate a dining room. He was going to do this with compositions depicting various *saints*. I suggested to him that a half-dozen scenes of peasant life in the Meierij (a rural area in Brabant)—at the same time symbolizing the four seasons of the year—might do more to sharpen the appetites of the good people who would be dining there than the mystical personages he had in mind. The man has now become quite keen on this after a visit to my

studio . . . He is decorating the ceilings and walls himself, and really does it well sometimes. But he positively wants painting in the dining room, and has begun to paint twelve panels of flowers. There are six panels left on the longest wall, and for these I gave him preliminary sketches of a sower, plower, shepherd, harvest, potato digging, ox wagon in the snow. *(The Complete Letters of Vincent van Gogh,* v. II, no. 374).

It was arranged that Vincent would provide small designs and painted prototypes from which Hermans would paint his own panels. The project took more time to refine and in late September he wrote Theo:

> Just this past week I have now also designed the last of the six canvases for Hermans: "Wood Gatherers in the Snow." So all six are now at his place for copying; when he is finished with them and they have meanwhile had time to become thoroughly dry, I am going to rework them in order to make them into paintings. (Letter no. 377)

The drawing exhibited here is Vincent's preliminary study for the old man who is one of the four figures in *Wood Gatherers in the Snow,* now in the collection of Mrs. L. Schokking-Ribbius Peletier, Doorn, The Netherlands (see Jan Hulsker, *The Complete van Gogh,* New York, 1980, fig. 516). The study has a rough, free quality characteristic of this group of works.

The subject of the wood gatherer bent under his load, although certainly one that van Gogh could have witnessed, inevitably reminds one of compositions by Millet, particularly his drawing of an *Old Wood Gatherer* (Louvre, see *Jean-François Millet,* exhibition catalogue, Paris, 1975-76, no. 35). This had been reproduced in Sensier's 1881 book on Millet, which van Gogh, in a letter to his friend van Rappard, records he received in August 1884 (see *Letters,* v. III, no. R47). It may indeed have been the work of the older artist which inspired van Gogh to alter his original scheme of design to include the wood gatherers.

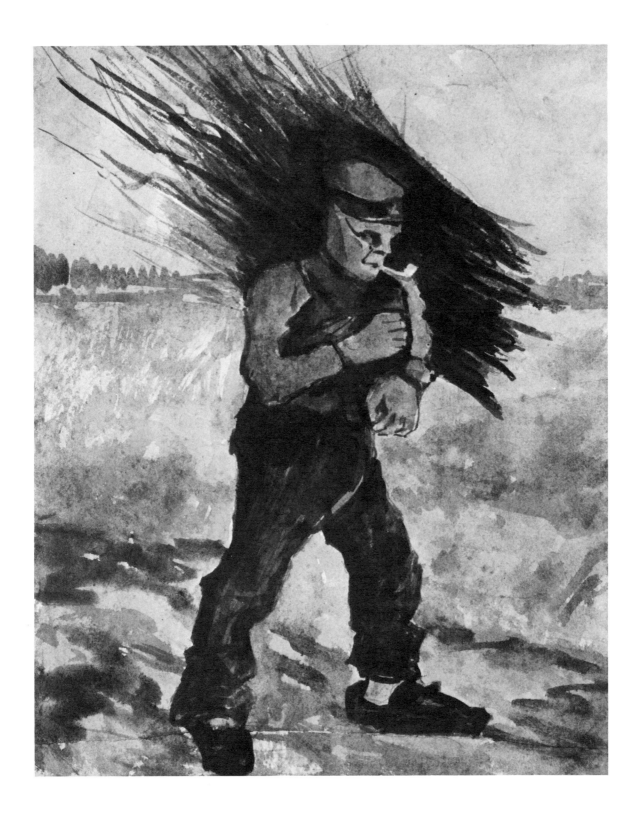

25. *Inn-Keeper at Verneuil*, 1886

Pencil on paper, 8½ x 6½ inches (21.6 x 16.5 cm.)

On the *verso*, a horizontal pencil study of a landscape.

Signed in ink along the lower right edge: *Emile Bernard 1886*

Inscribed in pencil at the upper right corner: *Verneuil le 9 avril 86 auberge;* and very faintly near the lower right corner: *L'aubergiste.*

Provenance: Paul Petrides, Paris.

Lent by Mrs. Robert R. Snodgrass, Atlanta.

The year 1886 was a significant one for the young Emile Bernard. He was dismissed from the studio of the academic painter Cormon for insubordination and set out in the Spring on a walking trip through Normandy and Brittany. During the course of this he developed his devout Catholicism, and in August he was introduced to Gauguin at Pont-Aven.

Bernard's skill as a draughtsman, even at this early stage, is evident in the series of drawings he made at the Norman town of Verneuil. This one and another dated a day later showing a women's head and a still life of a bottle (Altarriba collection, Paris, see the exhibition catalogue *Emile Bernard 1868-1941*, Palais des Beaux-Arts, Lille, April 12-June 12, 1967, no. 184) are both inscribed *"auberge"*—indicating they were studies of interesting individuals the artist observed in the local inn. In this case the faint inscription informs us it is the innkeeper himself. A landscape at Verneuil was also the subject of a sketch of April 10th (Altarriba collection, *Bernard* exhibition, Lille, no. 164). The size of all three sheets is nearly identical, indicating that they probably come from the same sketch pad. Both this work and the landscape bear signatures which appear to have been added later by the artist.

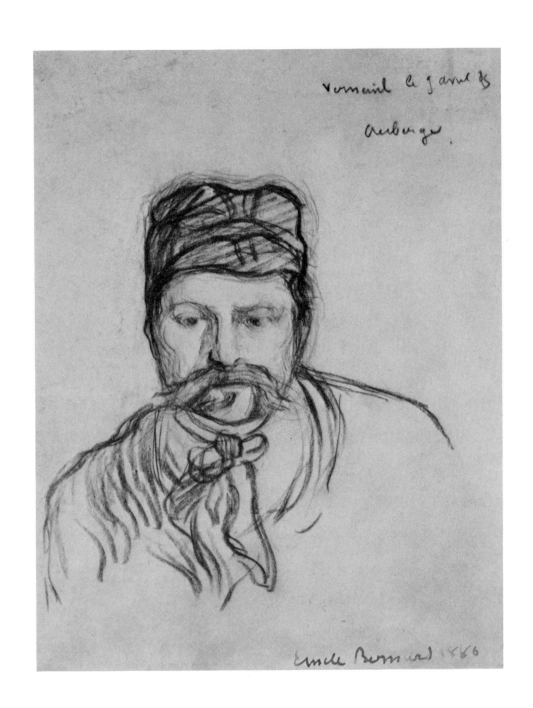

26. *Breton Peasants Outside a Church*, 1889

Watercolor and chalk on paper, 18⅝ x 24½ inches (47.3 x 62.2 cm.)

Signed and dated at the lower right edge: *Emile Bernard 1889*

Provenance: Paul Petrides, Paris.

Lent by Mrs. Robert R. Snodgrass, Atlanta.

On his first meeting with Gauguin, Bernard had not been warmly received, but when they met again at Pont-Aven in the summer of 1888 they developed a close working relationship. It was apparently Bernard who introduced Gauguin to the tenets of the Cloisonist movement, with its emphasis on flat patterning, dark contour lines, ambiguous space and vivid colors. Both of them were intrigued by the costumes and customs of the devout peasants of Brittany, especially the women's bonnets in which, as Gauguin explained in a letter to van Gogh, they found a religious symbolism in the cross-shape.

In the late spring of 1889, a number of their Breton subjects were exhibited in the show of Synthetist artists at the Café Volpini near the Arts Pavillion of the Paris World's Fair. That summer, Bernard worked at Saint-Briac and Pont-Aven, having been forbidden by his father to join Gauguin who was at Le Pouldu, not far away. It was probably during this period that Bernard made this watercolor. As in several major paintings of the previous year, such as the *Pardon at Pont-Aven* (Private collection, Paris, see *Post-Impressionism*, exhibition catalogue, National Gallery of Art, Washington, 1980, pl. 135), individual heads rise up in the foreground of the composition. The presence of the crippled man making his way toward the church might indicate that it contains a special relic reputed to have healing power. The medieval religious attitude embodied here was shortly to lead Bernard to the purely Biblical subjects of 1890-91 that van Gogh so deplored. Heeding his friend's advice for a time, Bernard returned to the strongly patterned Breton subjects in the years 1892-93. In *Breton Women at the Entrance of a Church* of 1892 (Hammer Gallery, N.Y., *Decades of Light*, October 8-25, 1980), the massing of the women and children outside the church door seems to have been adapted from this earlier large watercolor.

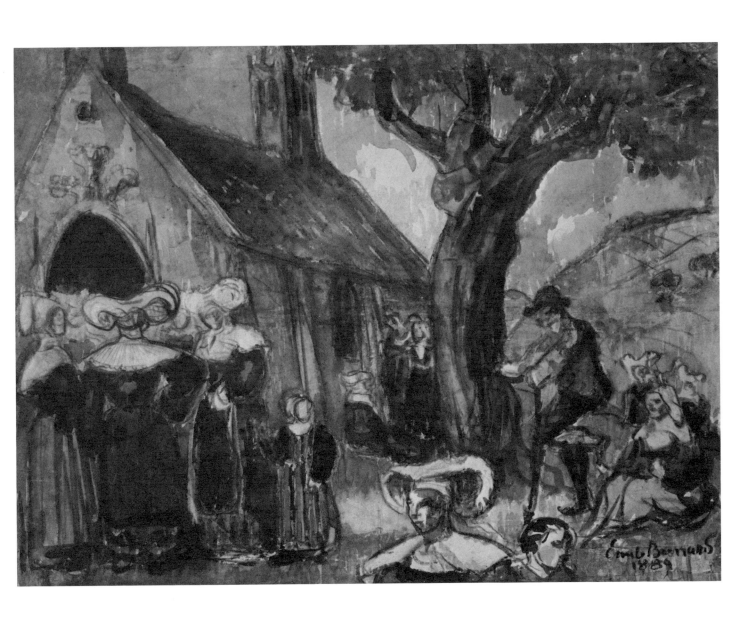

Paul Sérusier (French, 1864-1927)

27. *Studies of Breton Peasant Women*, ca. 1892

Watercolor on paper, 10½ x 9¼ inches
(26.6 x 23.5 cm.)

Stamped lower right with the artist's estate stamp: *PS*

Inscribed in pencil lower right edge: *Pont-Aven*

Bibliography: Marcel Guichteau, *Paul Sérusier*, Paris, 1976, p. 216, no. 92.

Provenance: Sale Christies, New York, November 1, 1978, no. 95.

Lent by Dr. and Mrs. Michael Schlossberg, Atlanta.

Sérusier, who had received a traditional training in art, met Gauguin in Brittany in 1888 and was inspired to begin producing radically simplified interpretations of landscape which became the basis of the style practiced by the group of artists who called themselves the *Nabis*. From 1888 onwards, Sérusier worked in Brittany at Pont-Aven (where this drawing was made), at Le Pouldu, or at his isolated retreat at Châteauneuf. In 1893 the artist declared, "I feel myself more and more attracted to Brittany, my true homeland, since it was there that I underwent my spiritual birth." The strong faces of the Breton peasants and their legends inspired a great series of decorative works whose flattened patterns often seem inspired by the manner of Puvis de Chavannes.

Although Guichteau dates this work 1894, the profile head of the old woman that dominates this sheet is similar to one that appeared in paintings of 1892, such as the *Le Marchande d'etoffes* and *Les Mangeurs de Serpents* (Guichteau, nos. 82 and 88).

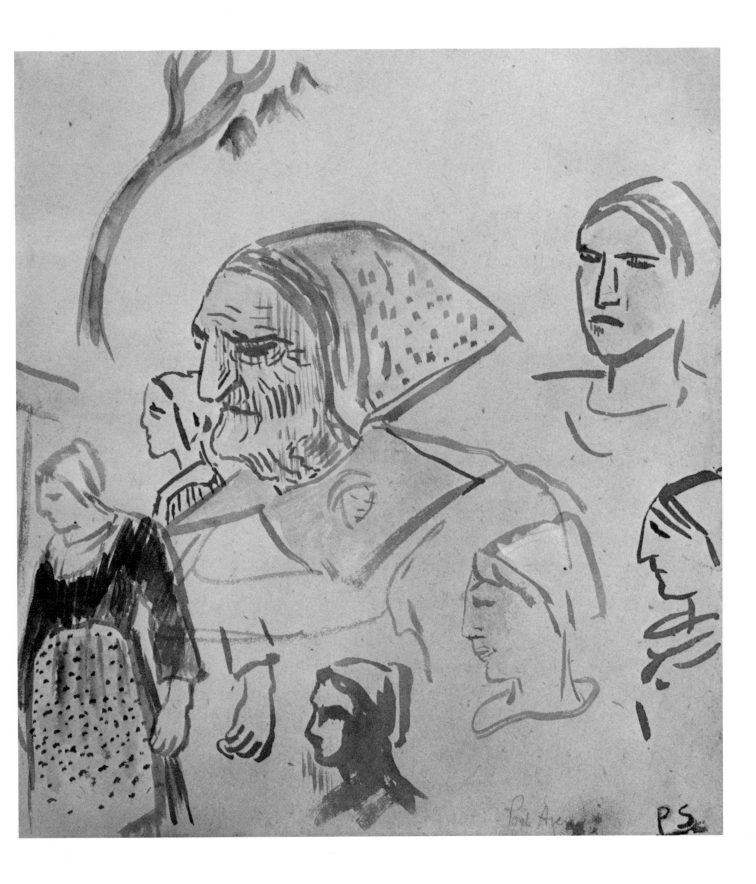

Odilon Redon (French, 1840-1916)

28. *Study of a Man's Back and a Melancholy Angel*, ca. 1865

Pencil on paper, 11⅜ x 8¾ inches (29 x 22.1 cm.)

Signed in pencil at the lower left corner:
ODILON REDON

Provenance: E. and A. Silbermann Gallery, New York; Dr. Paul Weiss, Woodside, New York; Sale Parke Bernet, New York, May 6, 1970, no. 27; Private Collection, New York.

Lent by a Private Collection, Atlanta..

The careful draughtsmanship of these drawings suggests a dating in the mid-1860s, before Redon developed his broad, black manner. A similar style is seen in the drawing of a striding figure sometimes known as *Le Géant* in the collection of the Fogg Art Museum (see Agnes Mongan and Paul Sachs, *Drawings in the Fogg Museum of Art*, Cambridge, 1946, v. I, no. 719, v. III, fig. 385). The decorative pattern of lines composing the muscles of the man's back is also seen in the mountains and rocks in Redon's etchings of this period.

The man in the upper study appears bald headed and that was the way Redon depicted the *Fallen Angel* in a charcoal of 1871 (Rijksmusem Kröller-Müller, Otterlo), and this figure too has the aspect of a defiant Lucifer. The despondent little angel also shown here is, however, quite different. Such winged figures occur often in Redon's work and are characteristic of the bizarre imagination that was to make him such an unusual figure in nineteenth century French art.

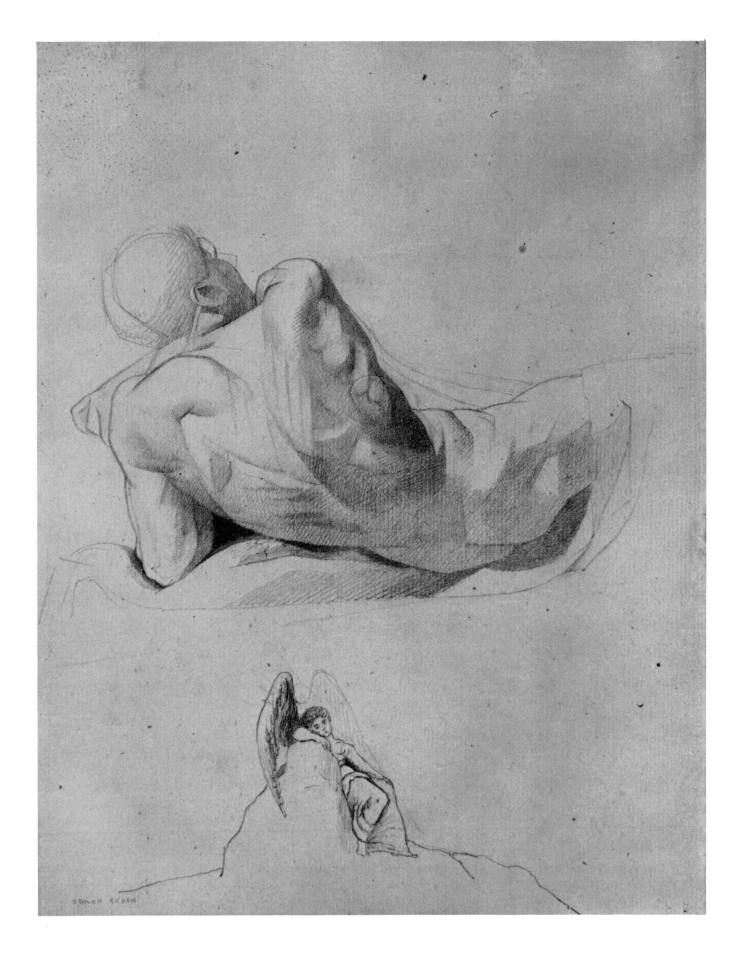

James Jacques Joseph Tissot (French, 1836-1902)

29. a. *Woman Looking through Binoculars*

Pencil and wash on paper, 10¼ x 6⅛ inches
(26 x 15.5 cm.)

b. *Woman Leaning on a Rail*

Pencil, wash, and white highlighting on paper,
10¼ x 11⅛ inches (26 x 28.2 cm.)

Provenance: Gari Melchers, Savannah.

Lent by The Telfair Academy of Arts and Sciences,
Inc., Savannah. Gift of Gari Melchers.

After participating in the Paris Commune of
1871, Tissot, who had already established
himself as a successful painter of society
subjects, fled to London. There he con-
tinued to produce elaborate pictures of
fashionably dressed women engaged in
various social activities. As Michael
Wentworth has pointed out (in corre-
spondence), these two drawings are pre-
liminary studies for figures in a now lost
painting of 1871-72, *La Tamise (The Thames)*,
of which a wood engraving appeared in *The
Graphic*, v. 7, February 8, 1873; similar
studies are at Smith College and the Ash-
molean Museum.

These drawings reveal Tissot's careful
preparation for his final compositions and
their elaborate textures. The fine pencil lines
combined with white highlighting are
probably a conscious attempt to integrate
into his works the manner of Italian Renais-
sance drawings, such as those he had copied
in Florence and Venice in 1862 (see *James
Jacques Joseph Tissot*, exhibition catalogue,
Museum of Art, Rhode Island School of De-
sign, 1968, no. 41). The pensive melancholy
of the sideways glance of the *Woman Leaning
on a Rail* is typical of Tissot's insightful de-
piction of his characters.

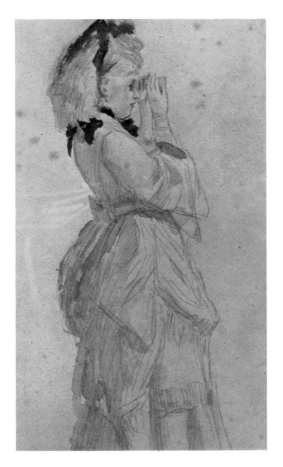

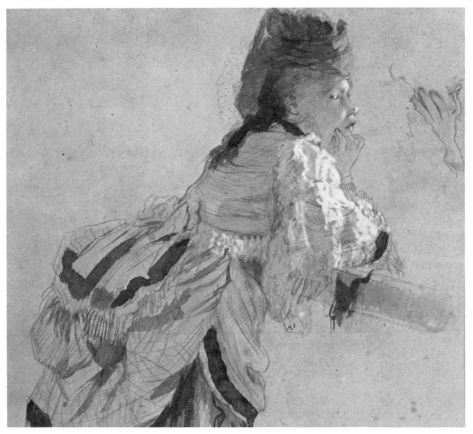

30. *Head of Mary Magdalene*, ca. 1880

Pastel on paper, 9⅞ x 7¼ inches (25 x 18.4 cm.)

Stamped at lower right corner: *J.J. HENNER*

Provenance: Private Collection, New York.

Lent by Dr. Ernest Abernathy, Atlanta.

Henner won the coveted *Prix-de-Rome* in 1858 and was able to spend six years in Italy. He was most influenced by Correggio, adopting the Italian master's soft modeling and vaporous forms for the series of quasi-religious works he painted upon his return to France. These brought Henner great acclaim. His 1874 painting *Mary Magdalene in the Desert* was bought for the Musée du Luxembourg and is probably the one now in the Musée de Toulouse. The artist produced a good number of variants on the theme of the scantily clad saint, and the critic Gabriel Seailles commented on these:

> The elegant simplicity of the attitude generalizes the sentiment, amplifies the legend to symbol; the Magdalene has been most often for Henner only a pretext, a chance to paint a female body touched with the unique grace of antique Aphrodite . . . This Magdalene is the symbol of inconsolable widows whose sadness is only coquetry which prepares for a season of new loves. (G. Seailles, ''J.-J. Henner,'' *La Revue de l'Art Ancien et Moderne,* Paris, 1897, p. 49 ff.).

This pastel study of the Magdalene's head relates to a painting exhibited at the Salon in 1878, the composition of which Henner repeated in a version painted in 1880 for Miss Sarah Hitchcock of New York and now in the Toledo Museum of Art (see *The Toledo Museum of Art European Paintings,* 1976, pl. 265). In this work, the figure is shown in profile, kneeling in prayerful attitude. A drawing for the full figure is reproduced in Louis Loviot, *J. J. Henner et son oeuvre,* Paris, 1912, p. 23; and another study of just the head was published by Frederic Lees, ''The Work of Jean-Jacques Henner,'' *The Studio,* v. XVIII, November, 1899, p. 78. Even in this head study, one gets an inkling of the languid sensuality of Henner's saint. Specific features are obscured in order to concentrate on the texture of the pallid white skin and the luxurious black hair.

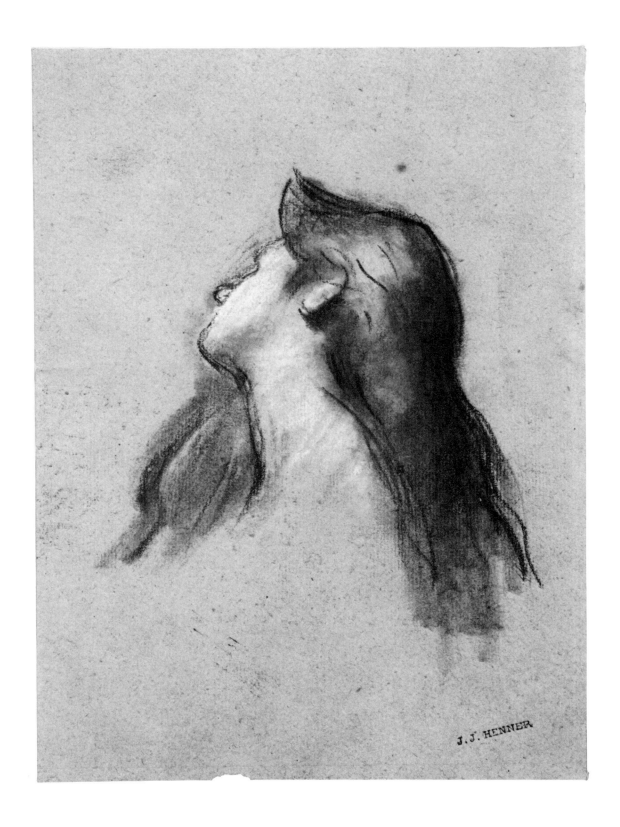

Alphonse Mucha (Czech, worked in France, 1860-1939)

31. *Study for a Monte Carlo Poster*, 1897

Colored pencil on paper, 21 x 15½ inches
(53.3 x 39.4 cm.)

Exhibition: The High Museum of Art, Atlanta, *A Thing of Beauty*, February 1-April 6, 1980, no. P.9.

Lent by a Private Collection, Atlanta.

Mucha, who arrived in Paris in 1887, was earning a meager living when he catapulted to overnight fame by designing a poster for Sarah Bernhardt's 1894 production of Sardou's *Gismonda*. Recognizing his unusual talent, she signed him to a six-year contract to design posters, sets, costumes, and even her hair-styles and jewelry. Thus, from 1895 to 1904, he was one of the most fashionable decorative artists working in Paris in the Art Nouveau style. He produced designs for a tremendous number of posters, not only for Bernhardt, but for everything from champagne and cigarette paper to Nestle's Milk.

This drawing is a preliminary study for an 1897 lithographic poster commissioned by the Compagnie de Chemins de Fer P.L.M. to attract tourist travel to Monaco and Monte Carlo (see Ann Bridges, ed., *Alphonse Mucha, The Complete Graphic Works*, New York, 1980, no. A21).

Mucha's conception was to show Spring coming to the Mediterranean in the form of a beautiful, innocent girl with an aureole of spring flowers placed over the coastline of the beach at Monte Carlo. Mucha often prepared compositions by first photographing his model in the desired pose. This girl, with her flowing hair and lithe figure composed of curving lines, is typical of his decorative manner, as is the intricate halo of flowers that appears in many other works. In the drawing we can enjoy the delicate tonalities of the colored pencil, which in the printed poster become much harsher.

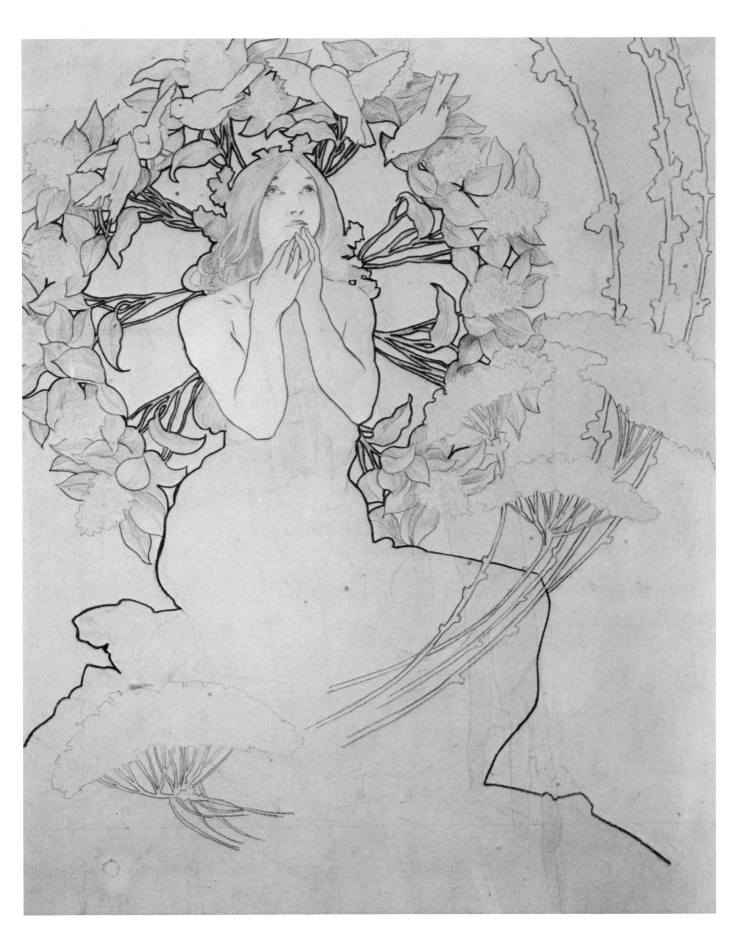

John Constable (English, 1776-1837)

32. *Water Street, Hampstead*, ca. 1831

Watercolor on paper, 5¾ x 7½ inches (14.6 x 19 cm.)

Inscribed in pen on back of wood mount and also transcribed on an old sticker: *Water Street/Hampstead/ To Mr. John Allen, East Bergholt, Suffolk/ with the sincere regards of his friend/John Constable R.A. Nov. 22, 1832.*

Exhibitions: Atlanta Art Association Galleries, *Landscape into Art*, February 6-25, 1962; Department of Art History, The University of Wisconsin, Milwaukee, *Constable, Symposium and Exhibition*, April 1-14, 1976, no. 7.

Provenance: John Allen, East Bergholt; Mr. and Mrs. Howard E. Coffin, Detroit and Sapelo Island, to 1932; Mr. and Mrs. Alfred Jones, Sea Island.

The High Museum of Art. Gift of Mr. and Mrs. Alfred W. Jones, 1961.

Constable was born at East Bergholt, Suffolk, the son of a prosperous miller. In 1799 he went to London to study at the Royal Academy, and although he was to spend much time there, he retained strong links with the Suffolk countryside of his childhood, even settling his family in Hampstead in 1820. He described the region in his book of mezzotints, *English Landscape:*

> The beauty of the surrounding scenery, the gentle declivities, the luxurient meadow flats sprinkled with flocks and herds, and well cultivated uplands, the woods and rivers, the numerous, scattered villages and churches, with farms and picturesque cottages, all impart to this particular spot an amenity and elegance hardly anywhere else to be found. (Quoted in *Constable: Paintings, Watercolors, and Drawings*, exhibition catalogue, Tate Gallery, London, 1976, p. 32.)

Constable frequently sketched these locations and produced watercolors of a freshness and immediacy lacking in his more finished oil paintings. This study combines some of his favorite motifs. There is the comfortable cottage nestling amidst the trees, resembling the home of Willy Lott, which frequently served as his inspiration (see Tate Gallery exhibition catalogue, no. 294). The cattle are the Suffolk breed to which Constable was so partial that, according to his first biographer C. R. Leslie, he included them no matter what the location of his subject (see Freda Constable, *John Constable: A Biography 1776-1837*, Lavenham, 1975, p. 68).

Constable is quoted as saying, "the landscape painter who does not make his skies a very material part of his composition, neglects to avail himself of one of his greatest aids." (See Basil Taylor, *Constable Paintings, Drawings, Watercolors*, London, 1973, p. 224). In this instance, we see how well he has followed his own advice. The sky with its suggestion of storm clouds provides a dramatic counterbalance to the pastoral scene. The watercolor medium served Constable especially well for capturing the shifting appearance of light and atmosphere.

In 1831 the artist made a group of sketches of this size. The Water Street referred to in the inscription has not been located. Perhaps it is the same as the Water Lane, Stratford St. Mary, Suffolk, in a drawing of 1827 (*Constable*, Tate, 1976, no. 252). From November 8 to December 13th, 1832, Constable was back in East Bergholt to attend the funeral of his young friend Johnny Dunthorne and during that time gave this drawing to John Allen. This was probably Constable's cousin, a captain in the Royal Navy, born ca. 1782 and living in 1849. (See R. B. Beckett, ed., "John Constable's Correspondence: The Family at East Bergholt, 1807-1837," *Suffolk Records Society*, v. IV, 1962, pp. 145, 200, 321.)

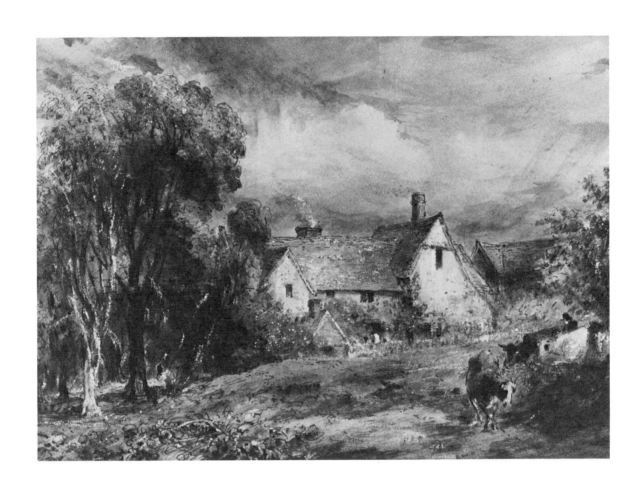

33. *Study for the Wheel of Fortune*, ca. 1871

Pencil on paper, 7 x 3½ inches (17.8 x 8.9 cm.)

Provenance: Julian Hartnoll, London, 1977.

Lent by a Private Collection, Atlanta.

The Wheel of Fortune was a theme that Burne-Jones first used as one of the dividing units on his predella for the large work known as *The Troy Triptych*, begun in 1870 (see *Burne-Jones,* exhibition catalogue, Hayward Gallery, London, 1975, p. 49). The composition, as seen here, depicts the allegorical personification of Fortune turning her wheel, so that the figure of a slave rises above that of a king. Fame, Love, and Oblivion were the allegorical figures on the other dividers, but Fortune and her wheel seem to have captured the artist's imagination. There are many sketches of the theme and, among large scale versions, a painting in the National Gallery of Victoria, Melbourne, and a gouache of ca. 1882 in the National Museum of Wales, Cardiff (see Martin Harrison and Bill Waters, *Burne-Jones,* London, 1973, p. 133).

This small and relatively rough rendering of the subject is probably an early one, for the figures of the slave and king are shown heavily draped, while in later versions they appear as heroic Michelangelesque nudes. Even here the elongated proportions of Fortune seem inspired by Michelangelo's *Sibyls* in the Sistine Chapel, which Burne-Jones studied in 1871.

34. *Studies of Embracing Figures*

Pencil on paper, 7⅛ x 9⅛ inches (18.1 x 23.2 cm.)

Provenance: Hartnoll and Eyre, Ltd., London, 1973.

Lent by a Private Collection, Atlanta.

Burne-Jones made many sensitive, detailed preliminary studies for his paintings and other projects. The three studies on this sheet are attempts to perfect the harmonious intertwining of two embracing figures. Originally, this couple was intended as an illustration to the Pygmalion story in William Morris's *The Earthly Paradise*. But this project of 1865 was abandoned, and the artist adapted the design for an 1874 gouache, *The Altar of Hymen* (see Martin Harrison and Bill Waters, *Burne-Jones,* London, 1973, fig. 166). These columnar figures with their delicate shading show how carefully Burne-Jones had studied both Italian Renaissance sculpture and engraving.

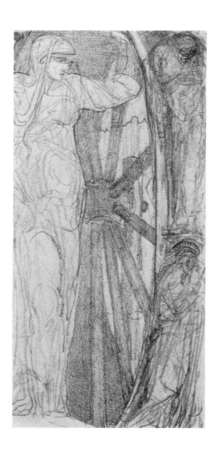

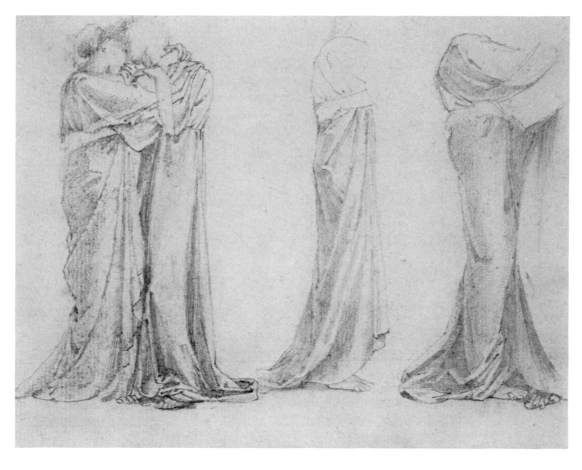

Simeon Solomon (English, 1840-1905)

35. *Pia de'Tolomei*

Pencil and chalk on paper, 13¾ x 16¾ inches (34.9 x 42.5 cm.)

Signed and dated at the lower right: *SIMEON SOLOMON 1896.* Inscribed along the lower edge: *LA PIA DE'TOLOMEI IMPRIGIONATA*

Provenance: E. and A. Silberman Galleries, New York; The Stone Gallery, Newcastle upon Tyne, England; Robert Walker, London, 1971.

Lent by a Private Collection, Atlanta.

Simeon Solomon was known as the *enfant terrible* of the Pre-Raphaelite movement. He blended elements of his Jewish background with the classical world that he discovered on his first trip to Rome in 1867. Both in his imagery and style, he was greatly influenced by Rossetti. In fact, Dante's La Pia had been treated by Rossetti in several drawings and a painting begun in 1868 and completed in 1880 (see Virginia Surtees, *The Paintings and Drawings of Dante Gabriel Rossetti*, Oxford, 1971, I, pp. 118-120, II, pl. 300-302).

The subject of Rossetti's painting, as described in the *Athenaeum* of February, 1881,

> is taken from the passage in the fifth canto of the "Purgatorio," in which Dante describes his meeting with Pia de'Tolomei among those whose opportunity of repentance was only at the last moment, and who died without absolution. She had been done to death by her husband, Nello della Pietra, who confined her causelessly in a fortress of the Maremma, where she pined and died of malaria, or, as some say, by poison. The words which her spirit speaks to Dante run thus:
> Ah! when on earth thy voice again is heard,
> And thou from the long road hast rested thee
> (After the second spirit said the third),
> Remember me who am La Pia; me
> Siena, me Maremma, made, unmade,
> This in his inmost heart well knoweth he
> With whose fair jewel I was ringed and wed

The haunted melancholy and heavy features of Rossetti's figure are taken up by Solomon, and his focus on head and neck and the enclosing wall is particularly reminiscent of Rossetti's bust-length study of La Pia (Surtees, pl. 302). But typically, whereas all of Rossetti's works show the head in three-quarter view, Solomon prefers a pure profile. The Michelangelesque proportions of this head recall profiles by Burne-Jones, such as that of the study for *Nimuë* of ca. 1873 (see *Burne-Jones*, Hayward Gallery, London, 1975, fig. 130).

The signature and date may have been applied some time after the execution of this masterly, highly-finished chalk drawing, for in the last years of his life, Solomon was in extreme straits, working as a pavement artist and ultimately dying in a London workhouse.

74

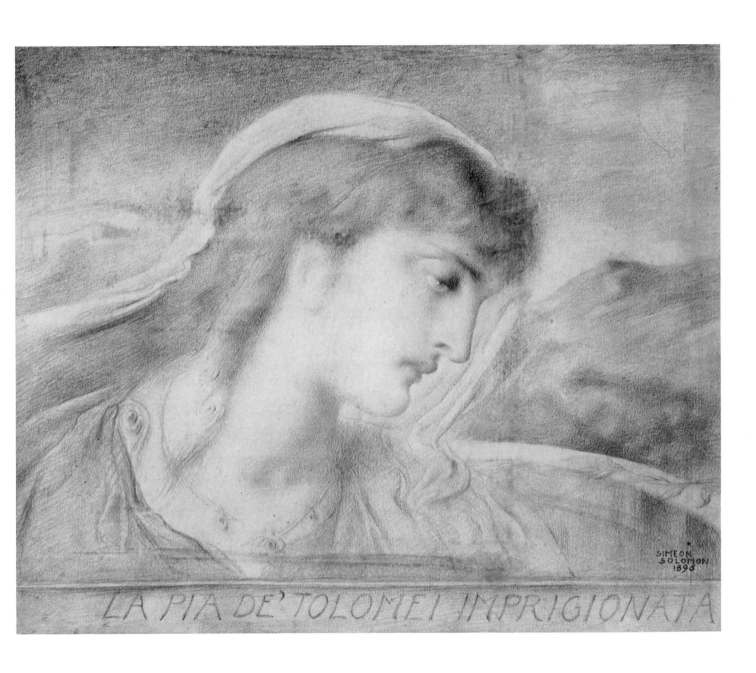

LA PIA DE'TOLOMEI IMPRIGIONATA

36. *Study of Samson Wrestling with the Lion,*
ca. 1863

Black chalk with white heightening on blue paper,
9 x 10 inches (22.9 x 25.4 cm.)

Stamped at the lower left with the artist's estate
stamp (Lugt 1741a)

Exhibition: Fine Arts Society, London Dec. 1896, no.
41 (?).

Provenance: Abbott and Hodler, London.

Lent by Professor Dorinda Evans, Atlanta.

Between 1863 and 1864, Lord Leighton produced nine designs for use in an illustrated Bible planned by the Dalziel brothers, but their *Bible Gallery,* as it was called, with sixty-two wood-engravings after designs by various artists, was not published until 1880. Lord Leighton's subjects were primarily scenes of powerful action: *Cain and Abel, Death of the First Born, Moses Viewing the Promised Land,* and several incidents from the life of Samson. The last were especially chosen by Lord Leighton, as a letter from him to the Dalziels reveals:

> The "Samson" is indeed short, but contains much that lends itself for illustrations. I should have wished to treat the following subjects at least: "The Angel Disappearing in a Flame after announcing to Manoah and his Wife, the Birth of Samson," "Samson and the Lion," "Samson and the Gates," "Samson in the Mill"; the other subjects from the wonderful story would require complicated groups. The above are all broad, simple, and very pictorial. (*The Brothers Dalziel,* London, 1901, p. 242.)

The incident is taken from *Judges* 14:5-6, which describes how Samson killed a young lion without any weapon. In order to establish the composition that would be given to the wood engraver, Leighton made a number of preliminary studies of his subjects. This is probably one of his earliest. The lion is barely sketched in and the artist concentrates on the dramatic pose of Samson, even repeating in larger form at the lower right the straining foot upon which his body balances. A slightly later stage in the work's development is seen in a drawing preserved at Leighton House (see Mrs. Russell Barrington, *The Life, Letters and Work of Frederic Leighton,* 1906, v. II, opp. p. 94) in which the lion and Samson's cloak are both more fully developed. The composition and the drawing in these works are unusually vigorous for Lord Leighton.

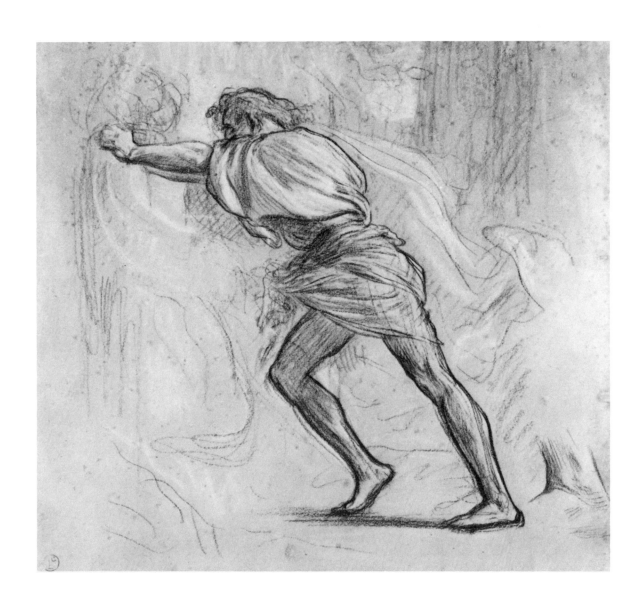

37. *Dante Implores Virgil to Save Him from the Three Wild Beasts*, ca. 1805

Pencil on paper, 10¹/₁₆ x 14¾ inches (25.5 x 37.5 cm.)

Provenance: Private Collection, New York.

Lent by a Private Collection, Atlanta.

Koch, who was the outstanding German classical landscape painter in the early part of the nineteenth century, settled in Rome in 1795. His passion for Dante's *Divine Comedy*—he produced a multitude of illustrations of it—dates from about 1800. The most important of these Dante works were undoubtedly the frescos for the Villa Massimo by Koch and members of the German Nazarene movement residing in Rome.

Marchese Camillo Massimo wished to create a monumental cycle of works. The ceiling of the Dante Room was decorated by Philip Veit with scenes from the *Paradiso* after drawings by Peter Cornelius. Koch worked on his designs for the *Inferno* and *Purgatorio* during 1824-25 and on the paintings from 1826 to 1829. On the entrance wall, he painted the scene from Canto I of the *Inferno* depicting Dante's first meeting with Virgil (see Ludwig Volkmann, *Iconographia Dantesca*, London, 1899, p. 142).

This drawing is one of Koch's first studies of this subject, probably dating from the early part of the century. In the poem, Dante relates how he awakened after a night spent in a dark wood and made his way to the foot of a hill where the sun guided his path upward; but he was met in succession by three beasts, a leopard, a lion, and a she-wolf, who drove him back with fear; and as he rushed downward, there appeared before him the figure of Virgil to whom he appealed for pity and protection. In this rapidly executed sketch Koch has tried to capture the drama of the meeting, even giving Dante three hands in his attempt to find the most suitable pose for his agitated entreaty. The beasts set on the side of the hill all have the proper ferocity, and in the background the sun and its rays break through the trees as described in the text. Dante is in profile but not with the carefully delineated features that are already found in the next stage, a drawing in a private collection in Karlsruhe (see Kurt Gerstenberg and Paul Ortwin Rave, *Die Wandgemälde der deutschen Romantiker in Casino Massimo zu Rom*, Berlin, 1934, fig. 50). This includes, as does the final composition, the slumbering-awakening figure of Dante at the far left and rearranges the position of the three animals, so that they seem less threatening; it also eliminates the sun. In the final design for the fresco in the Casino Massimo, as transferred to the squared drawing, and in a watercolor version, the composition is reversed and Dante is actually placed in the midst of the three beasts (see Gerstenberg and Rave, figs. 51-53).

Many other Koch drawings of the subject exist (see the references in Otto R. von Lutterotti, *Joseph Anton Koch, 1768-1835*, Berlin, 1940, nos. Z133, 167, 190, 313, 393, 539, 589, 702, and 2698). The artist also made an engraving of it (see A. Andresen, *Die Deutschen Maler-Radirer des 19 Jahrhundert*, 1878, v. I, no. 21).

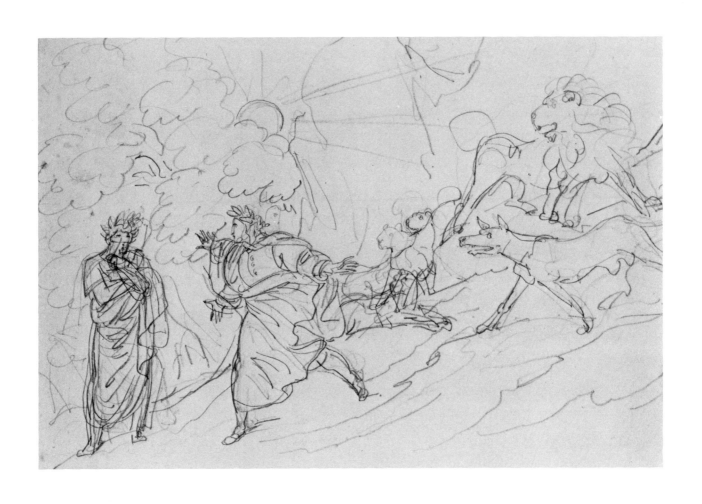

Adolph von Menzel (German, 1815-1905)

38. *The Cat with Adam's Wig. Design for an illustration to Kleist's "Der zerbrochene Krug,"* 1877

Pen and ink and ink wash on paper, 3¾ x 5½ inches (9.7 x 13.9 cm.)

Signed at the middle right with the artist's initials: *A.M.*

Provenance: Private Collection, New York.

Lent by a Private Collection, Atlanta.

Menzel's only formal training was a summer spent as a fourteen-year-old at the Berlin Academy. For the rest, he was self-taught. He learned by designing labels, invitations, and other practical pieces for his father's lithographic printing business. He gradually became proficient as an illustrator. Between 1840 and 1842, he prepared over four hundred drawings as illustrations to Kugler's *Life of Frederick the Great*. This work brought him a wide public following, and he continued to provide other popular illustrations while broadening his own knowledge and abilities by travel throughout Europe.

In 1877 Menzel designed thirty woodcuts for a centennial edition of Heinrich von Kleist's comic play, *Der zerbrochene Krug (The Broken Jug)*. The play had first been produced in 1808 under Goethe's direction, and it tells the story of a corrupt village judge, Adam, who attempts to place the blame for a broken jug and other disreputable actions on others, only to be unmasked at the end as a scoundrel himself. One of the comic points of the play turns on the judge's failure to wear his wig, which he had lost in the previous night's activities. Rather than reveal the truth, he invents the tale that the cat had stolen it:

> Adam: Go. Marguerite!
> Our friend, the sacristan, must lend me his.
> Tell him the cat, the dirty pig, has had
> Her litter in mine this very day. And it
> Now lies befouled beneath my bed.
>> Act I, scene 3, lines 241-245
>> trans. John T. Krumpelmann

Menzel's whimsical drawing of the pregnant cat dragging away the wig, to which a large question mark is attached, is thus a very apt illustration of these lines. The drawing, initials and all, was transferred to the woodblock by a photographic process and appeared on page 14 of the printed text. (See Elfried Bock, *Adolph Menzel, Verzeichnis seines graphischen Werkes*, Berlin, 1923, p. 483, no. 1103; and J. C. Jensen, *Adolph von Menzel, Das graphischen Werk*, 1976, v. I, p. 684.)

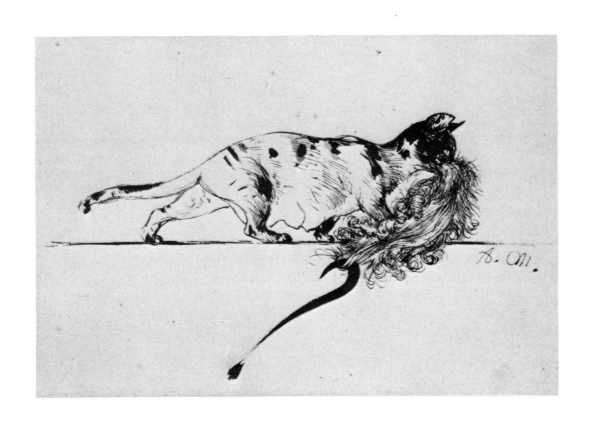

39. *A Sunflower for Teacher*, 1875

Watercolor on paper, 7 x 5½ inches (17.8 x 14 cm.)

Signed with the artist's initials and dated at the lower right corner: *W H 1875*

Bibliography: *Appleton's Journal*, February 19, 1876, p. 250; S. N. Carter, "Paintings at the Centennial Exposition," *The Art Journal*, v. 38, 1876, p. 284; Gordon Hendricks, *The Life and Work of Winslow Homer*, New York, 1979, pp. 104-106, 284, fig. 163, no. CL-91; Mary Ann Calo, "Winslow Homer's Visits to Virginia During Reconstruction," *The American Art Journal*, Winter 1980, p. 14, fig. 13.

Exhibitions: American Watercolor Society, New York, 1875-76; Georgia Museum of Art, The University of Georgia, *Opening Exhibition*, November 8, 1948-January 1, 1949; National Gallery of Art and Metropolitan Museum of Art, *Winslow Homer: A Retrospective Exhibition*, November 23, 1958-March 8, 1959; The University of Arizona Art Gallery, Tucson, Arizona, *Yankee Painter: A Retrospective Exhibition of Oils, Watercolors, and Graphics by Winslow Homer*, October 11-December 1, 1962; The Bowdoin College Museum of Art, *A Portrayal of the Negro in American Painting*, 1964; Georgia Museum of Art, *Twentieth Anniversary Exhibition*, November 8-December 8, 1968; Mobile and other locations, *A University Collects: Georgia Museum of Art*, organized by the Georgia Museum of Art and The American Federation of Arts, 1969-70, no. 24; Weatherspoon Art Gallery, The University of North Carolina at Greensboro, *Art on Paper*, November 14-December 17, 1971, no. 10; The High Museum of Art, Atlanta, *Children in America*, September 30, 1978-May 27, 1979, no. 25.

Provenance: Mrs. A. P. Homer, Virginia Beach, Virginia; William Macbeth Gallery, New York City.

Lent by the Georgia Museum of Art, University of Georgia, Athens. Eva Underhill Holbrook Memorial Collection of American Art. Gift of Alfred H. Holbrook, 1945.

During the Civil War period, Homer gained recognition as an artist-correspondent and began a successful career as a magazine illustrator. He had, however, become interested in developing his talents in oils and watercolors, and in 1867 traveled for the first time to Europe. He made two major dis-coveries there: Japanese prints, which provided new viewpoints on familiar themes; and contemporary English watercolors, which showed him the great potential of that medium. He gradually assimilated these into his own work, developing a watercolor technique of remarkable freshness.

In 1875, Homer stopped illustrating magazines and again visited Virginia, where he had worked many years earlier. He produced a number of works recalling the scenes of everyday life he witnessed there, and *A Sunflower for Teacher* is certainly one of the most charming. The same child appeared in other works of 1875, including *Contraband* (Canajoharie Library and Art Gallery), *Busy Bee* (Timkin Art Gallery), and *Two Boys in a Cart* (Philadelphia Museum of Art). Here he is given a particularly poignant attitude and through the association with the large flower and the butterfly appears very much as part of the natural world which forms a screen-like backdrop.

Following the work's exhibition in 1875-76, a reviewer for *Appleton's Journal* of February 19, 1876, observed:

Now this little urchin appears in a new character, that of a demure scholar at the dayschool . . . for he bears on his arm and presses against his heart a flower for the teacher, in the shape of a great yellow sunflower, with its petals all expanded nearly as big as the little fellow's head while its brown seeds that fill the center glisten as does the child's moist countenance. We think this is one of the funniest pictures Mr. Homer ever painted, and, with its sub-flavor of wit, not too broad, and its half-concealed pathos as well, it is one of the happiest efforts of the artist, under very modest form. (Quoted in Gordon Hendricks, *The Life and Work of Winslow Homer*, New York, 1979, p. 105)

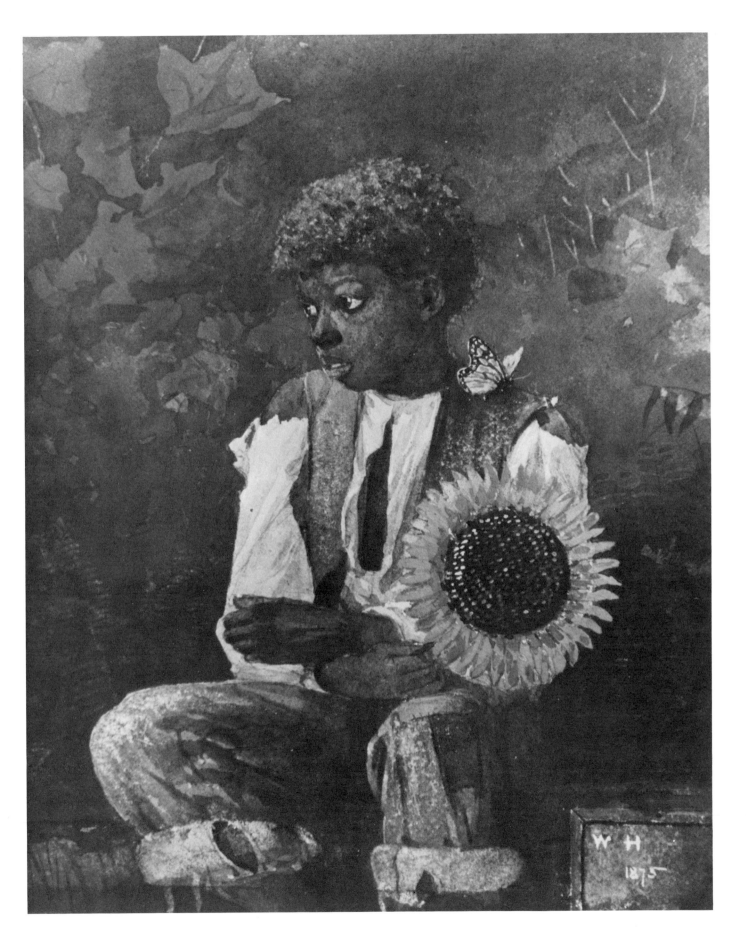

Auguste Rodin (French, 1840-1917)

40. *Head of a Cambodian*, ca. 1906

Pencil and crayon with watercolor on paper, 12⅝ x 9⅝ inches (33 x 25.5 cm.)

Bibliography: Elizabeth Chase Geissbuhler, *Rodin: Later Drawings*, Boston, 1963, p. 41, pl. 15.

Exhibition: Fogg Art Museum, Cambridge, 1958.

Provenance: Roche Collection; Private Collection, New York.

Lent by a Private Collection, Atlanta.

In 1906 King Sisowath of Cambodia visited France with a large retinue of dancers. Their performance so captivated Rodin that he invited the troupe to his home at Meudon for a further opportunity to sketch them, and he followed them afterwards from Paris to Marseille.

Rodin drew this Cambodian man first in pencil, and then strengthened in crayon the back of his head, neck, arm, and the folds of his clothing. Chartreuse, brownish-pink, and grey watercolor washes followed, fleshing out the body's masses. Through this sequence, Rodin sought a sense of vitality in the total effect, as well as a feeling for the individuality of his sitter. The delicacy of the man's long slender fingers and almond eyes may have been conditioned by the expressive use of the head and hands in Cambodian dance, but it is also possible that Rodin saw his sitter in terms of Khmer sculpture. The repetitive contours that surround the figure give it the three-dimensionality of a sculptor's drawing, and convey an impression of alertness and animation.

The traditional identification of the sitter as King Sisowath seems dubious: not only did Sisowath have a moustache, but he was also sixty-six at the time of the visit, far older than this subject appears to be.

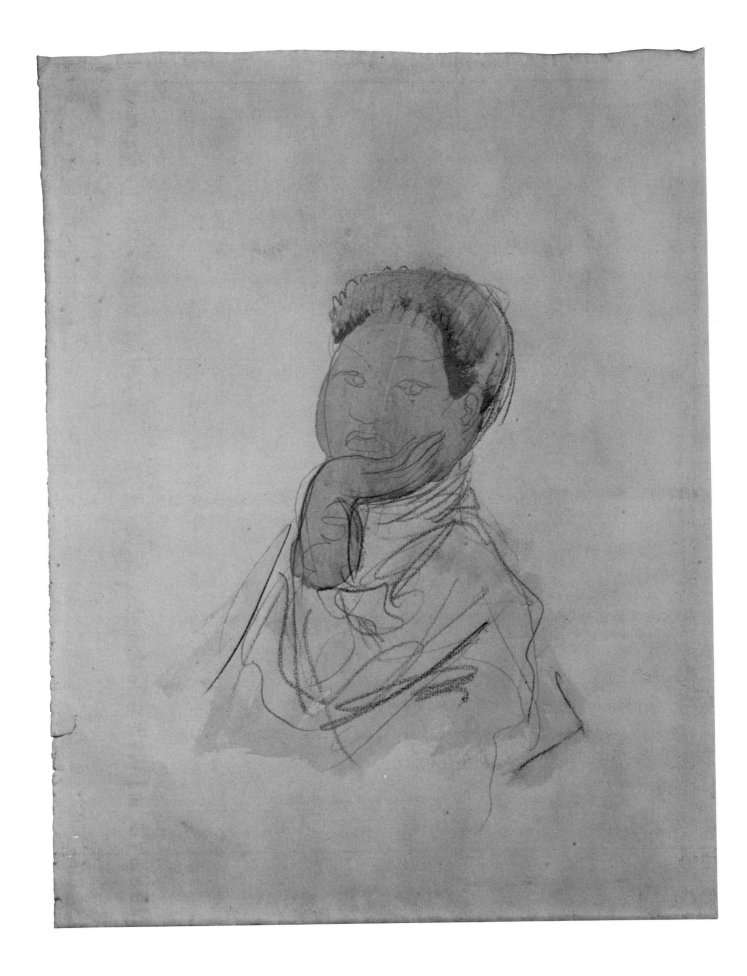

Henri Matisse (French, 1869-1954)

41. *Jeune Fille á la Table,* 1942

Lithographic crayon on paper, 20⅜ x 15½ inches (51.8 x 39.4 cm.)

Inscribed at the upper right in ink: *O6 Henri Matisse 42*

Bibliography: Louis Aragon, *Henri Matisse Dessins: Thèmes et Variations,* Paris, 1943.

Provenance: Victor Waddington, London, 1978.

Lent by Mr. and Mrs. Elliott Goldstein, Atlanta.

Unable to paint as a result of a serious operation in January of 1941, Matisse devoted himself to drawing. One of the results of this effort was the prodigious *"thèmes et variations"* series, which consisted of one hundred fifty-eight drawings, separated into seventeen themes, each designated by a letter of the alphabet. Some of these were still lifes, but most dealt with the female model. In both series "B" and series "O," the model wears a wristwatch. This drawing is the sixth of eighteen variations in the series "O." Each series begins with a drawing in charcoal, and is followed by subsequent drawings in ink or crayon, which clarify and refine the initial essay. In the variations, Matisse strove towards greater concision and simplicity of expression, and more expressive graphic signs for the delineation of the features of his models.

In this drawing, Matisse's ability to create animation and vitality with an extreme economy of accents is fully evident. The young woman's flowing hair establishes a rhythmical movement which is carried through in the depiction of all of her features. Matisse orchestrates the lines on the page to suggest her position in space and the roundedness of her forms without ever resorting to chiaroscuro modelling. There is a balance of attractions between all parts of the sheet. Matisse believed that his drawings modified the light of the page, serving as an inflection of its whiteness. In 1939, he wrote:

> My line drawing is the purest and most direct translation of my emotion. The simplification of the medium allows that. At the same time, these drawings are more complete than they may appear to some people who confuse them with a sketch. They generate light; seen on a dull day or in indirect light they contain, in addition to the quality and sensitivity of line, light and value differences which quite clearly correspond to colour. (Quoted in Jack Flam, *Matisse on Art,* New York, 1978, pp. 81-82.)

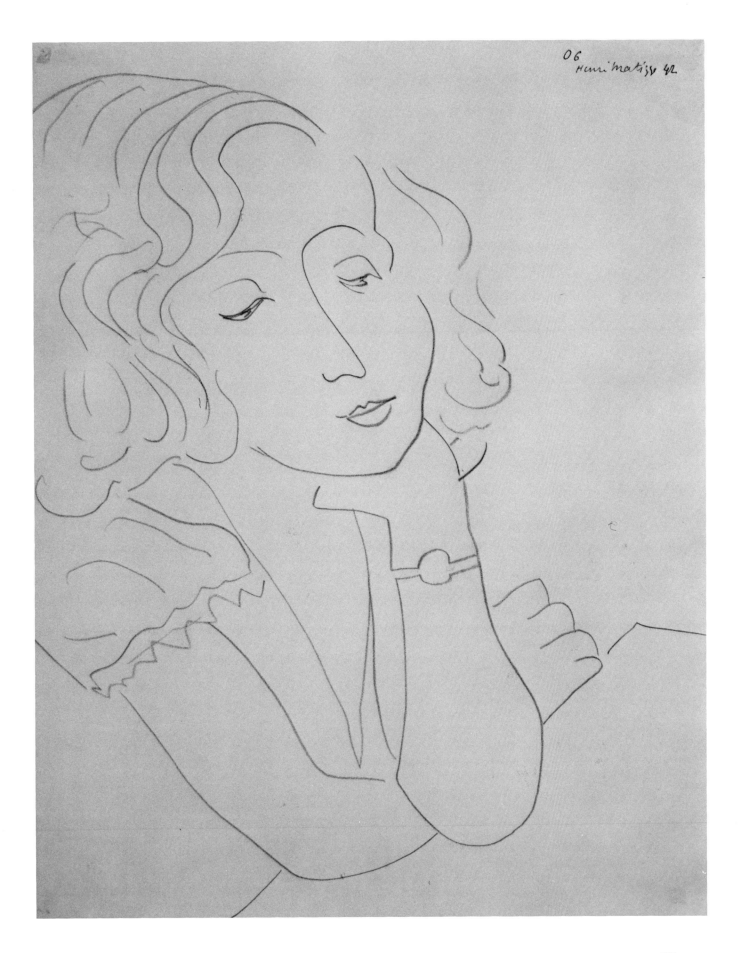

42. *Woman Combing Her Hair*, 1906

Pencil on paper, 6½ x 4¼ inches (17.5 x 11 cm.)

Signed in pencil at the lower right corner: *Picasso*

Bibliography: Christian Zervos, *Pablo Picasso*, Paris, v. VI, p. 90, fig. 743.

Exhibition: James Goodman Gallery, New York.

Provenance: Curt Valentin; Royal S. Marks, New York; Dr. Max Jacobson, New York; A. M. Adler, New York.

Lent by Dr. Ernest Abernathy, Atlanta.

Picasso had treated the theme of a nude woman adjusting her hair in *The Harlequin's Family* (Zervos, v. I, no. 298), a gouache of the Spring of 1905. A year later, after having seen an exhibition of primitive Iberian sculpture at the Louvre, Picasso began to incorporate the simplified and ponderous forms he had observed. This process was accelerated by his visit that summer to Gosol in the Spanish Pyrenees. During all this time, he worked steadily on the subject of *La Coiffure*, a woman combing her hair, both as an individual figure and as part of multi-figure compositions such as *The Harem* (Zervos, v. I, no. 321).

This small drawing is perhaps a key to the evolution of one aspect of this theme. As one can see, after an obvious struggle (unusual for Picasso), he achieved this design on top of a previous, partially erased one. The figure, with her broad, angular face cradled on her right arm which crosses the body to the hair, appears to float in space. In its final form with the legs bent under the body, it appears in several drawings (Zervos, v. I, nos. 329, 341; v. VI, no. 751), an oil painting (Zervos, v. I, no. 336), and a bronze sculpture (Zervos, v. I, no. 329), all of 1906. Picasso freezes a dynamic movement in a compressed structure, so that, despite its small size, the drawing radiates tremendous power. The unshaded areas of the body become brilliant planes which point the way towards the abstract stylization of *Les Demoiselles d'Avignon* of 1907.

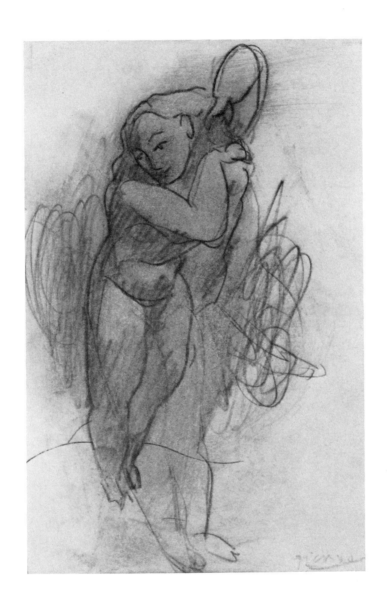

43. *Bust of a Woman with Left Hand Raised,*
1906

Charcoal, India ink, and watercolor on paper,
24½ x 18½ inches (62.2 x 47 cm.)

Signed at the lower right corner: *Picasso*

Bibliography: Christian Zervos, *Pablo Picasso,
Oeuvre 1895-1906*, 1957, v. I, p. 157, no. 334; Pierre
Daix and Georges Boudaille, *Picasso 1900-1906,
Catalogue Raisonné de l'Oeuvre Peint*, Paris, 1966, p.
330, no. D. XVI.7.

Exhibitions: Wellesley College Art Museum, Wellesley, Mass., 1953; Worcester Art Museum, Worcester, Mass., 1967.

Provenance: Ambroise Vollard, Paris; Galerie Jeanne
Bucher, Paris; Mary S. Higgins collection; Sale Parke
Bernet, New York, March 10, 1971, no. 19.

Lent by a Private Collection, Atlanta.

Another form given by Picasso in the Summer and Fall of 1906 to the image of the woman adjusting or playing with her hair (see no. 42) is seen in this impressive drawing. Here the impact of his stay in Gosol and the consequent absorption of a new "primitive" attitude combined with his admiration for the forceful figurative style of Cézanne can be appreciated in full. The face is a massive stone-like presence with sculpted eyebrows and an angular nose much like the one he gave to Gertrude Stein in her celebrated portrait of the same date. The modeled quality is emphasized by the texture of the watercolor and charcoal applied in a manner recalling both the *facture* and terra cotta color of his contemporary paintings.

This figure represents one-half of a composition that was seemingly inspired by a study of two Andorran peasant women (Zervos, v. VI, no. 780). Picasso worked on this theme in earnest after his return from Gosol. In its full and final form, as seen in the painting *Two Nudes* (The Museum of Modern Art, New York, Zervos, v.I, no. 366), it represents two large full-length standing nudes confronting one another. The one at the right has her hand raised to her hair with one finger extended. At first Picasso represented the pair with their arms intertwined, as in a gouache in the Cone collection, Baltimore Museum of Art, and several other studies (Zervos, v. XXII, no. 411; v. I, no. 359-60; and v. XXI, no. 409). In these, the figure at the right appears as in this study, facing to the right and with the hand raised pensively to the head. The concentration of the version exhibited here on just the head and bust give it a quality of rare grandeur, so that it exists perfectly well as an autonomous creation.

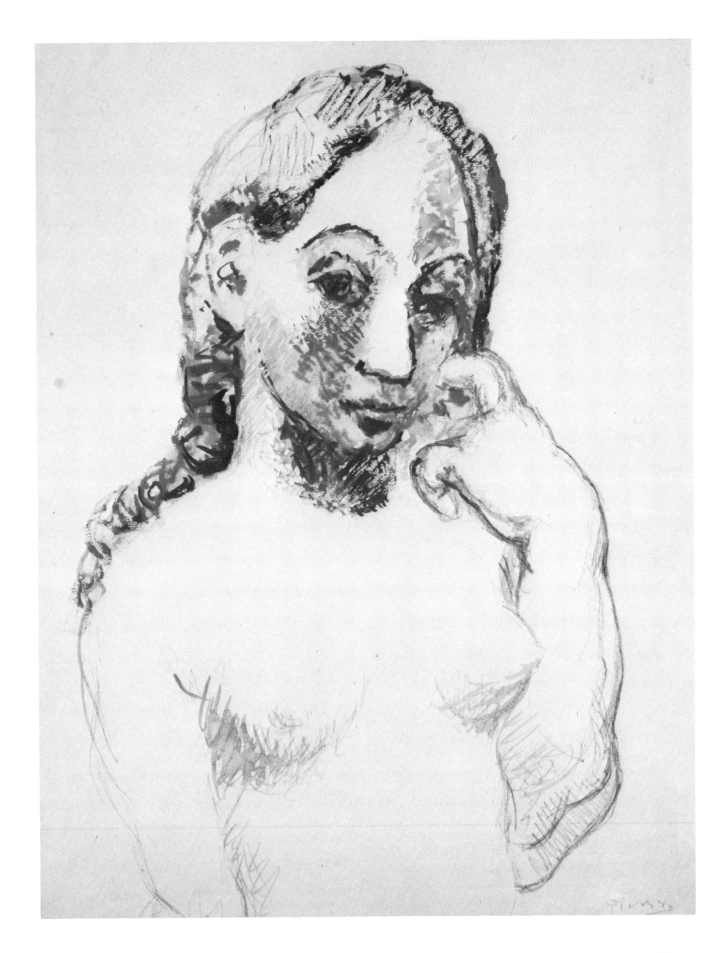

44. *Two Men Contemplating a Bust of a Woman's Head,* 1931

Pencil on paper, 12¹³/₁₆ x 10¼ inches (32.9 x 26.1 cm.)

Signed in pencil at the lower left edge: *Picasso Paris le 27 Novembre XXXI*

Exhibition: Fogg Art Museum, Cambridge, 1958.

Provenance: Private Collection, New York.

Lent by a Private Collection, Atlanta.

From his earliest days, Picasso had dealt with the theme of the artist in his studio and its variants—the artist and his model and the artist admiring his work. He seems to have been fascinated with the very idea of artistic creation, especially his own, and often related it to procreation or at least to sexual desires.

In the late 1920s this theme had been given a new impetus in the series of illustrations Picasso made for Balzac's *Le Chef d'oeuvre inconnu* which was published by Vollard in 1931. It was the story of a mad old painter who spent ten years upon the picture of a woman, repainting it until only he could discern the masterpiece. The theme of the artist in his studio, and particularly the sculptor, also came to be the predominant theme in the *Vollard Suite,* a series of etchings done from 1930 to 1937.

As was often the case, Picasso's art, especially in his graphic work, paralleled events in his own life. In 1931 he had converted the stables of the Château de Boisgeloup near Gisors into a sculpture studio and began a series of large-scale plaster female heads based loosely on the features of his then current mistress, Marie-Thérèse Walter. The features of this head evolved from a pure, realistic form into protuburent, abstract deformations, and ultimately, as he fell out of love with Marie-Térèse, a surreal scarecrow. The noble, somewhat archaic form of the sculpted head seen in this drawing is closest to the *Head of a Woman* cast in bronze in 1934. (See Werner Spies, *Sculpture by Picasso,* New York, 1971, p. 115, no. 128.)

This drawing, executed in November 1931, is in the "classical" manner Picasso also employed in his etchings for Ovid's *Métamorphoses* that same year. It is close to a drawing of August 4th done at Juan-les-Pins (see Christian Zervos, *Pablo Picasso, 1926-1932,* v. VII, no. 335) that also shows two bearded men in shorts and in profile to the left, regarding a sculpture, although in that case it is an almost full-length female figure. That we can regard the older bearded man as the artist/sculptor is made clear in another drawing of the same day (Zervos, v. VII, no. 337) in which he is actually shown modeling the sculpted head. The theme of contemplating such a head continues in a drawing of December 4th, (Zervos, v. V, no. 352) and in a more abstract manner in *Le Sculpteur* of December 7th (Zervos, v. V, no. 346).

In the example presented here, Picasso manages to delineate with great economy the rapt countenances of the two men, gazing upon this imposing female head. We feel that they are almost in awe of it, both as a work of art and the embodiment of a goddess-like woman. In fact her noble features and their simple attire combined with the lack of any real setting or props serve to suggest an idyllic, timeless realm, where art and inspiration are in perfect harmony.

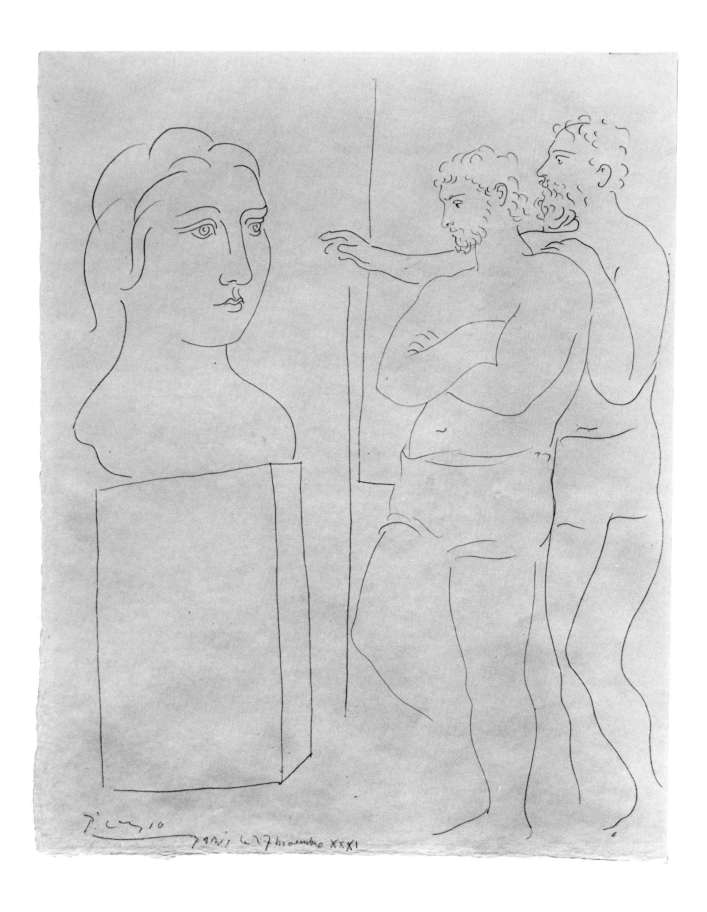

45. *Le Gentilhomme, Costume design for "Les Tentations de la Bergère,"* 1923

Watercolor, 7¾ x 5¾ inches (26.8 x 17.8 cm.)

Signed under the image with the artist's initials: *J G*

Inscribed at the lower left: *A M Simon Lissim Bien cordialement Juan Gris 1924.*

Exhibition: New York, American Federation of Arts, *Fifty Years of Ballet Design,* 1959, no. 304.

Provenance: Simon Lissim, Dobbs Ferry, New York; Perls Galleries, New York; Sale Parke Bernet, New York, Nov. 3, 1966, no. 22; Private Collection, New York.

Lent by a Private Collection, Atlanta.

Juan Gris, who had followed the lead of his Spanish compatriot Picasso in moving to Paris and becoming an adherent of Cubism, had by the 1920s evolved a personal, decorative style. Serge Diaghilev, the impressario of the popular *Ballets Russes* then established in Monte Carlo, sensed that Gris would probably be a good choice for a designer to join Picasso and Braque and the various Russian-born artists who already worked for him. Thus, in April 1921, Diaghilev first contacted Gris, who was staying at Bandol, about doing sets and costumes for a ballet.

Apparently Gris delayed too long in his reply, and by the time he joined the *Ballets Russes* in Monte Carlo, Picasso had been entrusted with the designs. Gris was only asked to do some portrait drawings of the leading dancers. Diaghilev, however, sought to right matters by inviting the artist in the Fall of 1922 to design another ballet. This was *Les Tentations de la Bergère ou l'Amour Vainqueur,* set to music by Michel Pignolet de Montéclair (1666-1737), which Diaghilev had culled from the Paris Opera library and had adapted by Henri Casadesus. The story was based on the dance interlude in the second act of Tchaikovsky's opera *The Queen of Spades* with choreography by Bronislava Nijinska (see Boris Kochno, *Diaghilev,* New York, 1970, p. 195).

His dealer and friend, Daniel-Henry Kahnweiler, relates that Gris made an exact model of his set and also did a large number of pastels and watercolors for the costumes. (Daniel-Henry Kahnweiler, *Juan Gris: His Life and Work,* New York, 1947, p. 20.) A watercolor design for the decor is in the Lifar collection at the Wadsworth Atheneum, Hartford, and various of the pastel designs for costumes are reproduced in Juan Antonio Gaya Nuno, *Juan Gris,* 1974, nos. 197-198 and 201-202. The last is another study of the foppish *Gentilhomme,* holding his plumed hat in his right hand. For these studies, it is evident that Gris abandoned his usual semi-abstract manner to capture the eighteenth century flavor and convey the fluidity and grace he imagined the dancers would bring to the costumes.

Les Tentations had its premier at Monte Carlo on January 3, 1924, and was presented in Paris from May to June. Following the premier, Gris wrote to Kahnweiler, "The Montéclair ballet has been a great success. The costumes are badly made but they go well in the set. I took a curtain call, and Nijinska said that she had never seen a more complete *ensemble.*" But this experience with the *Ballets Russes* had been enough for him and he continued, "What an infernal existence the theatre is! I assure you I have no desire to go through it all again . . . For the moment I am taking up painting again." (Douglas Cooper, trans. and ed., *Letters of Juan Gris 1913-1927, Collected by Daniel-Henry Kahnweiler,* London, 1956, pp. 164-165.)

It was fitting that Gris gave this drawing to the young Russian Simon Lissim (b. 1900), who was himself to have a distinguished career as a stage designer.

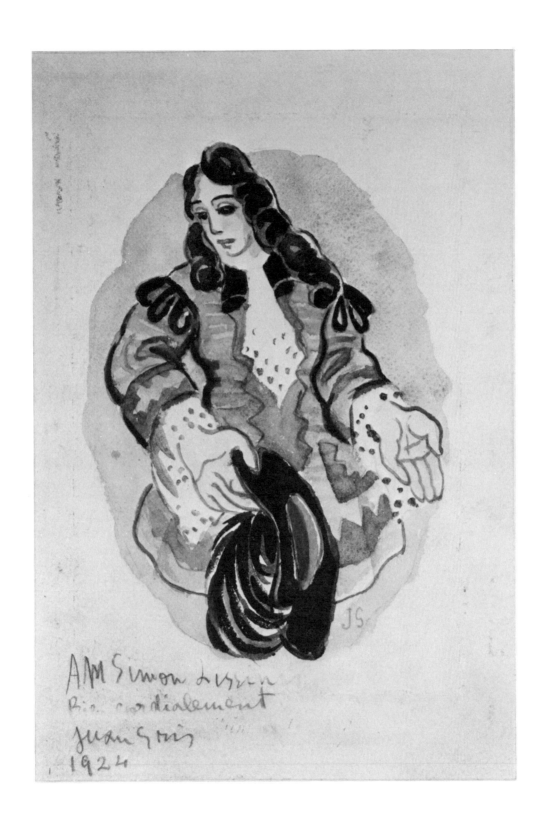

46. *Illustration for Rimbaud's Poem "Parade,"* 1948

Pen and ink, 13 x 9⅞ inches (33 x 25 cm.)

Signed in pen with the artist's initials and dated at the lower right: *F.L. 48*

Exhibition: New York University, 1962.

Provenance: Private Collection, New York.

Lent by a Private Collection, Atlanta.

In 1948, the Swiss publisher Louis Grosclaude asked Leger to design lithographic illustrations for a deluxe edition of Arthur Rimbaud's hallucinatory series of forty-two poems known as *Les Illuminations*, which had first been published in 1886. The book, published in an edition of 375 numbered copies in 1949, contained fifteen lithographs in color and black and white, including one after this design (see Lawrence Saphire, *Fernand Leger, The Complete Graphic Work*, New York, 1979, p. 84, no. 36). Leger delighted in the task of matching his own flattened, decorative forms to the images conjured up by the poems. Here, he resurrected the early Cubist practice, originated by Picasso and Braque, of integrating words in a collage-like fashion into the design. *J'ai seul la clef de cette parade sauvage* ("I alone have the key to this wild parade"), the last line of poem four, *Parade,* is one of the most potent phrases in Rimbaud's entire suite. The final section of the poem may be translated as follows:

> O the most violent Paradise of the enraged grimace! There is no comparison with your Fakirs and the other theatrical buffooneries. In costumes improvised with nightmarish taste they play laments, tragedies of brigands and demigods spiritual as history or religions have never been. Chinese, Hottentots, bohemians, ninnies, hyenas, Molochs, old madmen, evil demons, they mix popular, maternal tricks with bestial poses and endearments. They would interpret new plays and maudlin songs. Master jugglers, they transform the place and the people using magnetic comedy. Eyes blaze, blood sings, bones stretch, tears and red rivulets stream down. Their mocking or their terror lasts a minute, or months on end.

This was material particularly welcome to Leger since, as he said in his introduction to an album of circus lithographs, *Le Cirque,* of the same period, "If I have drawn circusfolk, acrobats, clowns, jugglers, it is because I have been interested in their work for the last thirty years—since the time I was designing Cubist-style costumes for the Fratinellis." His interest in these subjects had been re-stimulated by the circus and music-halls located on Broadway, which he frequented during his residence in New York in the early 1940s. In fact, the artist's same scratchy pen style and figures with similar upraised arms can be seen in a large drawing of *Acrobats and Musicians* of 1948, and the strange Chinese-style crown-headdress recurs in a pen study of an *Acrobat* of 1953 (see Jean Cassou and Jean Leymarie, *Fernand Leger*, Greenwich, 1972, figs. 289 and 291).

In this drawing there is, however, as demanded by the imagery of the poem, a greater fierceness of design. The winged figure at the top is probably the "demigod." The imperious mustachioed figure, acting like a ring-master directing the action, is probably meant to be the poet's alter-ego, declaiming the words, so boldly lettered that we read them as a shout.

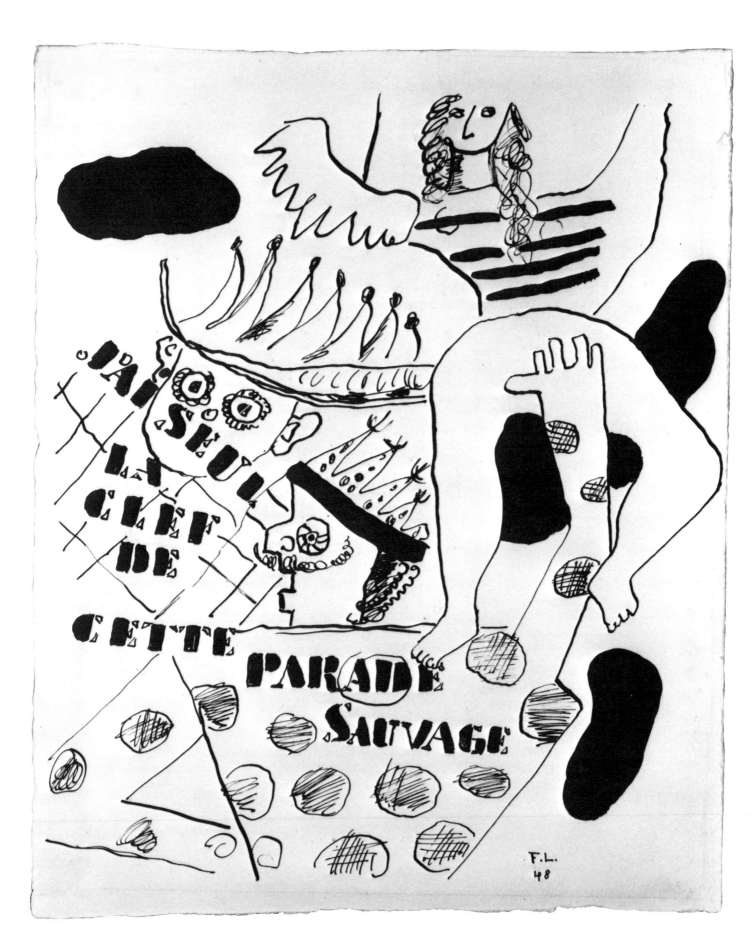

47. *Portrait of Paul Guillaume*, 1916

Pencil on paper, 15 x 10 inches (38.1 x 25.4 cm.)

Signed at the lower right: *Modigliani*

Provenance: Paul Guillaume, Paris; Armin Hansen, Carmel, California to 1974; A.M. Adler Fine Arts, New York, to 1979.

Lent by Dr. Ernest Abernathy, Atlanta.

In 1914 Modigliani was introduced to the Parisian art dealer Paul Guillaume by his friend the poet Max Jacob. Guillaume (1893-1934), who had been in the forefront of selling African art, was also to display a taste for contemporary *avant-garde* art, by exhibiting works of Picasso, Matisse, and Derain, as well as Modigliani.

Guillaume hired a studio for Modigliani in the Bateau-Lavoir, so that the artist could concentrate on painting with less interruption than he encountered at home, where he was then living with the poetess Beatrice Hastings. During the years 1915-16 when they were in close contact, and before the demanding Guillaume was replaced by Léopold Zborowski as Modigliani's dealer, the artist produced a number of portraits of him. Other drawings of Guillaume include one in the collection of Jacques Duborg, Paris (see Franco Russoli, *Modigliani, Drawings and Sketches*, New York, 1969, pl. 53); two studies of Guillaume's head reproduced in Jeanne Modigliani, *Modigliani, Man and Myth*, New York, 1958, pls. 82 and 83; and yet another in the Brillouin collection, New York (exhibited Fogg Art Museum, Cambridge, 1959, no. 12).

Guillaume was always elegant in appearance, and also, as one can detect even in the simplified forms of Modigliani's drawing, somewhat haughty. This drawing showing him with his hat on, as if he has just dropped in on his rounds to check up on his artist, is probably a preliminary study for the oil of 1916 in the Galleria d'Arte Moderna, Milan (see Ambrogio Ceroni, *Amedeo Modigliani, Peintre*, Milan, 1958, no. 62). There, unlike the similar 1915 portrait of Guillaume in the Jean Walter Collection, Paris, inscribed "Nuovo Pilota" (Ceroni, no. 55), the head, as in the drawing, is cocked inquisitively to the left, and the dealer's supercilious stare is more emphatic. This is a splendid example of Modigliani's ability to achieve through the simple format of a line drawing a total correspondence between subject and style.

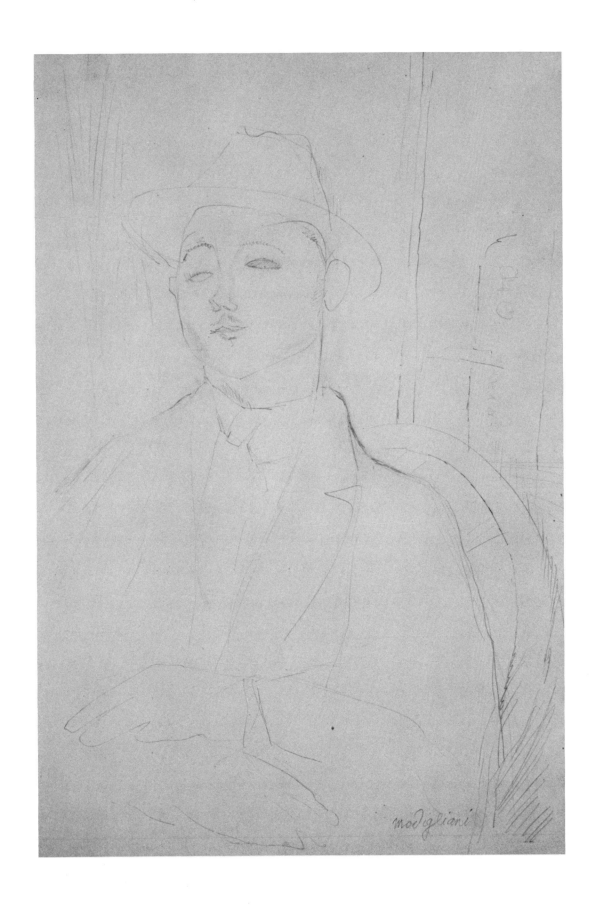

48. *Figure in a Turban*, ca. 1915-16

Blue pencil on paper, mounted on board 15¾ x 10¼ inches (40 x 27.7 cm.)

Signed at the lower right: *Modigliani*

Provenance: C.W. Kraushaar Art Galleries, New York; Ralph M. Coe to 1959; J. J. Klejman Gallery, New York; Dr. and Mrs. Robert Schermer, Shaker Heights, Ohio; Dayton Art Institute, Dayton, Ohio; Sale Sotheby Parke Bernet, New York, 1976, no. 221.

Lent by Dr. and Mrs. Michael Schlossberg, Atlanta.

The actual subject of this drawing remains uncertain. When sold most recently it was described as "*Femme au turban*," but there is certainly nothing specifically feminine about the figure. A full-length study of the same figure, also done in blue pencil but with the head bent to the left, in the collection of Mr. and Mrs. James Alsdorf, Winnetka, Illinois (see Gaston Diehl, *Modigliani*, New York, 1978, p. 20), is entitled *The Dancer Nijinsky*. A white silk turban with an ostrich feather was worn by Nijinsky as the Favorite Slave in *Le Pavillon d'Armide*, the role in which he made his sensational Paris debut in 1909 and repeated from 1910 to 1912 with the *Ballets Russes*. (See the photographs in Lincoln Kirstein, *Nijinsky Dancing*, New York 1975, pp. 72-73.) However, one should note that other features of his costume in-cluded a jewelled band worn under his chin and a ruffled shirt with a form of wired skirt, which appear in neither drawing. Stylistically, these drawings appear to belong to Modigliani's development of the years 1915-16, when Nijinsky was no longer dancing the role or even associated with the *Ballets Russes*. What is clearly a portrait of Nijinsky by Modigliani appears in an earlier drawing (reproduced in Stephen Longstreet, *The Drawings of Modigliani*, 1972), but here too there is some confusion, for while the dancer wears the turban headress of *Le Pavillon*, he also sports the open collar and necktie of *Jeux*, which he choreographed in 1913. It is possible that this mixture of costumes was witnessed at a rehearsal, or Modigliani may simply have done the work from memory, freely mixing distinctive elements of different ballets. Likewise, the drawing represented here and the one in the Alsdorf collection may be reminiscences of the great dancer, whose powerful neck and plastic features lent themselves so readily to Modigliani's style of sculptural reduction. Images of dancers occur in a number of Modigliani's drawings—for example, one sold by Knoedler and Co., New York (no. WCA 2570), as well as a *Harlequin* and a *Dancer* reproduced in Carol Mann, *Modigliani*, New York, 1980, figs. 12 and 111.

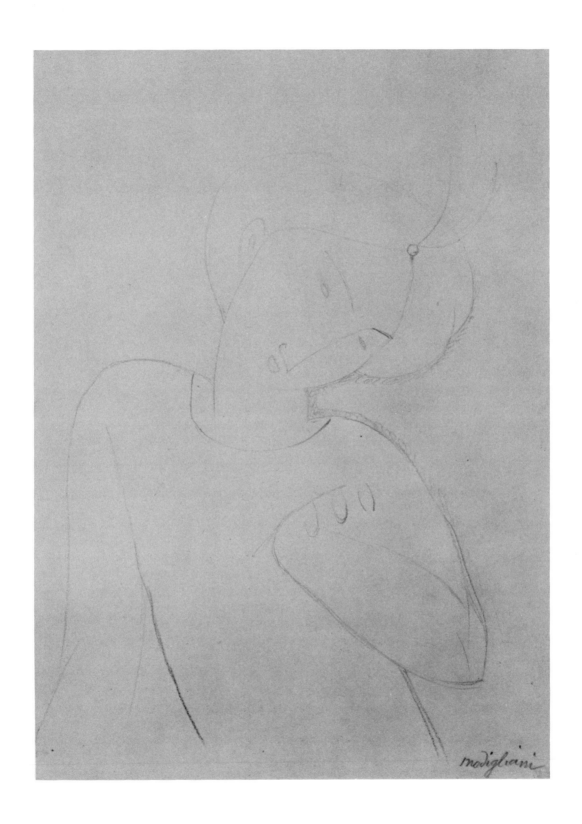

Constantin Brancusi (Rumanian, 1876-1957)

49. *Hands*

Pencil on paper, 16⅛ x 21⅛ inches (41.3 x 53.7 cm.)

Exhibitions: Gemeentemuseum, The Hague, *Brancusi,* September 19-November 19, 1970, no. 46; Guggenheim Museum, New York, *Constantin Brancusi 1876-1957: A Retrospective Exhibition,* 1969, also shown at the Philadelphia Museum of Art and the Art Institute of Chicago; The Drawing Center, New York, *Drawings by Sculptors,* April-May, 1981.

Bibliography: Sidney Geist, *Brancusi, The Sculpture and Drawings,* New York, 1975, p. 96.

Lent by a Private Collection, Atlanta.

Brancusi did not draw regularly, and his works on paper are rare. What drawings he did make seem to be finished works of art in themselves, since they usually were not preliminary drawings for sculpture. Brancusi's repetition and refinement of his limited subject matter also makes it impossible to firmly associate this study with a single sculpture. Nonetheless, Sidney Geist has suggested that this drawing may have been made of Margit Pogany with the 1913 bust in mind (Sidney Geist, *Constantin Brancusi 1876-1957; A Retrospective Exhibition,* New York, 1969, p. 137). Mademoiselle Pogany herself recalled:

> Once I had to sit for my hands but the pose was quite different to that of the present bust, he only wanted to learn them by heart as he already knew my head by heart. (Geist, p. 58).

The hand of Mademoiselle Pogany in yellow marble (Fogg Art Museum, Cambridge), with its smooth wrist and forearm, suggests a refinement of the closed gesture on the right of the drawing.

The extraordinary grace of this sheet recalls Rodin's response to the hands of Cambodian dancers, but in its precision, finesse, and quiescence this drawing is in stark opposition to Rodin's knobby sculptures of hands such as *The Cathedral,* 1908. Brancusi's search for simplicity can be seen in the differences among the three hands. Their placement on the page suggests that Brancusi turned the sheet as he drew to give himself the maximum amount of room with each succeeding attempt.

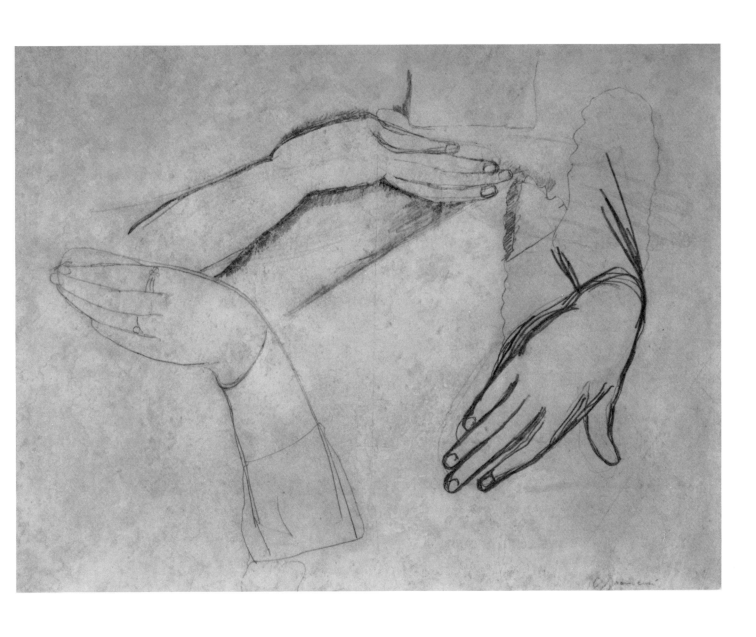

Alexander Bogomosov (Russian, 1880-1930)

50. *Composition with Woman*, 1913

Charcoal on paper, 15⅞ x 11⅞ inches
(40.3 x 30.2 cm.)

Signed at the lower right: *1913 AB*

Provenance: Luis Mestre Fine Arts, New York.

Lent by Genevieve Arnold, Atlanta.

Bogomosov was born in Kiev, and remained there for most of his life. For this reason, his work is little known, although he was a leader among Ukrainian artists and an important art theoretician in the early years of Russian modernism. In 1914 he wrote a treatise, "Painting and Its Elements," which postulated a "pure art" evolved from concepts of the Italian Futurists and the Russian Larionov. He predated Malevich by one year in proposing the black square as "the totality of signs in art." (Andrei B. Nakov, "Painting = Colored Space," *Artforum*, February, 1979, p. 58.)

In this drawing, Bogomosov is seen to practice a very personal interpretation of Futurism. A woman's back and an architectural environment are depicted schematically. Curved rhythmic vectors are centered at the back of her head, and suggest an integration of the figure into her environment. Bogomosov believed that these dynamic lines of force resulted from "the rotating motion of the light rays around a central focus situating itself at the point of juncture of different planes and the point of contact of the eye with the picture surface." (Artist's file, Museum of Modern Art, New York.) Somewhat humorously, Bogomosov shows the woman's coiffure subjected to these dynamic centrifugal forces.

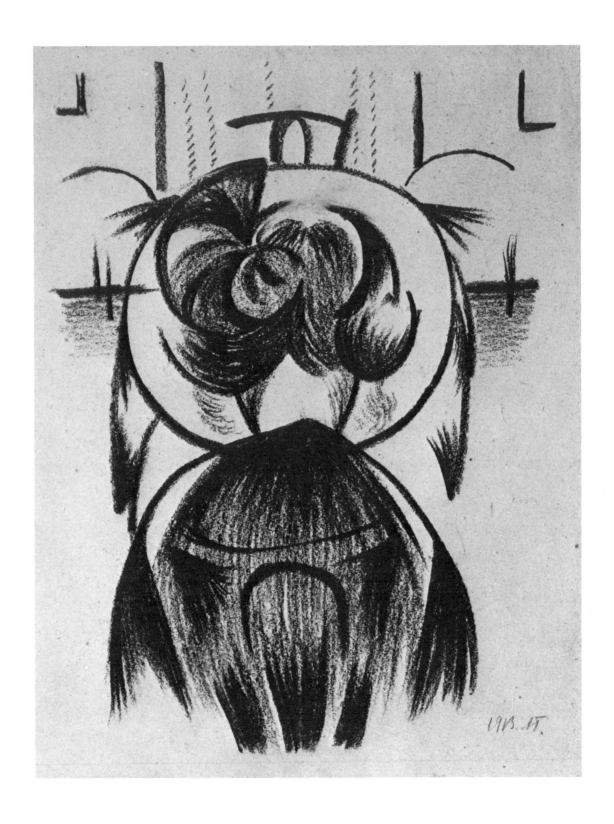

Jules Pascin (Bulgarian, worked in Paris, 1885-1930)

51. *Tante et Niece*, 1928

Pencil on paper, 22⅞ x 28¾ inches (58.1 x 73 cm.)

Stamped with the artist's estate stamps (Lugt 2014a and 2014b): *Pascin, ATELIER Pascin*

Inscribed: *L.K.* (Lucy Krohg)

Exhibition: A. M. Adler Fine Arts, New York, *Drawings by Jules Pascin,* December 9, 1978-January 20, 1979, no. 44.

Provenance: Estate of the artist; Lucy Krohg; Guy Krohg; A. M. Adler Fine Arts.

Lent by Harriet and Jerome Zimmerman, Atlanta.

Pascin was temperamentally more inclined toward drawing than painting. He drew incessantly, and was attracted to the possibility of making a very rapid, yet definitive statement without the protracted concentration demanded by a complex composition in oils. He was particularly intrigued by the challenge of unusual poses and unconventional combinations of two or three models. In the last years of his life, fully-realized model studies were his main preoccupation. Pascin's remarkable sensitivity of touch and placement is apparent in this large sheet. The spatial environment is molded around the figures; the couch is only summarily sketched in.

The "aunt" and "niece"—identifications providing the thinnest veil of respectability to the relationship between the two women—are contrasted in pose as well as in delineation of their features. The "aunt" sits with legs outstretched, gazing toward the viewer openly, while the "niece" curls up, absorbed in play with what seems to be a kitten in her arms. Pascin's interests and attention are apparent in following the outlines of the figures: heavy reinforcing emphasizes sinewy strength in the "aunt," while a soft and hesitant marking imparts a more tender character to the "niece." The nervous fluidity of Pascin's line lends vitality to both. Pascin's usual combination of cynicism towards, and erotic interest in, his child-women subjects seems somewhat abated here: the charms of his models elicited an elegant and sympathetic response.

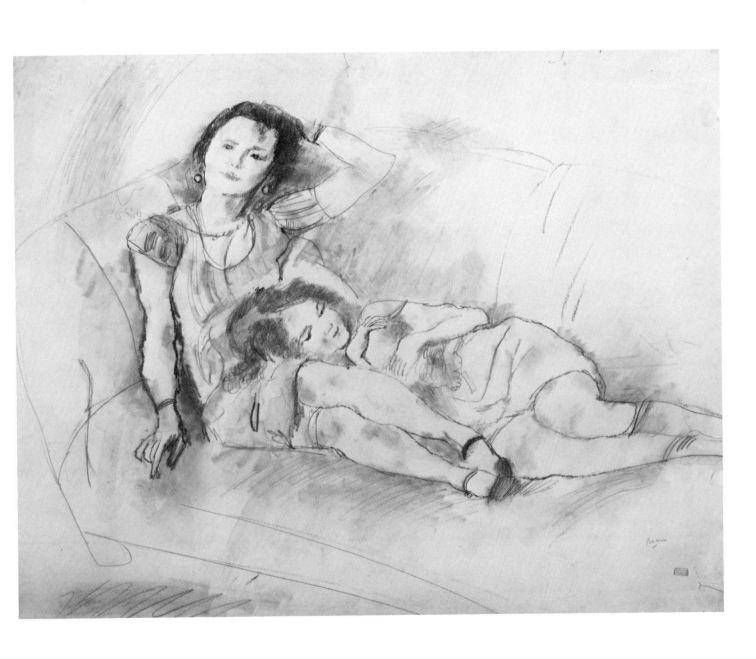

Paula Modersohn-Becker (German, 1876-1907)

52. *Fruit Tree in Bloom,* ca. 1902-1904

Charcoal on blue paper, 10¼ x 12¼ inches
(26 x 31.1 cm.)

Signed at the lower right with initials, above illegible inscription.

Provenance: Sale Parke Bernet, New York, September 18, 1968, no. 5; Private Collection, New York.

Lent by a Private Collection, Atlanta.

Although best known as a precursor of German Expressionism, Paula Modersohn-Becker has been critically reappraised in recent years because of the directness and honesty of her vision, particularly in the treatment of feminine subjects. Linda Nochlin has noted the apparent "sense of the creative self as a woman" (Ann Sutherland Harris and Linda Nochlin, *Women Artists 1550-1950,* New York, 1976, p. 59), which is especially striking in Modersohn-Becker's penetrating self-portraits.

The artist described her own art as a move towards "great simplicity of form." Her artistic sensibility was shaped by her participation in the Worpswede artists' colony near Bremen, Germany, which she joined in 1897. The leaders of the Worpswede Colony—Fritz Mackensen (1866-1953), Heinrich Vogeler (1872-1942), and Otto Modersohn (1865-1943), the artist's husband—sought a rebirth of German art in a landscape painting of mood. The basis of this new art was to be found in painstaking study of nature and the country peasantry, and in an unidealized acceptance of the appearance of the land. Reflecting the doctrines of the colony, Modersohn-Becker noted in her diary on 25 February 1903 her determination to seek out nature's remarkable forms through drawing: "I have a feeling for the interlacing and layerings of objects. I must develop and refine this carefully." (Gillian Perry, *Paula Modersohn-Becker: Her Life and Work,* New York, 1979, p. 114.)

This study bears witness to that ambition, and has the convincing look of authentic observation. However, the concentration on curved shapes suggests the influence of fellow colonist Heinrich Vogeler's lyrical *Jugendstil,* as well as the decorative patterning of the Nabis, whose art Modersohn-Becker had seen on trips to Paris. Unlike those artists, however, Modersohn-Becker's intensity of focus transcends the merely ornamental. The branches are seemingly weighted down by the burgeoning flowers, and the profusion of growth from the tree's short trunk dramatizes the eternal renewal of plant life in the Spring.

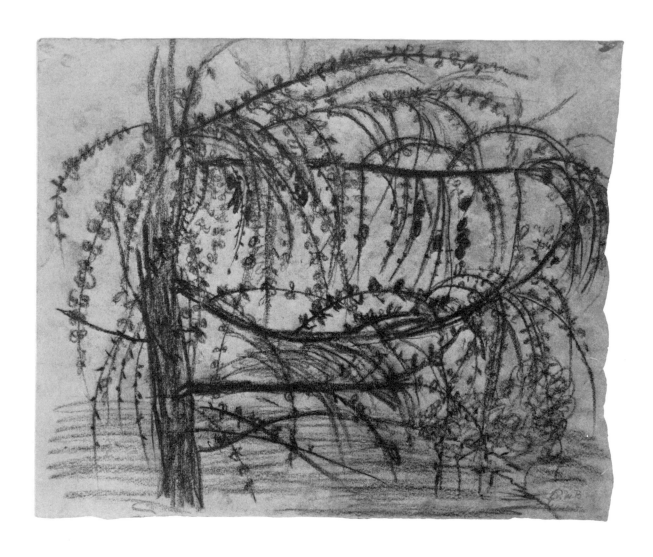

109

53. *Studies of a Horse's Head,* recto and verso, 1907

Charcoal on paper, 9^{1}/$_{16}$ x 6½ inches (23 x 16.5 cm.)

Bibliography: Klaus Lankheit, *Franz Marc: Tierstudien,* Wiesbaden, 1953, plate 5.

Provenance: Frau Maria Marc; Private Collection, New York.

Lent by a Private Collection, Atlanta.

Early in his career Marc found animal subjects more spiritually appealing than humans. His highest aim was to suggest a vision of animal life which was not anthropocentric:

> Is there a more mysterious idea for an artist than to imagine how nature is reflected in the eyes of an animal? How does a horse see the world, how does an eagle, a doe, a dog? It is a poverty-stricken convention to place animals into landscapes as seen by men; instead we should contemplate the soul of the animal to divine its way of sight. (Franz Marc, "How Does a Horse See the World?", translated by Ernest Mundt and Peter Selz, in Herschel B. Chipp, *Theories of Modern Art,* Berkeley, 1971, p. 178.)

In this early sketch, Marc's powers of sympathy for animal life are strongly evident, as is the artist's ability to seize on rhythmic and decorative features of his subject. On the *recto,* Marc uses the turning of the horse's head not only as an occasion for a study from nature, but also as a motivating force for a unifying circular sweep of movement. The strength of the horse is emphasized in the accentuation of its neck, breast, and shoulder, just as its intelligence is stressed by the fullness of forms of its head. On the *verso,* the bending of the horse's neck to the ground provides a motif of great dynamism, as the rest of the horse's body is omitted.

111

54. *Woman Seated at a Table*, ca. 1906

Pencil on paper, 9⅝ x 13¼ inches (24.4 x 33.6 cm.)

Signed at the lower right: *E.L. Kirchner,* and stamped on the *verso* with the artist's estate stamp.

Exhibition: Carus Gallery,New York, *Expressionists,* n.d., no. 33.

Lent by The Georgia Museum of Art, University of Georgia, Athens. Gift of Alfred H. Holbrook, 1968.

Kirchner's drawings are a major contribution to the history of draughtsmanship in the twentieth century, and have never been fully accorded the attention they deserve. The artist himself declared his drawings to be his purest and most beautiful work. He drew incessantly, with complete disregard for the finish or "look" a work of art is supposed to have. He believed that very rapid execution would yield the most direct and expressive results without the interference of refinement or intellection. Kirchner postulated that all drawing is an abstraction derived from personal fantasy, but that the real world guides the fantasy. (E. L. Kirchner, "Drawings by E. L. Kirchner," in Victor H. Meisel, *Voices of German Expressionism,* Englewood Cliffs, 1970, p. 23.)

The notion of this tangential relationship between the drawing and its visual source is reflected here in Kirchner's obvious disregard for accuracy of physical detail or proportions, and his frequent use of shorthand notations for features of the seated woman. The woman's neck is asymmetrically placed on her shoulders, her hands are claw-like and her left forearm is abnormally extended. Instead of striving for realism, Kirchner has concentrated on an even distribution of markings and divisions across the page. The two glasses on the table and the rectangles behind the woman's head define the lateral limits of interest. The horizontal structure of the composition is emphasized by her extended right shoulder and left arm. The crab-like right hand is a definite visual caesura, and a compelling, if discomforting, psychological note.

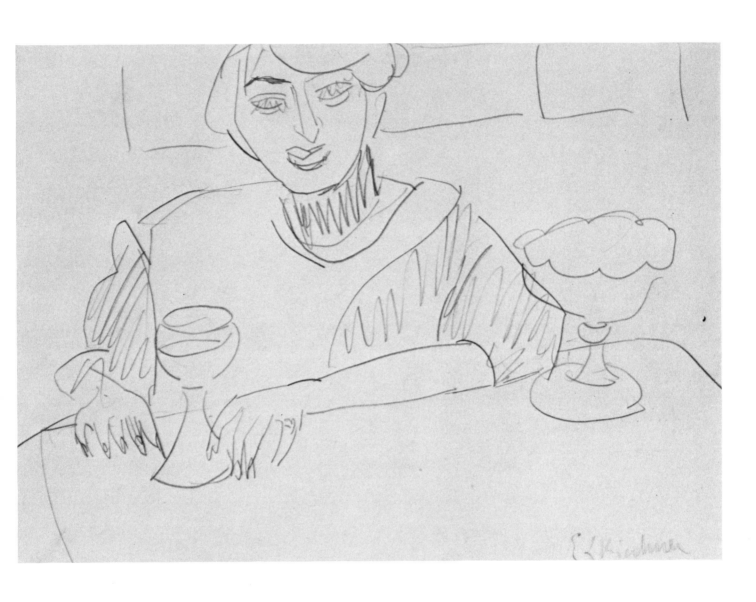

113

55. *The Buoys,* 1928

Ink and watercolor on paper, 10⅞ x 13¼ inches
(27.6 x 33.6 cm.)

Signed at the lower edge: *Feininger Bouys 26 xi 28*

Provenance: Lyonel Feininger; Ben-Zion; Krauschaar Gallery, New York; Peter Deitsch Fine Arts, New York; Mrs. Rose Wardlaw, New York.

Lent by Debi L. Irving and Rose Wardlaw, Atlanta and New York.

Feininger had a great love of the seashore, and beach and ship motifs form a large part of his *oeuvre*. From 1924 to 1935 he summered at Deep, a resort on the Baltic Sea. Feininger's usual working procedure was to sketch from nature in pencil, then later to make a finished charcoal-and-ink drawing from his first sketches. Watercolors typically came as a third stage, although reference was made again to the initial sketch as source material. The time between successive stages could be several months or even years.

This watercolor, based on a summer sketch, was executed in late November of 1928, when Feininger was artist-in-residence at the Bauhaus in Dessau. The compositional structure was first set down in ink, allowing Feininger to concentrate on his sonorous color harmonies. The artist wetted his paper in order that the blurry areas of color would float loosely on the sheet. Warm and cool colors are juxtaposed: yellow against black, rose against aquamarine and blue. The artist referred to his watercolors as "solutions of volumes of light" (Thomas B. Hess, "Feininger Paints a Picture," in June L. Ness, ed., *Lyonel Feininger*, New York, 1974, p. 245), and the subtle, glowing hues in this work bear witness to his aim. The eccentric and humorous outlines of the buoys recall Feininger's early career as a cartoonist.

Feininger Bouys 96 XI 23

Vasily Kandinsky (Russian, worked in Germany and France, 1866-1944)

56. *The Flying Dragon*, 1938

Ink on paper, 11½ x 9 inches (29.2 x 22.9 cm.)

Signed at the lower left with monogram: *VK 38*

Provenance: Madame Nina Kandinsky, Paris, 1938-1961; Galerie Karl Flinker, Paris, 1961-1963; Galerie Dresdener, Montreal, 1963; Sale Parke Bernet, New York, February 11, 1965, no. 56; Private Collection, New York.

Lent by a Private Collection, Atlanta.

Late in his career, Kandinsky adopted the biomorphic vocabulary of undulant forms which characterizes the work of Arp and Miró. The amoeba-shaped configuration which dominates this work is typical of a fanciful quality in many of his creations executed during the Paris period (1933-1944). Despite its playful quality, this is abstraction of the highest sophistication: whiplash curves which recall Kandinsky's origins in *Jugendstil* are played against a geometric language of circles, rectangles, and grids seen often in Kandinsky's production during his Bauhaus years (1922-1933). These conflicting elements are synthesized through Kandinsky's consummate skill in solving problems of compositional balance. Using a multiplicity of separate motifs, Kandinsky stretches the pictorial tensions nearly to a point of chaotic dissolution, yet finally brings these diverse sensations to an exact harmony. Illusions of overlapping and transparency, and interchanges of direction, light, shape, and focal depth, are among the other means used to attain unification.

The tower shapes at the left of the basic plane represent a walled city motif that recurs in Kandinsky's art. The image is associated with the artist's memories of Russia.

57. *Mary Merson*, 1931

Red chalk on paper, 17¾ x 12¼ inches (44.5 x 31 cm.)

Signed at the lower right: *O. Kokoschka*

Bibliography: Paul Westheim, *Kokoschka Drawings*, London, 1962, pl. 126, no. 126.

Provenance: Paul Cassirer & Co., Amsterdam; Private Collection, New York.

Lent by a Private Collection, Atlanta.

This drawing is one of approximately 20 studies of a Russian woman Kokoschka made in 1931 (Edith Hoffman, *Kokoschka, Life and Work,* London, 1947, p. 330). Other drawings in the series are in the Feilchenfeldt Collection in Zurich, the Lütjens Collection in Amsterdam, and at the Art Institute of Chicago. All are in red chalk. As a group, they display a remarkable variety of moods and attitudes, from bovine placidity to open eroticism. Here one is impressed by the sitter's quiet strength in reserve; her demure classical profile and tender gesture of holding drapery to her breasts is contrasted with her broad back and the rawness of her accented neck, backbone, shoulder, arm, and ribs. In opposition to the relaxation of the pose is the febrile energy and sense of urgency which always characterizes Kokoschka's draughtsmanship. Broad zigzag shading, hard stabbing lines defining the body's contours, and dark abstract calligraphy in the areas of her hair and the drapery serve more to convey the vitality of the model than to describe her physical forms.

Nonetheless, Kokoschka's expressionism is characterized by a selective realism. The artist believed that his inner visualization of the subject focused and honed his perception of the reality before him. As a draughtsman, Kokoschka compared himself to a surgeon, "who must find within himself the assurance to control what he is bent on undertaking." (Ernest Rathenau, ed., *Oskar Kokoschka Drawings, 1906-1965,* Coral Gables, p. 13.)

58. *The Blessings of Labor*, 1928

Watercolor on paper, 17¼ x 12¾ inches (43.8 x 32.4 cm.)

Signed at the lower right corner: *Grosz/1928/Berlin*

Verso: *45 USO*

Bibliography: George Grosz, *Das neue Gesicht der herrschenden Klasse,* Malik Verlag, Berlin, 1930, plate 4, reprinted by Frederick Basserman Verlag, Stuttgart, 1966; VEB Verlag der Kunst, Dresden, 1969, and Makol Verlag, Frankfurt am Main, 1973 (with *Der Spiesser-Spiegel).*

Exhibitions: Nashville, Tennessee, *A Century of American Painting,* Selected by Lamar Dodd from the Alfred H. Holbrook Collection of the University of Georgia, November 1-November 23, 1950; Washington and Lee University, Lexington, Virginia, *Paintings from the Georgia Museum of Art of the University of Georgia,* April-June, 1960; Mobile and other locations, *A University Collects: The Georgia Museum of Art,* September 7, 1969-October 11, 1970, no. 16; Charles H. MacNider Museum, Mason City, Iowa, June 29-August 13, 1972 and Canton Art Institute, Canton, Ohio, *Selections from the Georgia Museum of Art,* August 19-September 24, 1972.

Provenance: Associated American Artists, New York.

Lent by the Georgia Museum of Art, the University of Georgia, Athens. Gift of Alfred H. Holbrook. Eva Underhill Holbrook Memorial Collection of American Art, 1945.

This composition was one of sixty line drawings by Grosz published in 1930 in *Das neue Gesicht der herrschenden Klasse* (The New View of the Ruling Class). This is probably the original drawing elaborated with watercolor.

The device of a table seen from above with people seated around it is one of Grosz's characteristic formats. The paraphernalia of the nightclub table is thus brought into full view, emphasizing the materialism and over-indulgence of Grosz's subjects by the focus on the cocktail glasses, cigars, cigarette case, purse, and bottles in the ice cooler. Grosz also lavishes attention on the clothing of his porcine sitters: their bestiality is underlined by their pelt-like or bristly garments.

Grosz's art was motivated by his hatred of the smug bourgeoisie, and his revolutionary fervor for social justice. His acerbic wit was expressed more in bitter scorn than in simple ridicule. The artist's venom is not brought to full force here, however; Grosz seems to have become absorbed in illustrational details, such as the strapping girth of the man on the right, the Prussian haircuts of the two men on the left, or the vanity of the woman at the left who gazes into a compact mirror. Grosz's earlier drawings tended to be somewhat less detailed and considerably more acid in their depiction of humanity.

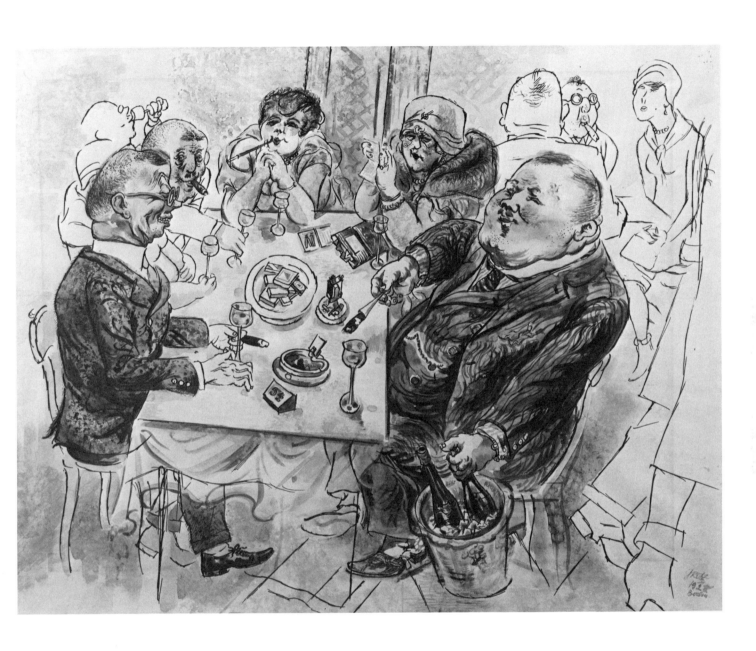

59. *City Lights*, 1924

Ink and watercolor on paper, 23⅞ x 20⅞ inches
(60.7 x 53 cm.)

Signed at the lower right: *FM 1924*

Provenance: George Poole, 1973; A. M. Adler Fine
Arts, New York.

Lent by Harriet and Jerome Zimmerman, Atlanta.

Frans Masereel is best known for his wood-
cuts, which often capture the Expressionist
tone of Fritz Lang's film *Metropolis*. The
tempo of modern urban life was Masereel's
primary artistic preoccupation. Crowds,
corruption, the downtrodden and the heroic
optimism of the working class were his fa-
vorite themes. A pacifist and a romantic
socialist, he remained an idealist through-
out his life.

This watercolor reveals the influence of
Masereel's close friend, George Grosz.
Grosz visited Masereel in the Spring of 1924
and found him to be the artist in Paris with
whom he was most in sympathy. Grosz de-
clared his admiration for Masereel: "He
distinguishes himself from other painters in
Paris by not painting guitars." (Hans Hess,
George Grosz, New York, 1974, p. 127.) To
Grosz, the guitar, prototypical subject of
Cubism, meant "art for art's sake."

In this large sheet, prosperous capitalists
converse in the foreground at an outdoor
cafe. Prostitutes mingle with the crowd,
hoping for customers. The Place Pigalle at-
mosphere is continued by the glare of
streetlights which cast the scene into lurid
hues of purple, rose, green, and yellow. The
palette is comparable to Grosz's, and
Masereel uses Grosz's device of depicting
clothed women as if their garments were
transparent. In contradistinction to Grosz,
however, one senses in Masereel's work that
even in corruption man is redeemable. The
venal enjoyments of city life are stressed
more than the purported decadence of the
capitalist system.

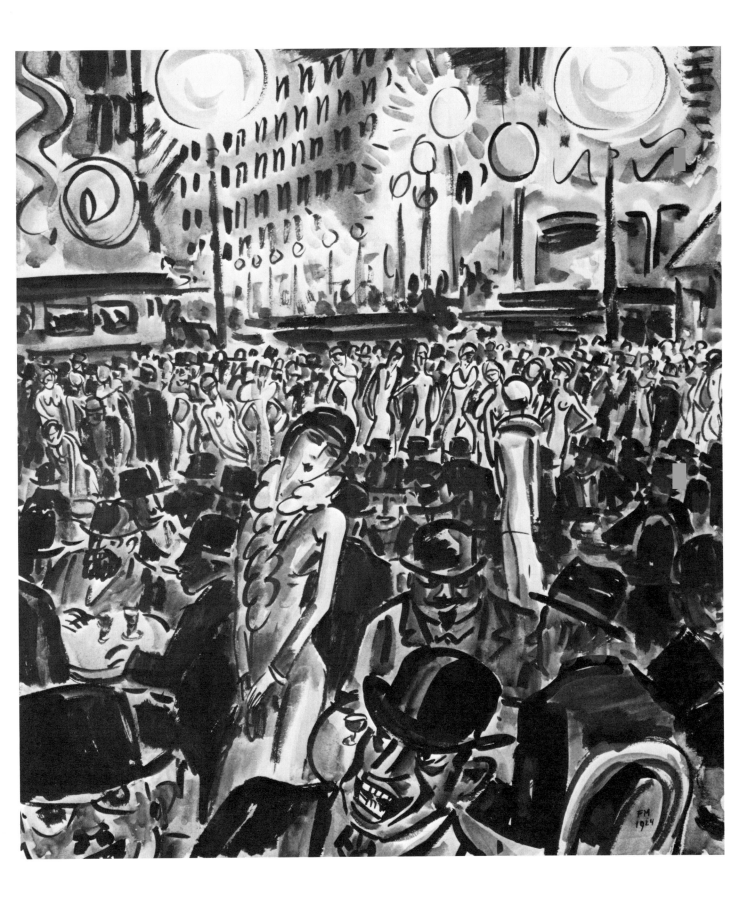

60. *Study of Dr. Helmut Lütjens*, 1944

Charcoal on paper, 10⅞ x 8⅝ inches (27.5 x 21.8 cm.)

Dated and signed with initial at the lower left: *24.11.44 b*

Bibliography: Erhard and Barbara Gopel, *Max Beckmann. Katalog der Gemälde*, Bern, v. I, 1976, p. 410.

Provenance: Dr. Helmut Lütjens, Amsterdam; Private Collection, New York.

Lent by a Private Collection, Atlanta.

Dr. Helmut Lütjens was trained as an art historian under Max J. Friedländer, and wrote his doctoral dissertation on the circle of Rembrandt. As director of the Paul Cassirer Art Gallery in Amsterdam, he was able to be of material assistance to Beckmann during World War II, buying pictures from him when it was dangerous to do so, hiding Beckmann's paintings in his own house, and even offering Beckmann the hospitality of his home for a week in September, 1944, during the Battle of Arnheim. Shortly after that stay, Beckmann proposed to do a family portrait of Lütjens, his wife Nelly, and their daughter Annemarie. This drawing is a study for that portrait.

Beckmann blocked in the essential features of his sitter with hard angular contours and sharp, precise accents. Hatching is not used as shading, but to suggest flesh tones. Beckmann's respect for his sitter is suggested in the broad forehead, discerning gaze, thin aquiline nose, and firmly set jaw. Lütjens was fifty-one at the time of the drawing, nine years younger than the artist.

On the day this drawing was made (November 24, 1944), Beckmann noted in his diary, "Drew at Lütjens', always very relaxed." The ease and apparent rapidity of this sketch may have been conditioned by the artist's friendship with his subject. There is also a sense of strain in Lütjens's rather acerbic features. At the time the portrait was made, the art dealer's family was huddled in the kitchen of their home, where a small oven provided the only heat, and kerosene lanterns the only reliable source of light. Lütjens has written of the finished portrait:

> The milieu of that time remains remarkably strong in the picture, a certain coldness and harshness, the flickering light, and yet an accord in coziness, life reduced to the simplest. (Gopel, p. 410.)

Seven other drawings of Lütjens were made in preparation for the painting.

61. *Three Personages*, 1935

Pen and ink on paper, 11½ x 8 inches (29.2 x 20.3 cm.)

Signed and inscribed: *pour le Societé manes, en hommage de leur bel effort et en souvenir de cette agréable soirée, Miró Prague 28/III/35*

Provenance: Manes Society, Prague; Galerie Motte, Paris; Perls Galleries, New York.

Lent by Lenore and Burton Gold, Atlanta.

In this quick sketch, line seems to be propelled without conscious volition. Limbs and torsos of the three figures flow together in one continuous motion which also binds them to the horizon and the heavens. Contours are partially detached from description and allowed to perform their own arabesques. Yet within this open and bemused spectacle, one is permitted to learn a great deal about the subjects: that one, of indeterminate sex, has hairy legs; that the second, a female, has hair on the wrist of her left hand, and on the left side of her head; that the third may or may not have hair on its left arm and neck. Without question, Miró creates a delightful and engaging fantasy in this drawing with remarkable simplicity and economy. The detachable anatomy of the central figure suggests Picasso's fantastic bathers of the Dinard period.

Towards 1935, as the tensions leading to the Spanish Civil War mounted, grotesque monsters appeared more frequently in Miró's paintings and drawings. In this example, the monsters have a decidedly friendly quality, and seem to comprise the kind of family group seen in other drawings and watercolors of the period. (See Jacques Dupin, *Miró: Life and Work*, New York, 1962, fig. 60.)

The Manes Society in Prague, to which this drawing is dedicated, sponsored exhibitions and promoted an awareness of contemporary issues in the arts. The exact occasion for Miró's trip to Prague remains unknown. The Manes Society was dissolved in 1947.

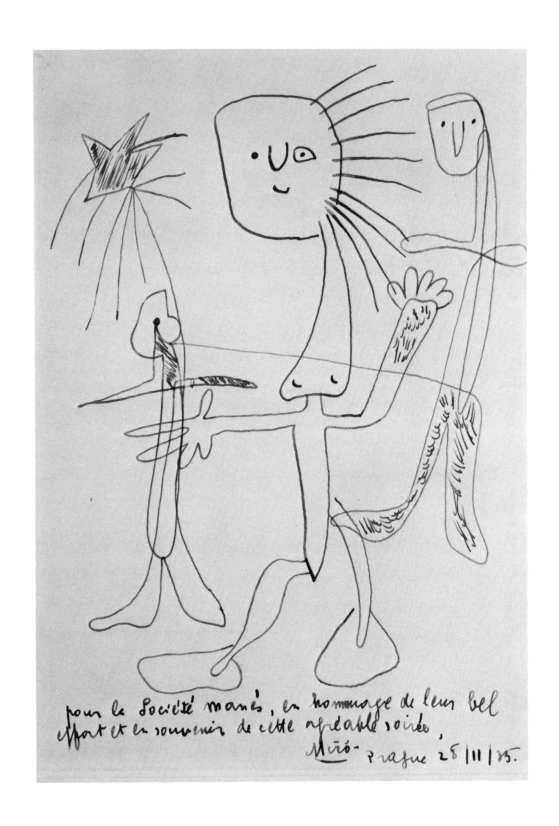

pour la Société manès, en hommage de leur bel
effort et en souvenir de cette agréable soirée,
Miró - Prague 28/11/35.

62. *City of the Skull*, 1940

Watercolor on paper, 19 x 25 inches (48.3 x 63.5 cm.)

Signed at the lower right: *André Masson 1940*

Bibliography: William Rubin and Carolyn Lanchner, *André Masson*, New York, 1976, p. 148.

Exhibitions: Museum of Modern Art, *André Masson and 20th Century Painting*, New York, 1976; Centre National d'Art et de Culture Georges Pompidou, *Exposition André Masson*, Paris, March 5-May 2, 1977, no. 77.

Provenance: The Blue Moon Gallery, New York; Lerner-Heller Gallery, New York.

Lent by Mr. and Mrs. Elliott Goldstein.

The labyrinth and the myth of the Minotaur has been a recurring theme for Masson. Here a labyrinth appears in the guise of a skull, which also suggests a Tower of Babel. The labyrinthine skull is conceived in architectural terms, with arches, buttresses, brick walls, steps, pipes and masonry blocks. Masson painted the head in delicate watercolor tints, matching the precision with which he constructed its impossible architecture.

As Whitney Chadwick has observed:
On an emblematic level, the image of the labyrinth became for the painter an essential cosmic symbol communicating through its cyclical structure the principles of unity within diversity order within apparent chaos. Derived initially from the geometric mazes placed in the naves of certain Gothic cathedrals, Masson found further philosophical support for his formal structure in Chinese ideograms, particularly that of the yin-yang. (Whitney Chadwick, *Myth in Surrealist Painting*, 1929-1939, Ann Arbor, 1980, p. 43).

In this drawing the labyrinth also stands for the inner recesses of the subconscious mind. This is one of several comparable skull drawings of 1939 and 1940, all of which are very convoluted in their structure. In these works, Masson re-interprets his free automatist drawings of the 1920s on a more concrete, illusionistic plane.

63. *La Condition Humaine*, ca. 1948

Pencil on paper, 12½ x 9⅛ inches (31.8 x 23.2 cm.)

Signed in pencil at the lower right corner: *Magritte*

Provenance: The Amel Gallery, Inc., New York; Bodley Gallery, New York; Mrs. Raymond J. Braun, New York.

Private Collection, on extended loan to the High Museum and Emory University.

The theme of a landscape painting set upon an easel placed within that very landscape immediately raises the question of reality and illusion so vital in Magritte's *oeuvre*. The image made its earliest appearance in a 1931 painting, *La belle Captive* (exhibition catalogue, *Retrospective Magritte*, Brussels and Paris, 1978-79, no. 104). In 1933-34, the ambiguity of the idea was elaborated by showing the painting within the painting placed in front of a window. Of this painting, *La Condition Humaine*, Magritte has written:

> In front of a window seen from inside a room, I placed a painting representing exactly that portion of the landscape covered by the painting. Thus, the tree in the picture hid the tree behind it, outside the room. For the spectator, it was both inside the room within the painting and outside in the real landscape. This is how we see the world. We see it outside ourselves, and at the same time we only have a representation of it in ourselves. In the same way, we sometimes situate in the past that which is happening in the present. Time and space thus lose the vulgar meaning that only daily experience takes into account. (Quoted in Harry

Torczyner, *Magritte, Ideas and Images*, New York, 1977, p. 156, fig. 315.)

In 1935 a second version of *La Condition Humaine* transformed the subject of the painting from a landscape to a seascape and placed a single cannon ball near the foot of the easel (James Thrall Soby, *René Magritte*, exhibition catalogue, Museum of Modern Art, New York, 1965, p. 14). In 1947, another version of *La belle Captive* took the easel out of the interior and actually placed it on a beach, this time accompanied by a large rock and a flaming tuba (Suzi Gablik, *Magritte*, 1970, fig. 69).

In many later works, this theme of the painting upon the easel was to undergo further metamorphoses. This drawing, however, seems most closely related to a color gouache of 1948, also called *La Condition Humaine*, in which the easel on the beach is surrounded by clusters of bells (René Passeron, *René Magritte*, Paris, 1972, p. 18). These bells first appeared in Magritte's work in 1928, most notably in his painting *Les fleurs de l'abime* where they are shown as strange flower blossoms (Torczyner, p. 94, fig. 138). It was in this way of combining diffuse motifs that Magritte allowed free reign to his imagination.

This highly finished drawing shows an exquisite technique, which the artist often went to great lengths to obscure in his paintings. Here we can admire his ability at capturing textures as diverse as the wood grain of the easel and the storm clouds in the sky. So precise is the rendering of the whole scene that at first glance one actually accepts it as a true transcription of the real and then only gradually becomes aware that it is indeed surreal.

64. *Woman with Detachable Skull*, 1933

Pen, ink, pencil on paper, 21⅜ x 16⅞ inches (54.3 x 42.9 cm.)

Signed at the lower right: *S. Dali 1933*

Provenance: Alexander Jolas Gallery, New York; Mrs. Raymond Braun, New York.

Private Collection, on extended loan to the High Museum and Emory University.

In a pose reminiscent of a traditional *Vanitas* subject—a woman or an allegorical figure of the vice *Superbia* gazing in a mirror—a tightly-corseted faceless woman here looks at an anamorphic skull. She stands on a beach in which outcroppings of rock and two figures are seen in the far distance. This very finished drawing was undoubtedly conceived as a complete work of art in itself, but thematically it is related to Dali's painting, *The Spectre of Sex Appeal*, also executed in 1933. In that painting, bones and portions of female anatomy are shown detached and propped up on crutches. In a 1934 essay inspired by Mae West, Dali explained his idea of "spectral sex appeal" in which women would detach parts of their bodies in order to satisfy their profound exhibitionism, and to admire themselves more analytically. He also called for "aerodynamic costumes," and "corsets of all sorts," as well as "new and uncomfortable artificial anatomical parts." (Salvador Dali, "Les Nouvelles Couleurs de Sex Appeal Spectral," *Minotaure* 5, 1934, p. 22). This drawing is probably an early attempt to illustrate some of these ideas. It may be significant that Dali also records in his biography a dream in which he envisioned the skull of his wife, Gala, detached from her head. Total dissection, proclaimed the artist, has no eroticizable meaning: "my method is to conceal and to reveal, delicately to suggest . . . " (*The Secret Life of Salvador Dali*, New York, 1942, pp. 247.)

The deep vista and hard unnatural shadows bear witness to de Chirico's influence, but the woman's attenuated proportions, prominent single breast, and macabre appearance are solely products of Dali's surreal imagination.

65. Le Beau Temps (Fair Weather), 1940

Pen, ink, and watercolor on paper, 10 x 14 inches (25.4 x 35.6 cm.)

Inscribed at the lower right: *Le Beau Temps Man Ray 1940*

Provenance: The Artist; Timothy Baum, New York.

Lent by Mr. and Mrs. Simon S. Selig, Jr., Atlanta.

In 1940 Man Ray fled the Nazi occupation of France, eventually making his way to Hollywood, California, where he remained for the duration of the war years. Starting from photographs he had brought with him, he executed a series of pictures as variations on works he had left behind. The last important large painting he had done in France had the ironic title *Le Beau Temps,* a work full of sinister and disturbing undertones. Man Ray described it as follows:

> a composition of several dreams, done in brilliant colors and using all techniques, from Impressionist to Cubist and Surrealist. Now and then I'd drive out to my new little house in St. Germain-en-Laye, where workmen were making some changes, and stay a couple of days. One night I heard distant guns, and when I fell asleep again, dreamed that two mythological beasts were at each other's throats on my roof. I made a sketch of this and incorporated it in the dream painting, which I called: *Le Beau Temps (Fair Weather).* (Man Ray, *Self-Portrait,* Boston, 1963, pp. 297-298.)

The French painting and this drawing have few motifs in common. The sense of impending violence is greater in the painting, but a disquieting mood of anxiety pervades the small watercolor executed in Hollywood. The roof of Man Ray's modern studio home, which figured prominently in the painting, is transformed into a suspended classical pediment, perhaps reflecting the artist's observation regarding Hollywood architecture that "its distinction was its anachronisms." (*Self-Portrait,* p. 328.) The pediment hovers threateningly over a woman turning with fateful gestures, and the pillar which would normally hold it up lies broken on the ground. On the opposite side of the page, the simple geometrical solids which were combined to construct a male and a female figure in the French painting lie scattered. Behind them is a disjointed tree, and scrolls of paper float above. Dominating the entire composition is a setting sun grasped by a divine hand. In comparing the two works with the same title, it is apparent that both are meditations on the fate of civilization in the face of war, each conditioned by the circumstances in which it was created.

Further possible clues to the watercolor's meaning were given by Man Ray in 1971, when he said that the watercolor was a study for a painting he never executed, to be entitled *L'Aventure* (information given to Timothy Baum by Man Ray, March 1971.) The adventure of the title might well be the adventure of Man Ray's escape westward to California, symbolized by the setting sun.

66. *Studies for Sculpture*, 1933

Pen, ink, ink wash, chalk, gouache, and collage on paper, 11½ x 15¼ inches (29.2 x 38.7 cm.)

Exhibitions: Galerie Beyeler, Basel, *Henry Moore– Drawings and Sculptures,* May-July, 1970, no. 28; Waddington Galleries, London; Waddington and Tooth Galleries, London.

Provenance: Galerie Beyeler, Basel; Waddington Galleries, London; Mrs. Jowell, London; Waddington and Tooth Galleries, London, 1978.

Lent by Mr. and Mrs. Simon S. Selig, Jr., Atlanta.

Although Henry Moore is thought of chiefly as a sculptor, his abundant powers of invention have spilled over into many works on paper. In this collage of 1933, five cut-out figures of reclining women are disposed across the page. Each is shown laterally, isolated and solitary, in an elusive middle ground between representations of sculptures and of animate human beings. It was in the early 1930s that Moore began the progressive deformations that led him away from reliance on the figure to a freer invention of form. The sculptor experiments here not only with different poses for his reclining women, but also with styles of draughtsmanship and the possibilities of abstraction. As might be expected of a sculptor, all of the drawn figures are fully modeled in three dimensions. Moore has remarked:

> My drawings are done mainly as a help toward making sculpture—as a means of generating ideas for sculpture, tapping oneself for the initial idea; and as a way of sorting out ideas and developing them. (Quoted in A. G. Wilkinson, *The Drawings of Henry Moore,* London, 1977, p. 21.)

There are several montages of this kind dating from the early 1930s. Moore was assisted in their fabrication by his wife Irina, who cut out and assembled small studies from Moore's sketchbooks. One which is directly comparable is in the collection of the National Gallery of Victoria, Melbourne, Australia. A figure in the Melbourne collage is a variant of the figure sitting on steps in the lower right of this work. After 1938, these steps and blocks would expand into austere architectural settings. It is typical of Moore's working method that concepts for sculptures first seen in drawings are translated into bronze or stone many years later.

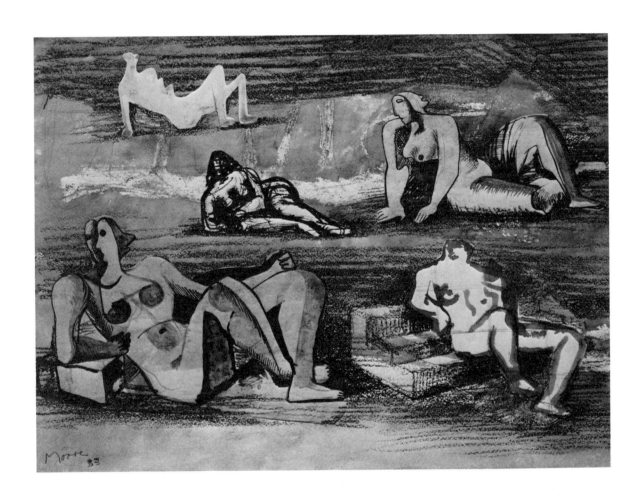

67. *April 1959 (Racciano from Car)*, 1959

Pencil and oil wash on paper, 16¾ x 21¾ inches
(42.5 x 55.2 cm.)

Exhibition: André Emmerich Gallery, New York, *Ben Nicholson*, April 11-May 6, 1961, no. 34.

Provenance: André Emmerich Gallery, New York.

Lent by a Private Collection, Atlanta.

Although Nicholson's finished oils and reliefs are primarily non-objective works dealing with formal problems of abstraction, his drawings frequently record his immediate and lively response to objects, landscapes, and buildings. This became particularly evident in 1950 when he made his first post-war visit to Italy and began a series of drawings of the sites he saw.

As he made auto tours through Italy and Greece in the 1950s, Nicholson, following the example of Matisse, recorded the views as perceived from within the automobile, even incorporating the outline of the windows, the dials, the steering wheel, and other mechanical details. (See, for example, the drawings, *Oct. 1955 (Road to Pienza)*, reproduced in Herbert Read, *Ben Nicholson, Work since 1947*, v. 2, London 1956, fig. 115; and *1958 (Tesserete)*, Victoria and Albert Museum, London, in *Ben Nicholson: Fifty Years of His Art*, exhibition catalogue, Albright-Knox Gallery, Buffalo, 1978, no. 68). The imposition of the circular form of the steering wheel upon the horizontal plane of the landscape is related to Nicholson's concern for the balance of geometric forms in his reliefs of the same period. Here the delicate shadings of the pencil line are also contrasted with the vivid orange tones of the oil wash that enliven the composition.

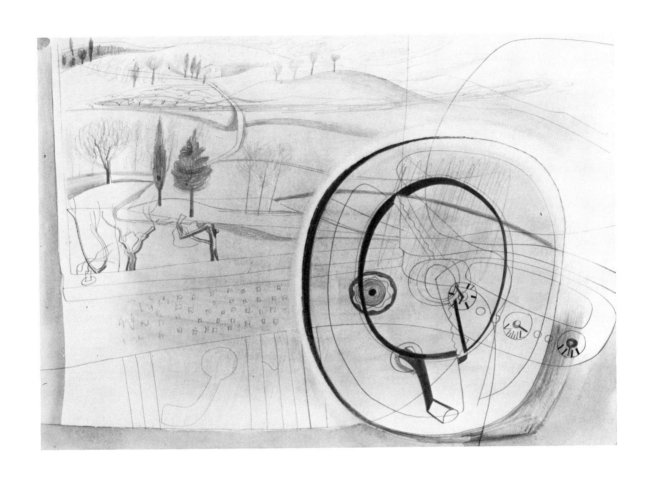

68. *Figure of Aesop*, 1966-67

Gouache on paper, 31½ x 27½ inches (80 x 69.8 cm.)

Exhibitions: Gimpel and Hanover Galerie, Zurich, October 10-November 18, 1967; Gimpel Fils, London, *Horst Antes*, January 23-February 17, 1968.

Provenance: Gimpel Fils, London.

Lent by Edith and Robert Fusillo, Atlanta.

Antes's homuncular figures are among the most intriguing products of post-war European art. Like Oskar Matzerath, the deformed dwarf in Günter Grass's *The Tin Drum*, Antes's gnomes are moral symbols, and have repeatedly been interpreted as metaphors for Germany's post-war conscience-searching. Although truncated and deformed, they stand with a Giotto-esque weightiness and seem to possess an air of implacability. Their large scale and enigmatic appearance forces a concentration on questions of meaning, which ultimately remain unanswered. Whatever significance Antes's brooding figures may possess, the messages they transmit are unquestionably ominous. In this work, a colorful piebald patching of the figure is felt as a kind of besmirching and distortion. This gouache is a preliminary study for a painting of Aesop (Gimpel Fils, London, *Horst Antes*, January 23-February 17, 1968, no. 14). In the final version the feet are more defined (although there are still only four toes on each foot), the buttocks are more protuberant, the legs thinner, and the clouds in the background more prominent. The transparency, freedom and spontaneity of this study does not seem to have been sustained in the final version.

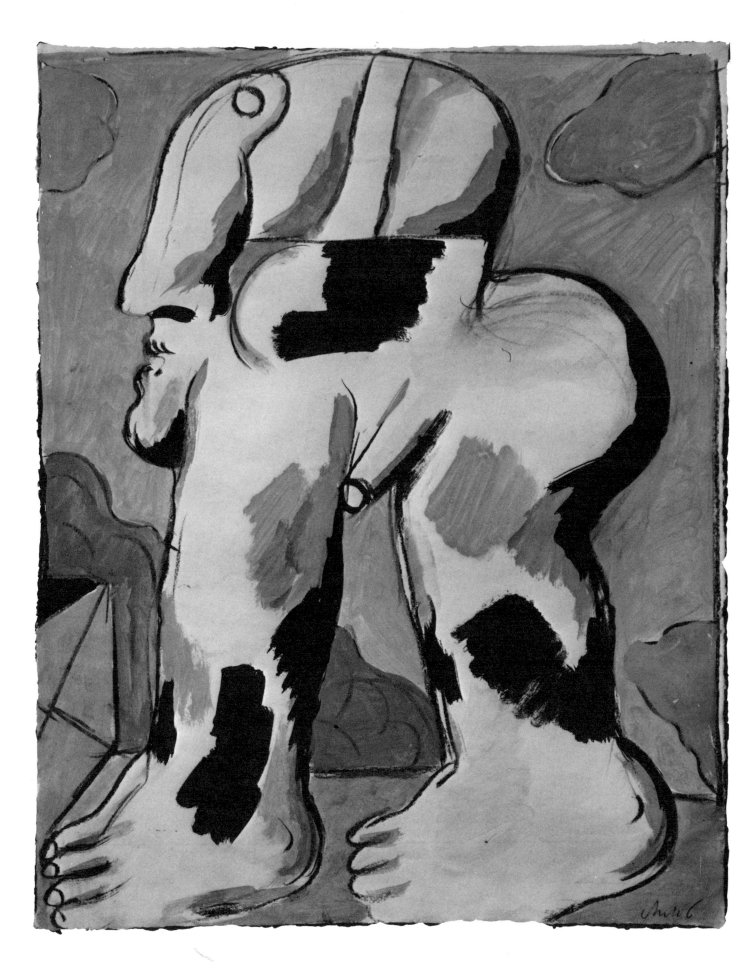

141

69. *Michel Tapié*, 1946

Charcoal on paper, 16⅜ x 10⅞ inches
(41.6 x 27.6 cm.)

Signed in pencil at the lower right:
Michel Tapié/J. Dubuffet

Bibliography: Max Loreau, *Jean Dubuffet: Délits, Départements, Lieux de haut jeu,* Paris, 1971, p.20.

Lent by a Private Collection, Atlanta.

This drawing is one of twenty related charcoal portraits Dubuffet made of his friend, the critic and spokesman for *l'art informel,* Michel Tapié. Ten of the drawings are the same size as this sheet; other images of Tapié treat him as a Grand Duke, as King of Carneval, as a condottiere, and as the sun. All of these drawings were executed in 1945 and 1946 as part of Dubuffet's series "Portraits: More Beautiful than They Think."

In this series, Dubuffet's ability to invent new visual languages for depicting the human form is amply evident. Not only do the artist's conventions for signifying physical features change from one sitter to the next, they also change in successive portraits of the same sitter. Dubuffet uses a varying repetition of signs to alter the nature of the composition: here circles stand for eyes, mouth, and chin, and an arrow shape works both for the nose and the tie and collar. Although these elements unify the composition, the portrait is also full of what Dubuffet calls "brambles," visual incidents which engage the viewer's attention in new ways each time the portrait is confronted.

Dubuffet decried portraiture which gave a good resemblance but failed to give life. The portrait must also be generalized, Dubuffet said, and ought to have an air of gaiety:

> In order that a portrait truly function well I need for it to scarcely be a portrait. It is then that it takes up its function in all its force. I like very much things carried to their extreme possible limit. (Quoted in Loreau, p. 15.)

Dubuffet's regressive humor and the indeterminate qualities of these portraits bring the duality of individuality and generality to a fine point.

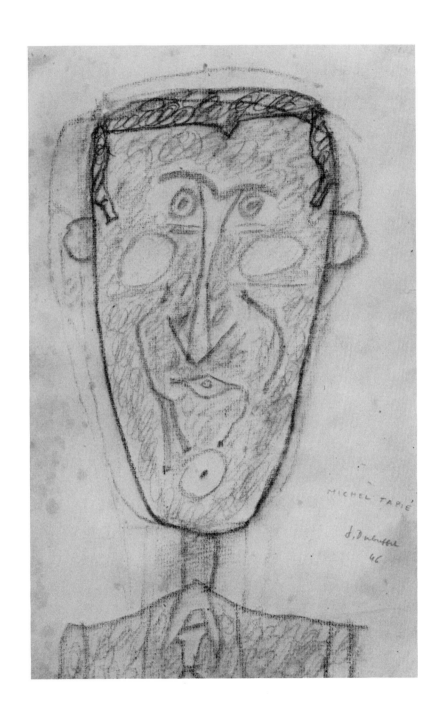

70. *Study in the Morphology of Orange Peels,*
1962

Ink on paper, 10 x 15 inches (25.4 x 38.1 cm.)

Signed at the lower right: *Alechinsky 1962*

Provenance: Galerie Espace N.V., Amsterdam, 1962.

Lent by Dr. Milton Mazo, Savannah.

In 1954, Alechinsky learned from Walasse Ting the Chinese method of painting in ink with the paper laid on the floor. The lesson was decisive for Alechinsky and became the basis for much of his later gestural abstraction. Alechinsky admired Ting's control of the dynamics of line and its application:

> Very important, the variations in the speed of a line. Acceleration, braking. Immobilization. The light fixed blob, the heavy fixed blob. The whites, all the greys, the black. Slowness and lightning application. (Quoted in *Pierre Alechinsky, Paintings and Writings,* Museum of Art, Carnegie Institute, Pittsburgh, p. 200.)

In this free improvisation, line has a directive and punctuating force. The maze of intertangled shapes is full of starts and stops. Alechinsky's vigorous patterning coalesces into an allover design of great fluidity and vitality.

A related series of etchings, ''Bites,'' was published in 1962 by Grafico Uno, Milan. The starting point for all of these works was orange peelings cut in a continuous spiral by Alechinsky's friend, the sculptor Reinhoud. The artist found the subject suggestive:

> Model: Armful of orange skin peeled by my friend Reinhoud, preserved dried or mildewed on the table, near the ink and paper. Drew them in the evening as though we were drawing a mute girl, dead perhaps from elegance but accessible to the gaze of the living . . .

> Means: Lone head. Lost. Spiral, snake, meander. One follows. Awkwardly, splutteringly. Down strokes and up-strokes spread out, gladly without reason. Without support? Prudence, guardrails. Leap if need be, pass to the other side of things, broadside on. . . . (*Pierre Alechinsky, Paintings and Writings,* p. 210.)

Giorgio Morandi (Italian, 1890-1964)

71. *Still Life*, 1953

Pencil on paper, 7¾ x 10⅝ inches, (19.7 x 27 cm.)

Signed at the lower center: *Morandi 1953*

Provenance: Curt Valentin Gallery, New York; David McKee, New York; Arnold Gallery, Atlanta.

Lent by Genevieve Arnold, Atlanta.

Stephen Spender insightfully divided twentieth century artists and writers into two main camps: "moderns and recognizers," and "contemporaries and non-recognizers." He has written:

> I see the "moderns" and the "recognizers" as deliberately setting out to invent a new literature as the result of their feeling that our age is in many respects unprecedented, and outside all the conventions of past literature and art. I see the "contemporaries" and "non-recognizers" as being at least partly aware that there is a modern situation, yet they refuse to regard it as a problem special to art. (Stephen Spender, *The Struggle of the Modern*, Berkeley, 1963, p. x.)

Morandi was a "contemporary" and "non-recognizer": his art was based on a profound understanding and interpretation of Cézanne, and a high regard for the traditions of contemplative still life. Morandi seems to have reacted against his early alliance with Futurism, although his subsequent association with the Scuola Metafisica may be responsible for his extraordinary sensitivity to the mysterious existence of things. The artist's intense concentration may be felt in this drawing of the contours of bottles and jars. Each line is precisely weighted and balanced, and contributes to an interchange of objects of great spatial richness. The artistic discipline imposed by Morandi's activities as an etcher is evident. Ultimately, Morandi's drawings have spiritual implications; his spectral geometry and fugitive contours imply the transience of earthly goods. The quietude of Morandi's drawings suggest a sensibility far removed from the extremism characteristic of the Italian avant-garde polemics of his day.

146

72. *Figures*, ca. 1914

Pastel on paper, 18 x 24 inches (45.7 x 61 cm.)

Signed at the lower right by the artist's widow, Frances Weber: *MAX WEBER (FW).*

Exhibition: The Downtown Gallery, New York, *Max Weber,* May 7-May 31, 1963, no. 33.

Provenance: Frances Weber; The Downtown Gallery, New York.

Lent by Mr. and Mrs. Louis Regenstein, Atlanta.

Max Weber had a profound attachment to music and dance throughout his life. This sheet is related to a series of dance themes executed between 1907 and 1913. The interknotted figures seem to be in frenzied and rhapsodic motion, a type of movement which recurs in the artist's cubist portrayals of New York, and in important later works such as *Hassidic Dance* (collection of Milton and Edith Lowenthal, New York) and *Exotic Dance* (University of Iowa Museum of Art), both of 1940.

Here an air of primitive ritual predominates, and reflects Weber's affinity for the decorative devices of ethnic arts. Another clear source is Marcel Duchamp's *Nude Descending a Staircase No. 2,* which was in the Armory Show of 1913, and in which Weber took a particular interest. Weber borrows Duchamp's device of an overlay of striated lines to convey movement, but does so in a totally original manner. Duchamp's repeated contours are all rectilinear, but Weber's curves convey the rhythm of human movement, and the flow of moving drapery. The net effect is closer to the sinuous curves of Fauvism than to Cubism's prismatic analysis of shapes.

73. *Daybreak*, ca. 1920

Watercolor on paper, 19½ x 27 inches
(49.5 x 68.6 cm.)

Stamped at the lower right: *C.E. Burchfield Foundation B-240*

Bibliography: John I.H. Baur, "Introduction," *Charles E. Burchfield at Kennedy Galleries: The Early Years, 1915-1929*, New York, 1977, n.p.

Exhibition: Kennedy Galleries, New York, *Charles E. Burchfield at Kennedy Galleries: The Early Years, 1915-1929*, October 13-November 12, 1977, no. 41.

Provenance: Charles E. Burchfield Foundation; Kennedy Galleries, New York.

Lent by The Columbus Museum of Arts and Sciences, Inc. Gift of the Royal Crown Cola Company, 1977.

All of his life, Burchfield was absorbed by the drama of weather and the seasons. His response to nature was ardent and empathetic, and was imbued with a sense of the dynamic life in all natural phenomena. Burchfield loved to capture the outdoors in transitional moments: the passage from Winter to Spring, from cloudiness to bright sunshine, or, as here, from night to day. In his treatment of these scenes, his constant aim was to create a mood reflecting the emotional impact of the view on his own feelings.

In this panoramic scene, strong value-contrasts and a decorative use of contour establish an emphatic two-dimensional design. At the same time, the spreading rays of the dawning sun over the silhouetted landscape also create a natural perspectival recession. The dark-edged jagged clouds have a rhythmic insistency which conveys Burchfield's transcendental conception. The promise of a Summer's morning is seen here in apocalyptic terms.

Charles Demuth (American, 1883-1935)

74. *Sun Bathing, Provincetown,* 1934

Watercolor and pencil, 8¼ x 11 inches (21 x 28 cm.)

Provenance: Kennedy Galleries, Inc., New York; Mr. George Frelinghuysen; Sale Sotheby Parke Bernet, Los Angeles, May 27, 1974, no. 196.

Lent by Mr. and Mrs. Bob London, Atlanta.

Demuth had first gone to Provincetown in 1914. He returned there for a Summer twenty years later, filling a notebook with pencil and watercolor studies of sun bathers on the beach. Twelve of these are listed in Emily Farnham, *Charles Demuth, Behind a Laughing Mask* (Norman, 1971, pp. 210-11) and several are illustrated in the exhibition catalogue *Charles Demuth,* The Art Galleries, University of California (Santa Barbara, 1971, pp. 75-76).

This drawing and another nearly identical one from the series now in the Herbert A. Goldstone Collection (The Brooklyn Museum, *The Herbert A. Goldstone Collection of American Art,* June 15-September 12, 1965, no. 16) are instructive as to the artist's working methods. After drawing his outlines in pencil, Demuth filled out the forms with watercolor washes of varying thickness. In this more fully developed study, all three figures have been painted in with watercolor, but in the Goldstone sketch the boy lying on the sand appears only in pencil, and the details of the striped blanket and umbrella are not indicated.

Demuth was a master of the watercolor wash technique and his late works, of which this is one, show no letdown in his ability, only a greater refinement of forms. In part, his technique was based on his observation of Cézanne's watercolors. Like the French artist, Demuth adopted muted colors, and varied the density of the watercolor to suggest shading. He also left large areas of the white paper exposed, which gives a purposely unfinished look. In this work, the color is used effectively to suggest the varying degrees of exposure the figures have had to the sun. The pattern of these color areas across the sheet and the manner in which the standing figure is cut off by the edge have an almost Oriental flavor.

75. *Black Place III*, 1945

Tempera and gouache on paper, 27¼ x 43⅜ inches (69.2 x 110.2 cm.)

Provenance: American Place Gallery, New York; Private Collection, Atlanta.

Lent by a Private Collection, Atlanta.

Georgia O'Keeffe has always been responsive to landscape, especially the harsh, barren landscapes of the Southwest. From 1914 to 1918, she spent the winters teaching in the Texas Panhandle and wrote in 1919, "It was a country of vast arid plains and wide skies, windswept, freezing in winter, without green grass . . . But I belonged. That was my country—terrible winds and a wonderful emptiness." (Quoted in Lloyd Goodrich and Doris Bry, *Georgia O'Keeffe*, New York, 1970, p. 9.) This Spartan attitude was also expressed in the form of the abstraction she first developed in this period. It is intensely personal and reduces forms to flowing anthropomorphic shapes corresponding to both light and music.

In 1929 she discovered the fascinating beauty of the New Mexico desert and began spending her summers at Ghost Ranch, in a remote area of the state. In her autobiography, the artist has recorded that:

> I must have seen the Black Place first driving past on a trip into the Navajo country and, having seen it, I had to go back to paint—even in the heat of midsummer. It became one of my favorite places to work . . .

> The Black Place is about one hundred and fifty miles from Ghost Ranch and as you come to it over a hill, it looks like a mile of elephants—grey hills all about the same size with almost white sand at their feet. When you get into the hills you find that all the surfaces are evenly crackled so walking and climbing are easy . . .

> There were probably twelve or fifteen paintings of the Black Place and I finally painted it from memory—red and later green. (*Georgia O'Keeffe*, New York, 1976, pp. 59 and 61)

Typically for O'Keeffe, the series of depictions of the Black Place passed from the representational paintings of 1944 to a gouache such as this one of 1945 in which the natural shape of the hills has been reduced to undulating forms, suggestive of primeval generative forces. The subtle blending of colors creates a haunting effect.

76. *Six Male Nudes Dancing*

Black and white chalk on buff paper, 28½ x 22¼ inches (72.4 x 56.5 cm.)

Signed at the lower left: *A.B. Davies*

Provenance: Ferargil Gallery, New York.

Lent by Dr. and Mrs. Michael K. Levine, Atlanta.

Nearly all the mature works of Arthur B. Davies are devoted to the study of the human form and its decorative potential. This decorative quality was achieved through careful attention to the posture, gesture, and disposition of the figures, the colors or highlights used to describe them, and the establishment of a visionary or dream-like mood. Davies favored compositions with multiple male or female nudes in which the rhythmic organization of the composition could be made apparent. The postures of the nude males represented here are similar to many seen in the 1910 painting known as *Tiptoeing Youths* (Whitney Museum of American Art, reproduced in Royal Cortissoz, *Arthur B. Davies*, New York, 1931).

This overlapping design of six male nudes is enlivened by Davies's free use of light and shade. Despite the interwoven limbs, the drawing retains a high degree of spatial clarity.

A.B.Davies

77. *Gas Pumps*, ca. 1931

Soft pencil on paper, 8¹⁵/₁₆ x 7½ inches (22.7 x 19 cm.)

Provenance: Estate of the artist.

Lent by Judge Phyllis A. Kravitch, Atlanta.

This study is a preliminary drawing for *New York-Paris No. 3*, 1931 (collection of Dr. Michael W. Watter). Davis frequently portrayed gas pumps as symbols of industrial life, and as geometrical shapes of uncommon interest. The inclusion of gas pumps was apt in the *New York-Paris* paintings, which juxtaposed the human-sized imagery of Paris with signs of the impersonality and mechanization of America. The source for the motif was probably observed in 1930 or 1931 in Gloucester, Massachusetts, where Davis summered. The motif appears virtually unchanged as a vignette in the center of the final painting; the landscape outlines of trees and hills at the left of the drawing are excised, and the name "Gulf" on the left tank is changed to "Gas." Davis's schematic line and sensitivity to the effects of transparency elevate this modest study into a two-dimensional design of great sophistication.

78. *Untitled*, 1942

Watercolor and ink on paper, 21⅞ x 29⅞ inches (55.6 x 75.9 cm.)

Exhibitions: The High Museum of Art, Atlanta, *Calder in Atlanta*, October 1-29, 1972.

Provenance: The artist; Willard Gallery, New York; Heath Gallery, Atlanta.

Lent by Lenore and Burton Gold, Atlanta.

In 1942, Calder was among the few Americans included in the exhibition *First Papers of Surrealism*, a landmark showing of the European *emigrés* who had fled from Hitler. Although Calder had long been on friendly terms with the Surrealists, particularly Miró, he had been more strongly associated with the artists of the group Abstraction-Creation, who worked in geometrical and biomorphic styles. But during the war years Yves Tanguy and André Masson were Calder's neighbors and close friends, and Surrealist undertones in his work are often pronounced at this time. The dripped and spattered ink on this sheet reflects an interest in the Surrealist technique of automatism, which was commonly practised in the early 1940s by Masson and Max Ernst. While their use of the technique was intended to prompt subconscious images and associations, Calder's is purely an illustrational device to suggest motion. The implication of the serpentine shapes pivoting and turning on vertical axes is very strong. The patterning of the dripped lines in parallel and repetitive formations also suggests that the artist might have been inspired by Herbert Matter's brilliant time-exposure photographs of his mobiles. The ink lines recall the linear wire elements of sculptures such as *Cockatoo* (1941), *Horizontal Spines* (1942), or *Little Tree* (1942).

The damage sustained at the bottom edge of this sheet probably occurred in the fire in Calder's Roxbury, Connecticut studio in 1943.

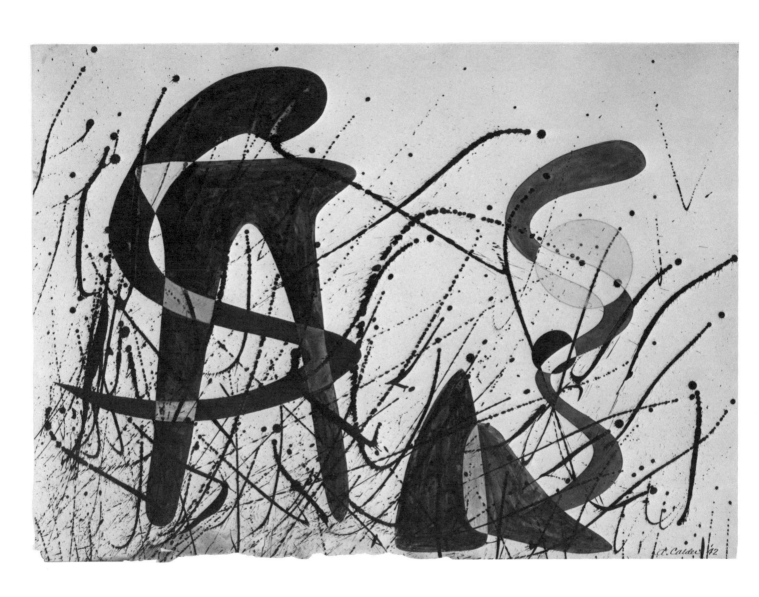

79. *Study for Medusa's Corner*, 1942

Pen and ink, ink wash, and white ink on paper, 22½ x 18⅛ inches (57.1 x 46 cm.)

Signed in ink at the lower left with the artist's initials, numbered *44* and dated *1942*.

Inscribed at the lower edge: *Un passe de Medusa* (?)

Exhibition: Knoedler and Co., New York, *Eugene Berman, Recent Works*, May 1-22, 1948.

Provenance: Knoedler and Co., New York, 1948.

Lent by a Private Collection, Atlanta.

Born and trained in Russia, Berman remained there until his family was forced to flee to Paris in 1918. There, along with his brother Leonid and his friends Pavel Tchelitchew and Christian Bérard, he was one of the group of artists known as the Neo-Romantics. His dream-like compositions incorporated realistically painted somnolent humans in settings of decaying sculpture and crumbling architecture inspired by the works of De Chirico. These were appreciated in America, and he came here for the first time in 1935, eventually becoming a citizen. In America, his work underwent significant change, as he became involved with theatre and ballet design.

It was in the early 1940s that the figure of a woman ("her head bowed and her hair mournfully shrouding her face," as Julien Levy described her) first appeared in works such as *Time and Monuments* and *View in Perspecitve of a Perfect Sunset*, both 1941. (See Julien Levy, *Eugene Berman*, New York, 1946, frontispiece and pl. LXIII.) She seems to be modeled in part upon his then wife—Ona Munson, who figures in many studies —and also the female figure in Dürer's engraving *Melencolia I,* which provided the basis for a number of meditative studies. (See *The Graphic Works of Eugene Berman*, New York, 1971, pps. 58-59 and 80.)

Berman's woman assumed various classical names such as Proserpina, Andromeda, and Cassandra. This drawing is a study for an enigmatic painting of 1943 called *Medusa's Corner*. Here the debt to Dürer is clear in the presence of what seems to be the large compass on the ground before her. The part-human, part-lion creature above her appears as a conflation of the child in *Melencolia* and the lion of *St. Jerome's Study* (another Dürer engraving, almost always reproduced in conjunction with the *Melencolia*). In the painting, this becomes a frightening woman's face. The bound figure at the right suggests an origin in some Renaissance image of St. Sebastian, just as the ruined structure reminds one of architectural ruins in Boticelli's paintings. The jagged lines converging on the head of the woman give the impression that we are looking at an image through a shattered glass, but the idea for this also might have occurred to the artist from looking at Dürer's engraving. The shooting star that occurs in the sky there has been directed squarely at the figure's head. Berman uses this device again in a painting of 1945-46, *The Spring* (Levy, pl. XCVI), in which the surface seems to have been shattered by a bullet. Medusa was a mythological being with snake locks whose visage would turn men to stone, and thus may provide an ironic title for a work in which the figure keeps her face hidden. Or perhaps the depiction of this frozen image indicates that this is a world already immobilized and shattered by her stony glance. In any case, we may suspect that the work is Berman's disconsolate meditation on the unhappy state of relations between men and women. Much later, in his works of the 1960s, the image of the Medusa head again figured prominently (see *Graphic Works,* pp. 316-319).

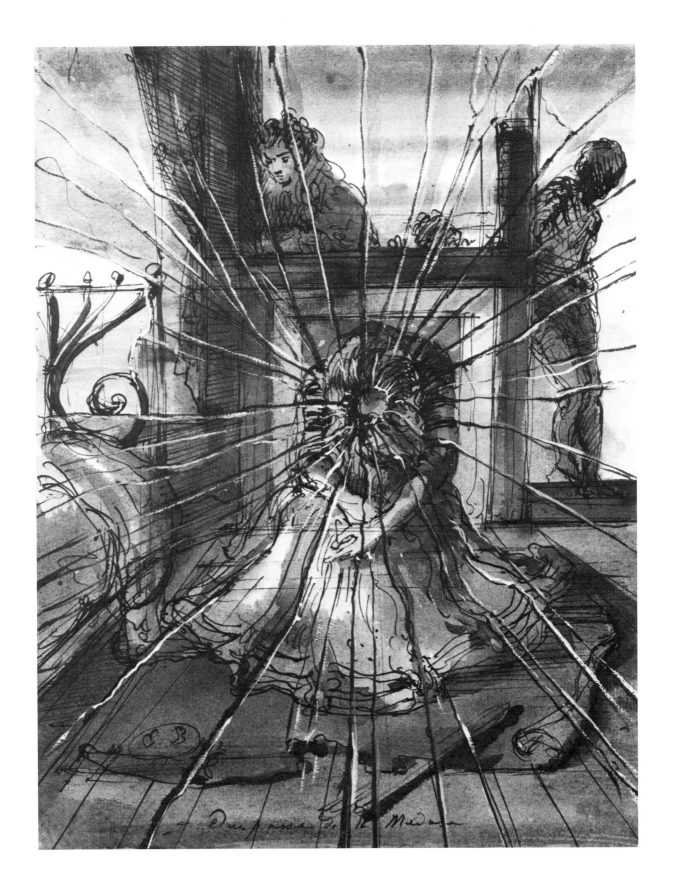

80. *Head VII*, 1950

Colored pencil on black paper, 19⅞ x 13¾ inches (50.5 x 34.9 cm.)

Exhibitions: Galleria dell'Obelisco, Rome, Italy, 1950; Durlacher Brothers, New York, 1951.

Provenance: Nelson Rockefeller, New York.

The High Museum of Art. Gift of Nelson Reckefeller in memory of Robert R. Snodgrass, 1971.

This is one of a series of drawings Tchelitchew made in 1950, while living at Grottaferrata near Rome. Each of the drawings in the series is in white colored pencil. The geometrical configurations which make up the heads in the drawings grow denser and more complex as the series progresses. The first and sixth drawing in this series are in the collection of the Museum of Modern Art; *Head I* consists of a continuous spiral line, while *Head VI* differs from the High Museum version principally in the absence of the elliptical shapes behind the eyes, the "target" at the juncture of the nose and eyes, and the French curve pattern in the neck. Tchelitchew's aim in these drawings was to create a transparent continuous surface which was spatially reversable; the tip of the nose, for example, may be seen either as a vanishing point or as the closest point to the viewer. The culmination of these studies was a 1956 painting, *Mercure* (Wescott Collection, New Jersey), in which a half-length figure is seemingly entrapped in a transverse grid superimposed on the circles and spirals which constitute the human form.

Tchelitchew thought of his transparent heads in allegorical terms. Upside down, he pointed out, they may be seen as vessels. He thought of the use of white pencil on black paper as a "thread of light." The head is also "a diamond head," since diamonds are the crystallized form of carbon, and the human body is, according to Paracelsus, mostly carbon. (Artist's file, Museum of Modern Art, New York.) Tchelitchew's principal biographer and interpreter, Parker Tyler, also points out that the heads are "celestialized," since they span "earth and air" and have a "planetary configuration." They also represent "the primal egg destined historically to be the human head." (Parker Tyler, *The Divine Comedy of Pavel Tchelitchew*, London, 1967, pp. 478-479.) Despite the complexity of this symbolism, Tchelitchew's draughtsmanship remains visually fresh and technically intriguing.

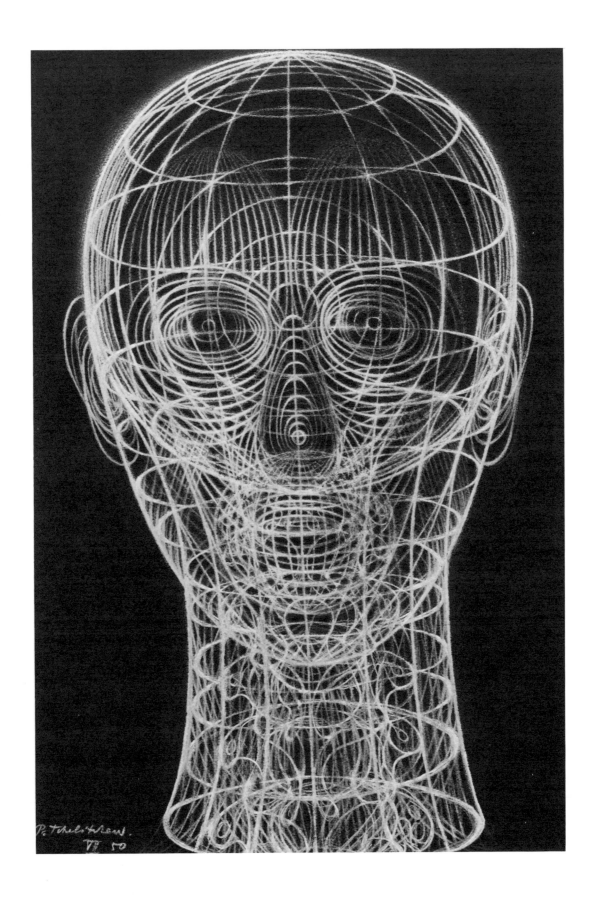

81. *Untitled*, 1944

Chalk, watercolor, and pen and ink on paper, 25⅛ x 38¼ inches (63.8 x 97.2 cm.)

Signed at the lower right: *Rothko*

Provenance: The Pace Gallery, New York.

Lent by Betty Bearden Pardee, Atlanta.

In this drawing, the veiled and indeterminate shapes of Rothko's mythic surrealism are set in a stage-like setting. The individual biomorphic motifs are isolated, yet they are linked by the potential for turning motion which each seems to bear. The viewer is presented with a drama which appears to be festive, but also august and sacerdotal.

Rothko's technique in this drawing is clearly derived from automatism, the surrealist method of free improvisation. The morphology of forms recalls Miró, Gorky, and Arp. Rothko's subtle command of color is already present in this early drawing. Shapes take on an unearthly glow in the pale, chalky light. His hybrid plant-fish-amoebae emerge and re-submerge in an atmosphere of eternal creation.

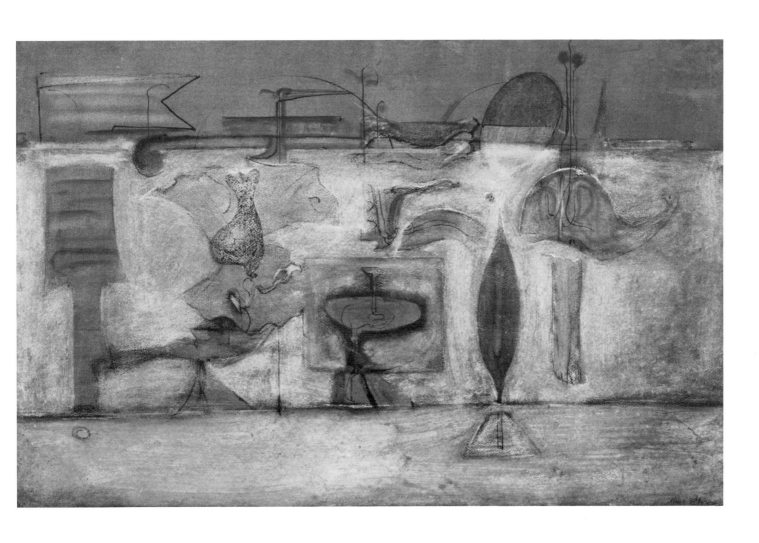

82. *Summer Delirium*, 1944

Crayon and watercolor on paper, 16¾ x 13¾ inches (42.5 x 34.9 cm.)

Signed at the lower left: *hh VIII 5 44.*

Inscribed at the lower right: *summer delirium*

Exhibition: Fine Arts Center, University of Tennessee at Chattanooga, *20th Century American Paintings: An Inaugural Exhibition for the Dorothy Patton Fine Arts Series*, September 8-October 10, 1980.

Provenance: Hugh H. Trotti, Jr., Decatur, Georgia.

The High Museum of Art. Purchase with general funds, 1977.

On October 12th, 1944, Hans Hofmann wrote to William N. Eisendrath regarding his November exhibition at the Arts Club of Chicago, and in his fractured English, conveyed his excitement and sense of accomplishment:

> I have undergone an operation which kept me throughout the month of June in the hospital. I worked afterwards in Provincetown, but I was not permitted to handle heavy weights. As a consequence of this restriction I have worked throughout the whole summer only on paper . . . I consider just this paintings as one of the beste of my work. . . .

(Arts Club of Chicago, Arts Club Papers, Newberry Library, Chicago.)

Perhaps because of the rapid progress he made in works on paper, 1944 was a breakthrough year for Hofmann. In that year he decisively abandoned the cubist/fauve style which had previously characterized his art, and began to work consistently in a freer, more intuitive manner. Color itself was allowed to determine pictorial structure.

In *Summer Delirium*, Hofmann's reliance on improvisation does not detract from a firm underlying order. The complementary red and green rectangles stabilize the rush and sweep of his dribbled, splattered, and dashed lines. Reserve areas in the upper center offer a respite from the frenetic pace of the rest of the composition. Hofmann's handling of watercolor is consistent with his belief in seeking inspiration from the qualities of the medium itself:

> To me creation is a metamorphosis. The highest in art is the irrational . . . incited by reality, imagination bursts into passion the potential inner life of a medium, the final image resulting from it expresses the *all* of oneself. (Exhibition announcement, Art of This Century Gallery, New York, March 1944.)

168

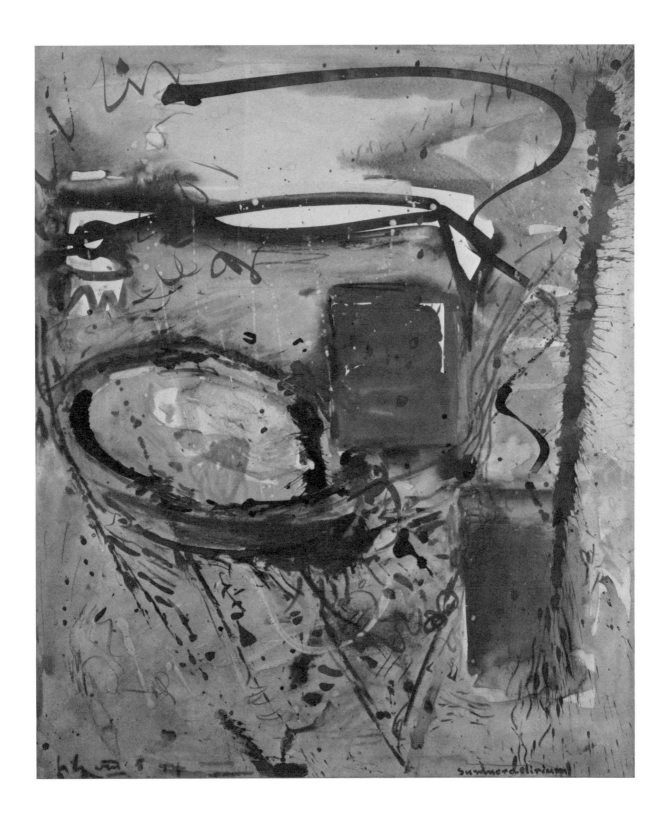

83. *The Bathers*, 1956

Watercolor on paper, 15 x 21⅞ inches
(38.1 x 55.6 cm.)

Signed at the lower right: *Milton Avery*

Provenance: Barbara Mathes Gallery, New York.

Lent by Dr. Elaine Levin, Atlanta.

Avery's watercolors were usually based on small notebook sketches and summary color notations. The watercolors served as an intermediate step from which oil paintings were developed, with greater refinement of color and design at each succeeding stage of the process. The transparency of watercolor, its lightness and flow as a medium, seems to have had an influence on Avery's mature style in oils. In the watercolors, as in the paintings, subtle inflections in a single hue are often the only illusionistic means employed.

In this charming and amusing example, four bathers are fitted together jigsaw fashion against a background of beach, sea, and sky. A key element in Avery's lyricism is his ability to conceive of his scenes in planar terms, as one uniform and continuous surface. The rounded ladies are reduced to their rotund essences, yet they remain accurate observations of local genre on an American beach.

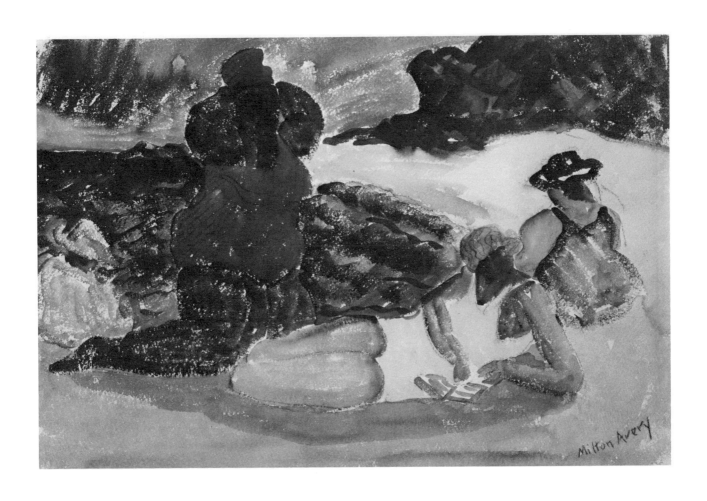

84. *Untitled*, 1968

Gouache on buff-colored paper, 22¼ x 14¾ inches (56.5 x 37.4 cm.)

Signed at the lower right: *Tobey*

Exhibition: Trosby Gallery, Atlanta, *Atlanta Collects,* April 23-May 3, 1980.

Provenance: The artist; Lawrence Ulvi Collection, Oregon; Private Collection, New York; Luis Mestre, New York.

Lent by Genevieve Arnold, Atlanta.

Tobey prepared this sheet with a sandy buff-colored gouache, which was rubbed over the surface in a more dilute second application. A loose all-over red and yellow pattern came next, establishing the difference between filled space and void. This was followed by Tobey's characteristic calligraphy of white, and finally black hooks and dashes. The greatest variety of notations occurs in the black lines, which vary from plump comma-shaped squiggles to thin fast strokes. Occasionally the brush was dragged across the page until dry, evoking a completely different linear velocity.

The markings become both smaller and denser in the center of the composition, creating an illusion of shifting depth. Paths link together momentarily to form elusive clusters of interest. This phenomenon in Tobey's art has been succinctly described by William Seitz:

> Space becomes "compound" as the depth systems of the various foci interpenetrate, and the eyes of the spectator (reversing the Renaissance rule) are given no focal area or object (as in figure paintings or portraits) at which to rest. They are forced to move across the surface of the picture. (William Seitz, *Mark Tobey,* New York, 1962, p. 27.)

This type of composition, in which the pictorial incidents are set free from the anchoring edge, is one that Tobey used intermittently since the mid-1940s. The nature of Tobey's graphic vocabulary evolved greatly over the years, although his attachment to small-scale elements of design never flagged. The virtues of Tobey's style were, first, great control over the illusion of space; and second, a delicate, subtle effect of spiritual light created through value contrast. Essentially, Tobey's works offer his viewers a contemplative experience of sublime infinitude.

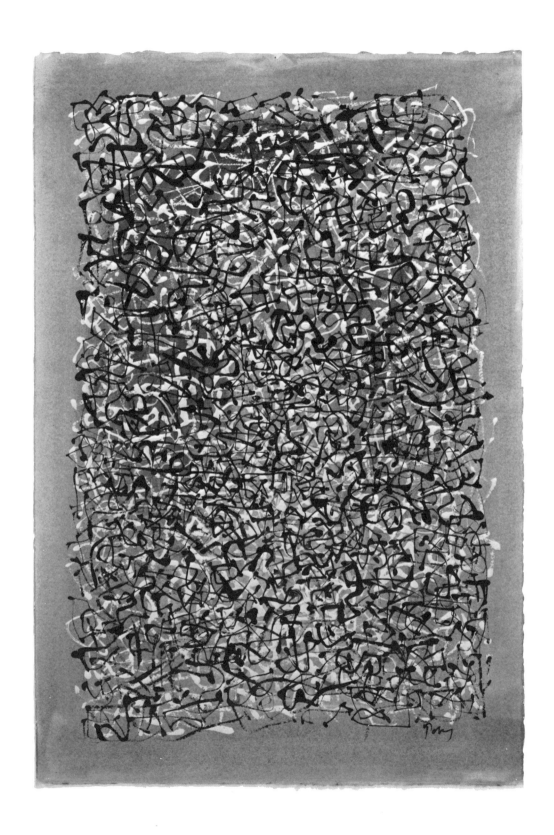

85. *Untitled*, ca. 1962

Watercolor on paper, 7⅜ x 10⅞ inches
(18.7 x 27.6 cm.)

Exhibition: Marlborough Gallery, New York, *William Baziotes, Late Work, 1946-1962*, no. 49.

Provenance: Marlborough Gallery, New York.

Lent by a Private Collection, Atlanta.

Of all the Abstract Expressionists, Baziotes remained closest to Surrealism, and to Surrealism's own inspiration in the poetry of the Symbolists. Baziotes's imaginative world recalls Redon's, in the taste they shared for evocations of all that is mysterious, sinister, and nocturnal. Baudelaire's *Correspondences* was central to the inspiration of both artists.

In this delicate watercolor, yellow and white shapes float in a purplish-blue subaqueous atmosphere. The imagery of water is reinforced by the liquid handling of the medium. The organic flowing shapes are slightly too rectilinear to suggest invertebrate creatures, but too undulant to be thought of as calligraphy. In each, Baziotes creates the illusion of slow movement. The twisting tentacle ends of the forms turn in at either side of the page, conveying a sense of a biological or metamorphic process.

Baziotes's method in creating this watercolor was first to lay in the background color, reserving the areas for the lighter colored shapes. After the yellow and white forms were painted in, their wavy contours were altered and reinforced with purple to promote an active interchange between figure and background.

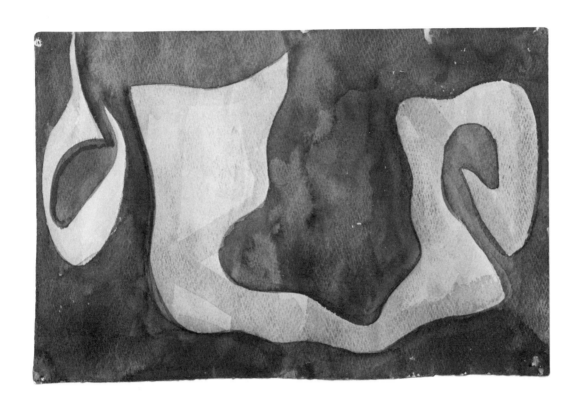

86. *Green Oblique*, 1956

Oil and collage on paper, 18½ x 23½ inches (47 x 59.7 cm.)

Signed at the lower right: *Kline 56*

Exhibition: Sidney Janis Gallery, New York.

Provenance: Sidney Janis Gallery; Marlborough Gallery, New York.

Lent by Genevieve Arnold, Atlanta.

This drawing is a preliminary study for *De Medici*, a Kline painting of 1956 which measures 82 x 115¼ inches (Collection of Mr. and Mrs. David Pincus, Washington, D.C.). It was one of Kline's largest paintings up to that point. In an interview with David Sylvester, the artist defined his working method:

> A lot of paintings have developed through painting out other paintings and then, in some way, I can use some reference maybe from part of another drawing, that maybe I had done three years ago or something like that . . . It might become a process of overpainting and underpainting to some extent. ("Franz Kline 1910-1962: An Interview with David Sylvester," *Living Arts*, I, Spring, 1963, p. 12.)

In this case, the larger work is a free variation on the smaller: the composition is made airier and more spacious, and motifs such as the diagonal leading from the top edge across to the right side are made stronger and more definite. The integrity of shape of the two green collaged blocks at the left and center is retained in the larger composition, as is the small yellow wedge in the left corner. The shapes in black paint are considerably expanded and made less compact. The white collaged rectangle in the upper right is recorded in the larger version as two straight-edges on the side of a massive black "V." Harry Gaugh, in his important study of Kline's works in color, has noted the artist's particular fondness for the "De Medici Green" which occurs in this collage as well as in many of Kline's color works beginning in the 1940s. (Phillips Collection, Washington, D.C., *Franz Kline, The Color Abstractions*, 1979, p. 14.) It is also possible from Gaugh's study to determine that this collage was probably executed early in 1956, since Kline completed *De Medici* in time for an exhibition in March of that year.

As important as this work is in documenting the artist's creative process, it also stands on its own merits as abstraction of great sophistication. The collage elements are played against the framing edge to create negative spaces precisely where anchoring to the sides would be expected. In addition to an ambiguous interchange between foreground and background, diagonal and rectilinear forces are played off against one another to create a compelling lateral tension. Upon close examination, Kline's care and precision are apparent, albeit within the context of an intuitive and impetuous working method. The collage elements of green and white papers are placed over an existing composition in black and white, which is further altered with a second application of black paint. Glue stains to the sides of the white paper in the upper right indicate that it was shifted several times to achieve exactly the "right" placement. Draughtsmanship was of great importance to Kline, and his works on paper constitute a major part of his *oeuvre*, both quantitatively and qualitatively.

87. *Untitled*, 1968

Charcoal on paper, 19 x 24 inches (48.2 x 61 cm.)

Signed at the lower left: *de Kooning*

Exhibitions: Whitney Museum of American Art, New York, *Human Concern Personal Torment: The Grotesque in American Art*, October 14-November 30, 1969, no. 36; Whitney Museum of American Art, *Contemporary Painting*, May 25-June 22, 1973; Walker Art Center, Minneapolis, *Willem de Kooning, Drawings and Sculpture*, March 9-April 21, 1974, no. 115; also shown at The National Gallery of Canada, Ottawa, June 7-July 21, 1974; The Phillips Collection, Washington, September 14-October 27, 1974; Albright-Knox Gallery, Buffalo, December 3, 1974-January 19, 1975; The Museum of Fine Arts, Houston, February 21-April 6, 1975; Norton Gallery of Art, West Palm Beach, Florida, *De Kooning, Paintings, Drawings, Sculpture, 1967-1975*, December 10, 1975-February 15, 1976, no. 13; Gimpel & Hanover Galerie, Zurich, August 27-October 3, 1976; Gimpel Fils Gallery, London, 1976; Arts Council of Great Britain, *The Sculptures of De Kooning with related paintings, drawings and lithographs*, Fruit Market Gallery, Edinburgh, October 15-November 12, 1977; Serpentine Gallery, London, November 26, 1977-January 8, 1978.

Provenance: William Zierler, Inc., New York; M. Knoedler & Co., New York; The Pace Gallery, New York; Barbara Mathes Gallery, New York.

Lent by Dr. Elaine Levin, Atlanta.

In the late 1960s, De Kooning experimented with ways of breaking his habits of hand and vision in his drawings. He drew with his left hand, or both hands, with his eyes closed, or while watching television. Out of the context of these attempts to create a more personalized, intuitive, abstract figuration, De Kooning evolved a particularly wry and relaxed treatment of his woman image. An especially readable series of these images was executed in 1968 and 1969. Perhaps in reaction to the free experimentation of the "awkward hand" drawings, this generation of De Kooning's women have more-or-less defined contours, and "realistic" details—high heels, cigarettes, long eye-lashes, sunglasses, and muscular haunches. De Kooning's interest in the easy smiling presence of advertising and pin-up imagery is apparent, and he also seems to refer to the Hollywood conventions of exaggerated make-up. These figures have more psychological independence than the celebrated women in De Kooning's paintings and drawings of the early 1950s; they appear to be bound up in their own self-mocking attitudes. In their aggressiveness and splayed postures, they are also related to Picasso's *Demoiselles d'Avignon*, a source to which De Kooning has repeatedly returned.

The drawings of 1968 and 1969 must also be seen in the context of De Kooning's sculptures of those years, with which they share wavering, flickering outlines, and, occasionally in the drawings, the implication of rugose textures. The woman on the left is very similar to a 6-inch-long bronze which is designed to lie flat. The figural integrity of these drawings suggests that De Kooning may have made them with his sculpture in mind, but they are nonetheless conceived two-dimensionally.

de Kooning

Robert Motherwell (American, born 1915)

88. *Untitled*, 1967

Ink on paper, 13⅛ x10⅝ inches (33.3 x 27 cm.)

Signed and dated at the lower left: *RM 67*

Lent by The Georgia Museum of Art, University of Georgia, Athens. Purchase, 1974.

Robert Motherwell's automatism is characterized by accuracy and exactness. Despite the rapidity of execution and free reign given to the liquid medium, Motherwell achieves in this drawing a compelling duality of round and straight, open and closed, concave and convex, organic and geometric.

Motherwell had refined this calligraphic style in 1966 in a series of works he called *Spontaneities,* and then he applied it to the group of works inspired by Alban Berg's *Lyric Suite.* Moving from music to poetry as the source of his inspiration, Motherwell was commissioned by the Museum of Modern Art to illustrate a deluxe edition of Rimbaud's *A Season in Hell.* The project was later abandoned for lack of funds, but Motherwell had already prepared a number of ink designs. Of these he has remarked:

> Given the spontaneity and brutality of Rimbaud's original poem, these drawings are among the most spontaneous and savage works that I have made. The only other thing to add is that Rimbaud's work was one of the many deep influences on my artistic development. (Artist's statement, Fendrick Gallery, Washington, D.C., November 2, 1974.)

Other ink drawings from the Rimbaud series are illustrated in H. H. Arnason, *Robert Motherwell,* New York, 1977, figs. 182-187.

181

89. *Untitled*, 1977

Pastel on paper, 30¾ x 22½ inches (78.1 x 57.1 cm.)

Signed at the lower right: *Joan Mitchell*

Provenance: Ruth S. Schaffner Gallery, Santa Barbara; Janie C. Lee Gallery, Houston; Xavier Fourcade, Inc., New York.

Lent by Robert and Edith Fusillo, Atlanta.

Among American Abstract Expressionists, Joan Mitchell is perhaps closest to the French tradition of *belle peinture*. Mitchell does not hesitate to use lush and sensuous combinations of colors that other artists would reject as being too ingratiating. Her inspiration is landscape, particularly the landscape north of Paris where she lives, but she uses landscape as idea—as the essence of color and light and as the most direct manifestation of nature's creative force.

In her painting, as in this pastel, Mitchell layers her colors, but she always retains contact with the white support, and her color atmosphere never becomes clogged and airless. Densities of markings suggest greater or lesser penetration into depth, and suffuse the whole image with a sense of immersion in verdant plant life. If any one artist has had a profound impact on Mitchell, it is Monet, whose late water lily paintings have a comparable sense of the infinite possibilities of nature within the finite means available to the artist.

90. *How to Draw: Reclining Nudes and Rectangles with Legs,* 1962.

Collage, pencil, and watercolor on paper, 14 x 16⅞ inches (35.5 x 42.9 cm.)

Signed at the lower right: *Rivers '62*

Bibliography: Sam Hunter, *Larry Rivers,* New York, 1968, plate 138; Larry Rivers with Carol Brightman, *Drawings and Digressions,* New York, 1979, p. 147.

Exhibitions: Brandeis University, Rose Art Museum, *Larry Rivers,* 1965, no. 143; also shown at the Pasadena Art Museum, The Jewish Museum (New York), Detroit Institute of Arts, and the Minneapolis Institute of Arts; Trosby Gallery, Atlanta, *Atlanta Collects,* April 23-May 3, 1980.

Provenance: Marlborough-Gerson Gallery, New York.

Lent by Comer Jennings, Atlanta.

Rivers was first attracted to the possibilities of his "language" series by a lesson book he encountered at an Alliance Française in Paris in 1961. The absurdity of the book illustration of a boy with arrows identifying his features struck Rivers. He used the device to call attention to the syntax of his visual vocabulary, allowing the deadpan identification of parts of the body to cast into doubt art's representational role. The naming of sexual features also had a jarring effect on the acceptance of the nude as a traditional pictorial idiom. Furthermore, the stenciled letters gave "a kind of manufactured look with a hard edge in contrast to the softer indefinite lines from my hand." (Quoted in *Drawings and Digressions,* p. 139.)

Here Rivers has compacted parts of five drawn or collaged women, stressing the roundness of their forms. The perfect ovals which constitute their heads refer to the first part of the title, *How to Draw,* and the popular teach-yourself art book advice to reduce anatomical forms to a circle. Illustrations from such drawing manuals were cut up, drawn over, and included in this work. Once again, Rivers calls ambiguous attention to the syntax of his drawing, denying its value as a teaching model through the complexity of his composition. The improvisational nature of this drawing—its overlays, smudges, and erasures—suggests that the figures are not the real subject of Rivers' interest, but only a pretext for his digressive graphic notations. Through repetition of the parts of the body and through their naming, the individual human figure is seen as an amalgam of replaceable parts.

Claes Oldenburg (American, born in Sweden, 1929)

91. *Outboard Motor*, 1964

Crayon and watercolor on paper, 17½ x 12¼ inches (44.5 x 31.1 cm.)

Signed at the lower left: *C.O. 64 Paris*

Bibliography: Gene Baro, *Claes Oldenburg: Drawings and Prints*, London, 1969, p. 254, no. 200.

Exhibition: The High Museum of Art, *Contemporary Art in Atlanta Collections*, April 24 - May 30, 1976.

Provenance: Sidney Janis Gallery, New York.

Lent by Mr. and Mrs. Donald Gold, Atlanta.

Oldenburg's consummate skill of hand is evident in this ironic study of an outboard motor. The metallic forms are deflated into an amorphous mass, hanging loosely from the starting rope. The metamorphosis of the machine is conveyed by the sag at the back of the motor cover, the wavy lines of the propeller shaft, and the limp steering bar. Hatching along the contours not only describes the volume of the outboard motor, but indicates ways in which it might be sewn and fabricated if transformed into cloth. Blocks of orange, blue, green, yellow, red, and pink watercolor further remove the machine from a context of function, and suggest how Cézanne might have envisioned this mundane object.

Oldenburg's use of the conventions of old master drawings elevates his subject matter, and adds to the effects of irony and parody. The monumentalizing, high-art description of the outboard motor is effectively undercut by its transformation. For students of Oldenburg's art, the outboard motor is also a metaphor for the human body, and a close relative of other Oldenburg objects—the vacuum cleaner, the three-way plug, the soft fan, the soft drainpipe, and, more remotely, the soft Dormeyer mixers.

This drawing was executed in October of 1964, when Oldenburg worked in Paris at the Ileana Sonnabend Gallery. His work there reflected the sense of order he perceived in the Parisian *milieu*, and a classical restraint characterizes many of his works of that period.

92. *Seated Nude No. 30,* 1963

Ink on paper, 17 x 12⁹/₁₆ inches (43.2 x 31.9 cm.)

Bibliography: Department of Art and Architecture, Stanford University, *Drawings by Richard Diebenkorn*, Palo Alto, 1965, p. 47.

Exhibition: *Richard Diebenkorn,* Stanford Art Gallery, April 1964.

Provenance: Poindexter Gallery, New York.

Lent by The Georgia Museum of Art, University of Georgia, Athens. Purchase, 1971.

Diebenkorn's nudes have a clear relationship to Matisse as a source, but the American's work is executed with far greater freedom and spontaneity. The marking line is given independent interest, and its weight corresponds more directly to the artist's expressive and compositional needs than to the exact modeling of the contours of the body. The artist responds to the pressures of reality and the surprises of visual discovery, but intellect and an abstracting sensibility intervene in the final results. A fine balance is struck between the description of sensuous form, pure line, and the need to integrate the figure into a flattened overall design.

This drawing was executed in 1963 while Diebenkorn was artist-in-residence at Stanford University. It was a period of intense interest in drawing for Diebenkorn.

93. *Nancy*, 1979

Graphite, oil, ink wash, and charcoal on torn, scraped and punctured paper, 44 x 31 inches (111.8 x 78.8 cm.)

Signed and dated at the lower center: *Jim Dine 1979*

Provenance: Pace Gallery, New York; Janie C. Lee Gallery, Houston; Harcus Krakow Gallery, Boston; Barbara Mathes Gallery, New York.

Lent by Dr. Elaine Levin, Atlanta.

Dine has frequently used his wife as subject matter. The artist has acknowledged that the valentine hearts in his work of the late 1960s stood for his wife, just as the bathrobes and neckties were metaphors for himself. In the 1970s, Dine turned from the depiction of common objects to the human form as his primary artistic concern. He explained:

> I want to draw people . . . I want to be able to *depict* the human face, charging it with all the things that I can bring to it with forty years of experience. (*Jim Dine Prints 1970-1977*, New York, 1977, p. 35.)

Dine's search for visual and emotional truth is searingly honest, and in this image, psychologically painful. Nancy Dine's head is surrounded by a black nimbus, setting off her delicate features. The image is worked and reworked in graphite, charcoal, ink, and oil. One ply of the heavy paper is pulled up at the lower center and upper right to provide a clean surface, and then marked over. Finally, Dine has repeatedly punctured the paper with a sharp instrument, particularly in the area of the right eye. Ironically, from a distance, the effect is to convey an unnatural glint.

A very similar drawing of Nancy was recently shown at The Richard Gray Gallery in Chicago (see *Jim Dine: An Exhibition of Recent Figure Drawings, 1978-1980*, January 24-March 7, 1981, no. 3). Although the frontal pose with crossed arms is the same, the Chicago drawing is less immediately cathartic.

NANCY

94. *Head and Rocks*, 1964

Pencil and crayon on paper, 13¼ x 9¾ inches
(33.6 x 24.7 cm.)

Signed at the lower right: *DH 64*

Exhibitions: The Alan Gallery, New York, 1964;
Heath Gallery, Atlanta, *Hockney*, 1976.

Provenance: The Alan Gallery, New York.

Lent by a Private Collection, Atlanta.

This is a drawing in Hockney's best discursive manner. The two rocks, profile of a head, frame, and Camel cigarette pack are aligned vertically according to a loose principle of contingency: Hockney stacks his motifs and thereby suggests some common ground of meaning for his disparate subject matter. In fact, what is compelling about the drawing is the sense of mutual alienation among the things. The purple and blue rock balances precariously over the green rock, which is partially superimposed on the head. The green rock, in turn, rests unevenly on the inner border of the frame, which fails to contain the head. The cigarette pack near the open mouth suggests smoking, but no cigarette appears. The over-large scale of the pack provides a psychological dislocation.

The Camel cigarette pack is a theme associated with Larry Rivers, who visited England in 1961-62 and had a strong influence at that time on younger English artists. The rocks are not unlike the lozenges of color in Ray Parker's highly publicized paintings of the early 1960s. Hockney's juxtaposition of different contemporary sources transcends mimicry to open up unforeseen possibilities of meaning.

95. *Hollywood Pool*, 1966

Pen and ink on paper, 9⅞ x 12½ inches
(25.1 x 31.8 cm.)

Signed and inscribed in pen at the lower right corner:
Hollywood Pool DH 66

Exhibition: Heath Gallery, Atlanta, *Hockney*, 1976.

Provenance: Kasmin Gallery, London, 1967.

Lent by a Private Collection, Atlanta.

David Hockney first went to Los Angeles in 1963 and he has recalled that "as I flew over San Bernardino and looked down—and saw the swimming pools and the houses and everything in the sun, I was more thrilled than I've ever been arriving at any other city." (*David Hockney, Paintings, Prints, and Drawings 1960-1970*, Lund-Humphries, London, 1970, p. 11.) It was indeed the swimming pool that was to become almost symbolic of Hollywood and Los Angeles glamour to the artist, and the challenge presented by depicting the water fascinated him. He has written:

> Water in swimming pools changes its look more than in any other form. The colour of a river is related to the sky it reflects, and the sea always seems to me to be the same colour and have the same dancing patterns. But the swimming-pool water is controllable—even its colours can be man-made—and its dancing rhythms reflect not only the sky but, because of its transparency, the depth of the water as well. If the water surface is almost still and there is a strong sun,

then dancing lines with the colours of the spectrum appear everywhere. If the pool hasn't been used for a few minutes and there's no breeze the look is of a simple gradation of colour that follows the incline of the floor of the pool. Added to all this is the infinite variety of patterns of material that the pool can be made from. (*David Hockney by David Hockney*, New York, 1977, p. 104.)

The swimming pool does not appear in his paintings until the *California Art Collector* of 1964, and then, over the next several years, it proceeded to take an amazing number of variations in both painting and drawing. This pen study is related to another entitled *Peter, Swimming Pool, Encino California, 1966* (Hockney, 1977, fig. 180). In both, the figure of Peter Schlesinger seated reading by the side of the pool is left incomplete and the artist concerns himself with the texture of the water. As in his series of pool paintings, Hockney varies the treatment of the water. In the drawing exhibited here, it is like strings of spaghetti, while in the other it is given a blotchy texture of reflections. The unfinished figure may suggest that in these cases Hockney was working directly from the subject and not from polaroids, as he often does. But it should also be observed that the faceless figure and the partially drawn-in chaise suggest that these are works about the cognitive process of creation as it literally works its way across the surface of the paper. The isolation and character fade-out are, of course, qualities not unknown in California.

Hollywood pool
Oct '66.

96. *Richard Wollheim (Study for Three Philosophers)*, 1976

Charcoal on buff paper, 22 x 30 inches
(55.9 x 76.2 cm.)

Signed at the lower left: *Kitaj*

Exhibitions: Marlborough Gallery, London, *R. B. Kitaj: Pictures*, April-June, 1977, no. 39; Marlborough Gallery, Zurich, June-July, 1977, no. 43.

Provenance: Marlborough Gallery, London.

Lent by a Private Collection, Atlanta.

Richard Wollheim is a professor of philosophy at University College, London. His seminal discussions of Minimal Art had a profound international impact in critical and artistic circles. In essence, Wollheim separated out the notion of "work" in a work of art, and posited that art objects be judged for and in themselves on the basis of their differentiation from other categories of objects.

It is perhaps ironic, then, that Kitaj shows Wollheim himself to be a very workmanlike philosopher, writing intently, caught between his desk and his bookshelves. The repetitive contours of his arms and the stop-action image of papers being flipped over convey a sense of intellectual energy. The figure of Wollheim is the stable vertical accent in a pictorial structure dominated by horizontal tracks; he resists but also reflects the implied motion of the world in front of and behind him. The sense of dynamism and creative ferment is also increased by setting the lines of the composition slightly askew, as if to imply this is an uncommon man in an uncommonly active environment. Kitaj is an intensely intellectual artist who has always drawn heavily on literary sources. Walter Lippman and Walter Benjamin, among others, have been the subjects of his paintings.

Kitaj works in London and, although born in America, considers himself part of the figurative "School of London," in which he includes Francis Bacon and David Hockney, among others. His own commitment has been to an open-ended and ambiguous painting of the human form in mysterious interiors. Kitaj has remarked:

> It's only that so much of the sophisticated art stream has, for very interesting and, for me, often enigmatic reasons, been diverted away from even the most recent models of the art which has always responded to the human form and always will . . . There are resilient painters conducting their own refusals . . . The single human figure is a swell thing to draw. (London Arts Council, *The Human Clay*, 1976.)

Claudio Bravo (Chilean, born 1936)

97. *Seated Model*, 1974

Pencil on Arches-France rag paper, 22½ x 14⅞ inches (57.1 x 37.8 cm.)

Provenance: Staempfli Gallery, New York.

Lent by Mr. and Mrs. Edward E. Elson, Atlanta.

In this exquisite study in colored pencils, Bravo displays his extraordinary technical proficiency and eye for nuance and detail. Unlike the American photo-realists, Bravo never uses photography in his working procedure: as a result his work is warmer, more classical, and less detached in feeling than that of most of his American counterparts. Humanist concerns and respect for the traditions of still life and figure painting inform Bravo's art.

Here placement in the corner provides the sitter with a plausible environment on the space of the sheet of paper. The cropping of the figure on the right creates an element of tension, as does the shift in vision between the frontal pose of the Oriental girl and the oblique angle of her chair. With great subtlety, Bravo delineates the textural contrasts between the girl's flesh and hair and the chair's shiny chrome and leather. Bravo uses a wide variety of techniques, from meticulous stippling in the flesh tones to long continuous lines for hair. Slight touches of sanguine in the lips and breasts relieve Bravo's concentration on gradations from black to white. Serene detachment and accuracy of vision are the constant characteristics of Bravo's art.

198

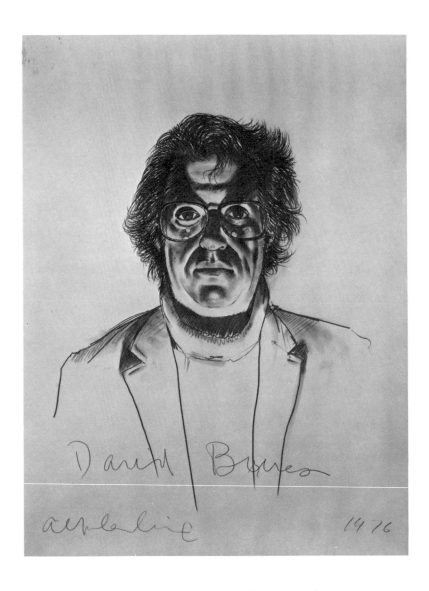

98. a. *David Burres*, 1976
 b. *Helen Searing*, 1976

Both: 4b graphite pencil on 2-ply 100% rag Strathmore paper, medium finish, each 40 x 30 inches (101.6 x 76.2 cm.)

a. Inscribed, lower half: *David Burres, Al Leslie, 1976*
b. Inscribed, lower half: *Helen Searing, Al Leslie, 1976*

Provenance: Allan Frumkin Gallery, New York.

Lent by Mr. and Mrs. Edward E. Elson, Atlanta.

These two drawings are part of a series of family sets that Leslie did in the winter of 1975-76, using close friends as his models. These drawings were conceived as a pair in order to emphasize portraiture's innate narrative or historical character. Leslie placed his sitters under a strong overhead light, while he himself remained in the shadows. By looking into the light of the sitter, the artist's sensitivity to darks and highlights was made more acute. Leslie's usual procedure in these drawings is to begin with a line running down the center of the page, in order to place the head in the middle of the sheet. Cross lines mark the upper and lower boundaries of the top of the head and bottom of the chin. Leslie uses a combination of contour and chiaroscuro drawing, without relying wholly on either method. Shadows are hard and are not uniformly graded off

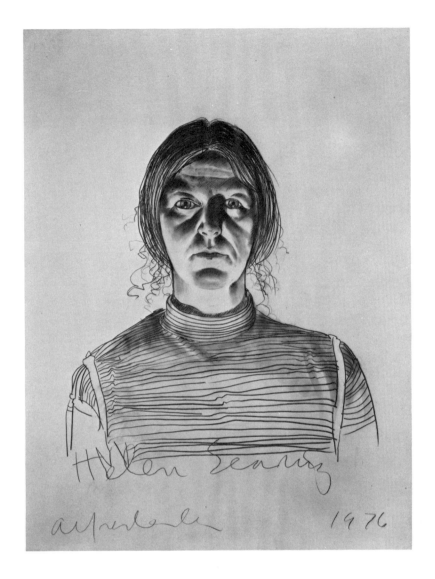

into middle tones, while outlines are allowed to lapse in places. Highlights—as at the tips of the noses, and in the glare on David Burres's glasses—are symbolically indicated by small circles.

The artist points out that the unshaded background around the shaded heads is also a symbolic space:

> You can use white as black as long as the area behind the figures is not marked. You can use your imagination and make of it what you will. It's flat and an endless distance at the same time. (Telephone conversation with Alfred Leslie, 23 March 1981.)

Leslie's procedure then, is a combination of signs and drawing systems based on careful empirical observation. The isolation of the heads on the page and the strong contrasts in the modelling of forms endow the visages with a presentational immediacy, a quality Leslie refers to as "confrontational art":

> I made pictures that demanded the recognition of individual and specific people, where there was nothing to be looked at other than the person—straightforward, unequivocal, and with a persuasive moral, even didactic, tone. (Boston Museum of Fine Arts, *Alfred Leslie*, 1976.)

Helen Searing recalls that these portraits were completed with only a half-hour sitting for each.

Edward Ruscha (American, born 1937)

99. *Walk*, 1972

Gunpowder and graphite on paper, 11½ x 29 inches
(29.2 x 73.7 cm.)

Signed at the lower left: *E.R. 1972*

Exhibition: The High Museum of Art, *Contemporary Art in Atlanta Collections,* April 24-May 30, 1976.

Provenance: Ronald Feldman Fine Arts, New York.

Lent by a Private Collection, Atlanta.

Ruscha's multiple ironies are a radical extension of the approaches of Pop artists like Dine and Oldenburg. His mixture of verbal and visual means is often absurd, and may legitimately deserve to be described as a kind of neo-Dada. At the same time, Ruscha is the archetypal Los Angeles artist, and his technical showmanship and sitcom gag-line sensibility owes much to the influence of the entertainment industry there.

The first of Ruscha's ironies is the use of gunpowder as a drawing medium, one of many unconventional media he employed in the early 1970s. Whatever it may imply about the artist's relationship to the world of sterner realities, it lends a cool sheen to the paper surface. The word "walk" written illusionistically in *trompe l'oeil* paper strips is seen in oblique perspective, as if the letters were themselves walking or floating through the amorphous atmosphere. The panoramic format is cinematic and by implication casts art altogether in the realm of "special effects." Comparable drawings of 1970-72 include *Soup, Stains, Are, Vanishing Cream,* and *Sudden Spurts of Activity.* (See Edward Ruscha, *Guacamole Airlines,* New York, 1980, pls. 21, 22, 25, 28, and 30.)

100. *Mark*, 1974

Ink and graphite on paper (Veritable Papier D'Arches/Satine), 8⅜ x 6¹⁵/₁₆ inches (21.2 x 17.7 cm.)

Signed at the lower right: *C Close 1974*

Provenance: Pace Gallery, New York.

Lent by The Georgia Museum of Art, University of Georgia, Athens. Purchase, 1979.

This is the smallest of a series—which includes a full-scale painting—of images of *Mark*. Close's art is based on the use of a grid, not only as a method of scaling his work up, but also as a way of codifying visual information. Close paints and draws from photographs, breaking down the perceptual data into what the artist calls "art marks." Their manner of application constantly evolves in Close's work, and airbrush, thumb prints, and rubber stamps have been among the methods used. Perhaps inspired by Information Theory, the artist has experimented with the amount of detailing required to convey the appearance of a face and the photograph which recorded it. In this drawing, a structure of four dots set in a square are used to record the lightness or opacity of the corresponding area in the photographic model. Close pursues an ideal of maximum neutrality towards every part of the face:

> Looking at the eye is one thing and looking at the cheek, another, but I have always tried to have the same attitude toward both of them. But because of the nature of things I had to function differently. The act of making an eyelash with one long stroke is not the same as making a cheek. So as much as I was interested in sameness, there was still a need to function differently, depending on what I was doing. But by breaking it down this way I can make the act of painting exactly the same all the way through. (William Dyckes, "The Photo as Subject: The Paintings and Drawings of Chuck Close," *Super Realism: A Critical Anthology*, New York, 1975, p. 161.)

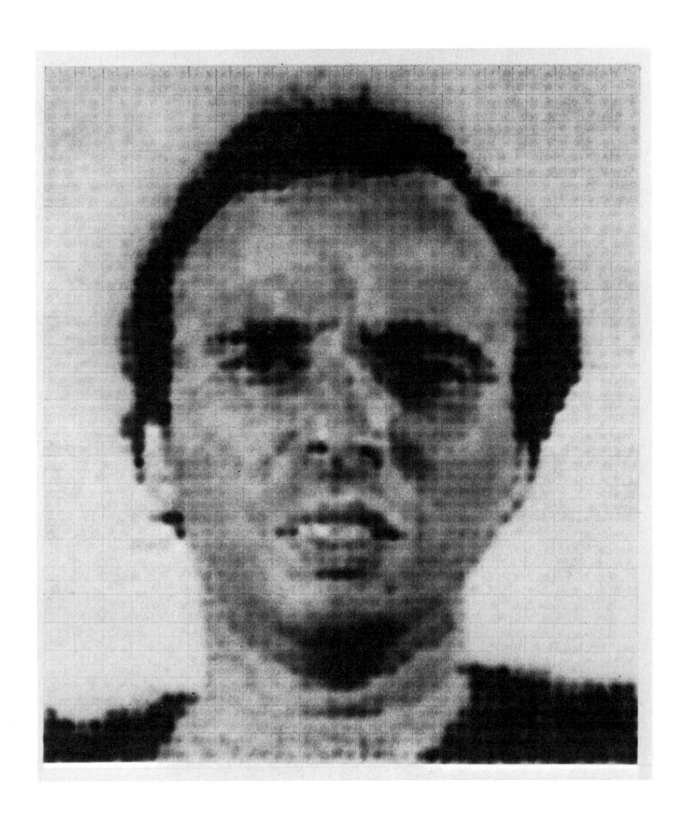

101. *Untitled*, 1979

Charcoal on paper, 17¾ x 22⅞ inches
(45.1 x 58.1 cm.)

Exhibition: Texas Gallery, Houston, 1979.

Lent by a Private Collection, Atlanta.

Joel Shapiro's charcoal drawings of the 1970s convey a sense of decision-in-process: smudges and erasures read as ghosts of other possible configurations and give an unexpected tentative character to the ruled black lines. Shapiro's drawing serves as a reminder that "even the most orderly geometrics emerge from an untraceable series of gestures." (Carter Ratcliff, "Joel Shapiro's Drawings," *The Print Collector's Newsletter*, March-April, 1978, p. 2.)

In this work, the enclosed rectangle does not take on strong figural connotations, since the velvety charcoal bars themselves read as discrete positive shapes, and have strong directional force. Rather than separate shape and background, the black bands seem to demarcate separate regions of the same white void. The tentative character of the rectangle is also suggested by the implication of a spatial shift backwards or to the left at the upper edge. The sense of motion is blunted, however, by a blur at the end of the finely honed point. Attention focused on the making and materiality of the lines returns a dynamic impulse to a condition of stasis, of abstract simplicity.

Shapiro's personalized minimalism, in his drawings as in his sculptures, has emotional and psychological overtones. The meanings of enclosing and being enclosed, of bounded space and free space, of rigid order as opposed to irrationality, are some of the themes of this drawing.

Barry Le Va (American, born 1941)

102. *Corner Sections (of 3 Triangular Boundaries Hovering Overhead)*, 1978

Ink, graphite, and red crayon on construction paper and tracing paper, 40 x 70 inches (101.6 x 177.8 cm.)

On *recto* at the lower left corner in graphite: *Corner sections (of 3 triangular boundaries hovering overhead from ceiling) separately projected from 9 positions of viewing. Each position (not necessarily stationary) is located at a specific depth below ceiling level and outside the boundaries (except one) of the surrounding walls.*

Exhibitions: Ackland Art Museum, *Drawings About Drawing*, University of North Carolina at Chapel Hill, January 28-March 11, 1978; The University of Tennessee at Chattanooga, *Twentieth Century American Painting*, September 9-October 3, 1980, no. 16.

Provenance: Sonnabend Gallery, New York.

Lent by The Georgia Museum of Art, University of Georgia, Athens. Purchase, 1979.

Barry Le Va is a former architecture student. His recent drawings concern the plotting of boundaries and locations. Some have been made into actual installations, but most remain purely visionary. Le Va's interest lies in making perspectival shifts tangible, concentrating on the transition from one spatial projection to another. His notational systems indicate locations rather than defining them, and remain only partially formulated. The interaction of space and time, however, is made almost palpably visible in these large and complex works.

In this drawing, corners of imagined boundaries are superimposed on each other, and cut through the space in which they are projected. The boundaries are situated inside one another, and are seen from diverse (and impossible) viewing points. The inner corner boundaries and also the outside "viewing" boundaries, are tilted at different axes. Because of Le Va's use of multiple points of view, one's understanding of his drawing is ultimately conceptual rather than perceptual. The artist has commented: "I'm not interested in altering spaces unless they're mentally rather than visually altered." (The New Museum, *Barry Le Va: Four Consecutive Installations and Drawings, 1967-1978*, New York, 1978, p. 26.)

103. *Untitled*, 1977

Oil, paint stick and pastel on paper, 76⅜ x 42¼ inches (194 x 107.3 cm.)

Provenance: Leo Castelli Gallery, New York.

Lent by Arthur E. Smith, New York and Vidalia.

In this oversized sheet, predominantly grey pigments are blended thickly to suggest a surface with the texture and light-reflective qualities of stone or concrete. The image has a feeling of hardness, and the markings never become hazy. Yet, Westerlund's random order of application, her scoring and scratching, convey the feeling that the ground may be malleable and changeable. The sense of turgid motion in a fixed field reflects some of Westerlund's procedures in her own sculpture. The size of the drawing and its high degree of detail make it impossible to tell whether the sense of motion arises from the composition or the movement of the viewer's eye over the flowing, luminous field. The drawing is overwhelming in its presence, immediacy, and textural richness.

Hans Arp (French, 1886-1966)
104. *Untitled.* Watercolor on paper, 8⅛ x 5½ inches (20.6 x 14 cm.). Lent by a Private Collection, Atlanta.

Eugene Berman
(American, born in Russia, 1899-1972)
105. *Summer Sun,* 1939. Watercolor on paper, 13¾ x 10¼ inches (34.9 x 26 cm.). The High Museum of Art. Gift of Dr. Glenn Crawford, 1980.

Pierre Bonnard (French, 1867-1947)
106. *After the Bath.* Pencil on paper, 4½ x 7 inches (11.4 x 17.8 cm.). Lent by Dr. Ernest Abernathy, Atlanta.

Edward Burne-Jones (English, 1833-1898)
107. *Ecclesiastical Figure.* Chalk on reddish paper, 15⅝ x 9¾ inches (39.7 x 24.8 cm.). Lent by a Private Collection, Atlanta.

Alexander Calder (American 1898-1976)
108. *Globes,* 1931. Pen and ink on paper, 23 x 31 inches (58.4 x 78.7 cm.). Lent by Lenore and Burton Gold, Atlanta.

Eugène Carrière (French, 1849-1906)
109. *Studies of Figures.* Charcoal on buff paper, 12³/₁₆ x 9¼ inches (31 x 23.5 cm.). Lent by Dr. and Mrs. Michael Schlossberg, Atlanta.

Elliott Daingerfield (American, 1859-1932)
110. *Celestial Figure, Drapery Study,* 1902. Pencil on paper, 19½ x 15⅝ inches (49.5 x 39.7 cm.). Lent by Dr. Robert P. Coggins, Marietta.

Charles Demuth (American, 1883-1935)
111. *Study of a Tree.* Watercolor on paper, 13 x 12 inches (33 x 30.5 cm.). The High Museum of Art. Purchase, 1967.

Jim Dine (American, born 1936)
112. *Toothbrushes and Tumbler Holder #1,* 1962. Pencil and crayon on paper, 30 x 24 inches (76.2 x 61 cm.). The High Museum of Art. Purchase with funds from the National Endowment for the Arts and an anonymous gift, 1973.

113. *Pallette(N) #2,* 1963. Ink wash on paper, 48 x 36 inches (121.9 x 91.4 cm.). Lent by Robert and Edith Fusillo, Atlanta.

Jean Dubuffet (French, born 1901)
114. *Arab Woman.* Colored pencil on paper, 10 x 7¼ inches (25.4 x 18.4 cm.). Lent by a Private Collection, Atlanta.

115. *Personage,* 1960. Pen and ink on paper, 12½ x 8⅞ inches (31.7 x 22.5 cm.). Lent by a Private Collection, Atlanta.

Lyonel Feininger (American, 1871-1956)
116. *Four Mast Bark III,* 1934. Watercolor and ink on paper, 9⅛ x 7 inches (23.2 x 17.8 cm.). Lent by Judy and Stan Cohen, Atlanta.

117. *Spain,* 1946. Pen and ink with watercolor on paper, 6⅞ x 11 inches (17.5 x 28 cm.). The High Museum of Art. Gift of James V. Carmichael, 1955.

Georges Grosz
(American, born in Germany, 1893-1959)
118. *Figures in a Bus.* Ink on paper, 18 x 23½ inches (45.8 x 59.7 cm.). Lent by Dr. Ernest Abernathy, Atlanta.

Ernest-Hyacinthe-Constantin Guys
(French, 1802-1892)
119. *Study of a Woman in a Dress.* Pen and watercolor on paper, 8 x 5¾ inches (20.3 x 14.6 cm.). Lent by Dr. and Mrs. Michael Schlossberg, Atlanta.

Henri Joseph Harpignes (French, 1819-1916)
120. *The Joys of Painting,* 1869. Watercolor on paper, 6½ x 8¾ inches (16.5 x 22.2 cm.). The High Museum of Art. Gift of Mrs. Henry D. Sharpe, 1955.

Hans Hofmann
(American, born in Germany, 1880-1966)
121. *Untitled,* 1946. Gouache on paper, 17½ x 22½ inches (44.5 x 57.2 cm.). Lent by a Private Collection, Atlanta.

Rudolf Jettmar (Austrian, 1869-1939)
122. *Studies of a Male Nude.* Pencil on paper, 11⅝ x 18½ inches (29.5 x 47 cm.). Lent by a Private Collection, Atlanta.

Paul Klee (Swiss, 1879-1940)
123. *Der Verkaufer (The Vendor),* 1937. Watercolor on paper, 7 x 11 inches (17.8 x 28 cm.). Lent by The Georgia Museum of Art, University of Georgia, Athens. Gift of Alfred H. Holbrook, 1946.

Frederic Leighton, Baron Leighton of Stretton
(English, 1830-1896)

124. *Studies of Female Figures including Helen of Troy*. Charcoal on paper, 11 x 9¾ inches (28 x 24.8 cm.). Lent by a Private Collection, Atlanta.

René Magritte (Belgian, 1898-1967)

125. *Le Rideau*, 1959. Collage and gouache on paper, 12½ x 9 inches (31.8 x 22.8 cm.). Lent by Mr. and Mrs. Simon S. Selig, Jr., Atlanta.

Brice Marden (American, born 1938)

126. *Untitled*, 1972. Graphite on paper, 30 x 22½ inches (76.2 x 57.2 cm.). Lent by a Private Collection, Atlanta.

Henri Matisse (French, 1869-1954)

127. *Head of a Woman*. Pencil on paper, 20 x 14 inches (50.8 x 35.6 cm.). Private Collection, on extended loan to the High Museum and Emory University.

128. *Woman by a Table*, 1944. Pen and ink on paper, 21 x 15⅜ inches (53.4 x 39 cm.). Lent by Mr. and Mrs. Louis Regenstein, Atlanta.

Roberto Sebastian Matta Echaurren
(Chilean, born 1911)

129. *Les Oeux de la Tête*, 1967. Colored pencil on paper, 19¾ x 25¾ inches (50.2 x 65.4 cm.). The High Museum of Art. Gift of Arthur E. Smith, 1980.

Maxime Maufra (French, 1861-1918)

130. *Les Falaises d'Etretat*, 1895. Charcoal on paper, 11 x 15 inches (28 x 38.1 cm.). Lent by Glenn and Jean Verrill, Atlanta.

Elizabeth Murray (American, born 1940)

131. *Winter Drawing*, 1979. Pastel on paper, 20½ x 15½ inches (52 x 39.4 cm.). Lent by a Private Collection, Atlanta.

Gladys Nilssen (American, born 1940)

132. *Bean Carried Off*, 1970. Watercolor on paper, 11¼ x 15 inches (28.6 x 38.1 cm.). Lent by Mr. and Mrs. Bruce Bobick, Atlanta.

Georgia O'Keeffe (American, born 1887)

133. *Sun, Water – Maine*, 1922. Pastel on paper, 25 x 19 inches (63.5 x 48.3 cm.). Lent by a Private Collection, Atlanta.

Paul Ranson (French, 1862-1909)

134. *Mountain Landscape*. Ink and watercolor on paper, 18¼ x 11¾ inches (46.4 x 29.9 cm.). Lent by Dr. Michael Schlossberg and Richard Schlossberg, Atlanta.

Edda Renouf (American, born in Mexico, 1943)

135. *New York Sound Drawings 2*, 1977. Graphite on scored paper, 15 x 11 inches (38.1 x 28 cm.). Lent by Arthur E. Smith, New York and Vidalia.

Théo van Rysselberghe (Belgian, 1862-1926)

136. *Mother and Child*. Charcoal on paper, 20¾ x 15 inches (52.7 x 38.1 cm.). Lent by Dr. and Mrs. Michael Schlossberg, Atlanta.

Claude-Emile Schuffenecker
(French, 1851-1934)

137. *Parisian Street Scene*. Pencil and chalk on paper, 13¼ x 11¾ inches (33.6 x 29.9 cm.). Lent by a Private Collection, Atlanta.

Paul Signac (French, 1863-1935)

138. *Les Barques, Bourg St. Andriels*, 1926. Watercolor on paper, 10½ x 16⅝ inches (26.7 x 42.2 cm.). The High Museum of Art. Purchase, 1968.

Théophile Steinlen (French, 1859-1923)

139. *Studies of Figures*. Blue chalk on paper, 8½ x 11¼ inches (21.6 x 28.6 cm.). Lent by Dr. Ernest Abernathy, Atlanta.

George Trakas
(Canadian, working in America, born 1944)

140. *Project in Poughkeepsie, N.Y.* Charcoal on paper mounted on wood, 25¾ x 39¾ inches (65.4 x 101 cm.). Lent by Carolyn Brooks and Peter Morrin, Atlanta.

Richard Tuttle (American, born 1941)

141. *Harbor Tree*, 1969. Watercolor on paper, 12 x 9 inches (30.5 x 22.9 cm.). Lent by a Private Collection, Atlanta.

Louis Valtat (French, 1869-1952)

142. *La Dame Pres du Lac*, ca. 1896. Watercolor and pencil on paper, 9⅜ x 12¼ inches (23.8 x 31.1 cm.). Lent by Dr. and Mrs. Michael Schlossberg, Atlanta.

INDEX